HIKING LAKE TAHOE

HIKING
LAKE TAHOE

A HISTORY AND TRAIL GUIDE

SUZIE DUNDAS

THE
History
PRESS

Published by The History Press
Charleston, SC
www.historypress.com

First published 2021

Manufactured in the United States

ISBN 9781467148603

Library of Congress Control Number: 2021938366

Notice: The information in this book is true and complete to the best of our knowledge. It is offered without guarantee on the part of the author or The History Press. The author and The History Press disclaim all liability in connection with the use of this book.

CONTENTS

CONTENTS

PREFACE

This book would not have been possible without the dedicated and meticulous recordkeeping, journaling and photography of those who first explored the Sierra Nevada. That includes the Washoe People, who were the first (and likely best) stewards of the land around the Tahoe region. Their story is much more robust than suggested in this book. Unfortunately, history has shown us that white settlers have a history of discounting indigenous peoples' knowledge and rights, leaving more blank spots in their story than a writer would want.

Much of Tahoe was developed on the backs of those who remain nameless—countless gold miners who came west hoping to make their fortunes, workers and laborers who engaged in literal backbreaking work to build the railroads and thousands of hourly employees who cleaned the bedrooms and fueled the fires at Tahoe's earliest luxury resorts. While writing this book has been a pleasure, one hopes that the history and stories from current-day Tahoe do a better job of accurately reflecting the diverse experiences and people who make up the region's rich communities.

I've made every effort to tell these histories as accurately as possible, taking into account the sometimes conflicting accounts of individuals and places, plus newspaper records that sometimes included fiction as much as fact. Sources range from historical accounts to journals, modern-day research and archaeological efforts that have helped shine a light on Lake Tahoe's people and places. If you enjoy the histories in this book, I suggest doing your own research to learn more about the people and places

covered—there are many more layers to many of these stories than I'm able to include.

If you enjoy your experiences on the trails in this book, consider donating to one of the several state and nonprofit groups throughout California and Nevada that work so tirelessly to maintain the extensive trail system, or perhaps to one of the historical societies whose members volunteer their time to keep history alive.

ACKNOWLEDGEMENTS

A special thank-you to the editors who took a chance on a first-time writer, Gary and Carol Dundas—who now have their names published in a book—and Aren, my favorite mountain-biking architect.

A final thank-you to Doolie, the best trail buddy I could have for exploring Tahoe.

Introduction

THE JEWEL OF THE SIERRA

Whether you want to call it the "Jewel of the Sierra," the "Lake of the Sky," "Big Blue" or "Da ow aga"—the very first name for Lake Tahoe—there's no denying the beauty and allure of the lake. And although travelers may think that Lake Tahoe was somewhat under the radar until the tourism boom of the mid-1900s (kicked off by the 1960 Winter Olympics at Squaw Valley Resort), emigrants and adventurers have been trekking through Tahoe since the 1840s. (*Emigrant* was the historical word used for people moving toward California in the 1800s and will be used as such throughout the text.) Of course, the real history of Tahoe goes back to the native Washoe Tribe and Martis Complex, both of whom used the lake as a summer home for thousands of years well before America's westward migration began.

The earliest evidence of habitation in the Tahoe area comes from around 2000 BCE by the Martis Complex, likely one of the first tribes in the Sierra Nevada. Although remaining evidence is scant, petroglyphs around the lake indicate to researchers that the region was likely a summer home for many years, making the Martis Complex the area's first inhabitants.

Next to come was the Washoe Tribe, who may have descended from the Martis Complex. The Washoe occupied the basin during the summer and surrounding valleys in the winter from around the third century BCE to the current day, although America's Manifest Destiny mentality nearly destroyed their culture. And just north and east of the lake toward Nevada were the Northern Paiute, a tribe very distinct from the Washoe.

Introduction

The land around Tahoe was a special place, especially the valleys where indigenous Americans made their summer homes (like the Lam Watah Meadow and beaches near the former Bijou Lodge) and the sites still considered sacred, like Cave Rock. The Washoe and Northern Paiute took advantage of the rich resources around the lake for centuries, using the land to hunt, fish and grow crops. But when American settlers moved west, it drastically changed the story of Tahoe, pushing out native cultures to make way for the eventual boom of the mining, logging, rail and tourism industries.

The first record of white explorers coming through Tahoe begins with John C. Frémont, who traveled with renowned mountain guide Kit Carson. His party crested the eastern Sierra Nevada in 1844; however, the lake didn't begin to play an important role to migrants until the discovery of the Comstock Lode in nearby Virginia City in 1859. Suddenly the sleepy hillside developments just east of the lake came alive with thousands of settlers hoping to strike it rich.

Tahoe quickly became one of the country's most important centers of commerce. Massive logging operations emerged around the lake to supply timber for the mines and fuel for the railroads. Captains of industry and wealthy entrepreneurs built flume systems that crossed the mountains, carrying water and wood to the mines. Logging companies built small-gauge railroads around the lake to move logs and supplies between their remote operations and the transcontinental railroad station in Truckee, and landowners developed roads and service stations for travelers passing through the area.

By the early twentieth century, travel to Tahoe from San Francisco and Sacramento was long and onerous but possible. Train travel for tourists became *en vogue* in the very late nineteenth century, and wealthy California families flocked to the luxury lakeside resorts of Tahoe Tavern, the Tallac Hotel, the Bijou Lodge and the early Summit Hotel, perched near the tracks on the highest point of the Sierra Nevada crossing. Travelers came to Tahoe for recreational activities like hiking, horseback riding, boating, hunting, fishing and, by the 1910s, skiing. Tahoe's slopes were soon dotted with ski lifts, from the West Coast's first mechanized ski lift at Truckee's Hilltop Lodge to the isolated rope pulls near current-day Sugar Bowl Ski Resort.

By the 1930s, the lake was offering no shortage of hotels and lodges welcoming travelers taking advantage of the safer and speedier Lincoln Highway and paved interstate routes across California. Even Mark Twain

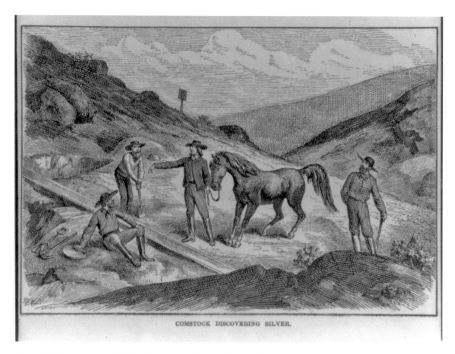

An artist's rendering of the discovery of the Comstock Lode, circa 1850. *Library of Congress, LC-USZ62-42750.*

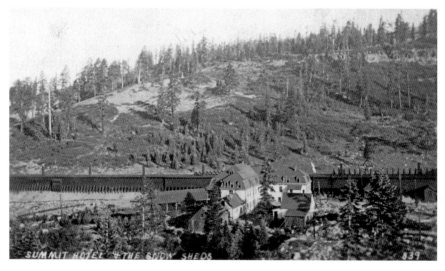

The Summit Hotel was most frequently used by guests stranded on the summit when snow covered and closed the train tracks. 1914. *California History Room, California State Library, Sacramento, California.*

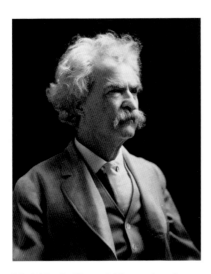

Mark Twain (Samuel Clemens) took his pen name while writing at Virginia City's *Territorial Enterprise* newspaper. *Library of Congress, LOC LC-USZ62-5513.*

made frequent trips to Tahoe while he was working in nearby Virginia City. Nationally recognized resorts opened. Walt Disney himself financed Sugar Bowl Ski Resort's development, and Rat Pack crooner Frank Sinatra took ownership of the border-straddling Cal-Neva Lodge. With a painted line through the swimming pool marking the border between California and Nevada, the hotel became the place to be seen in the 1950s and 1960s for Hollywood's elite. Secret tunnels under the property helped furtively move both mob bosses and celebrities—and liquor, during the hotel's Prohibition years. Stars like Judy Garland, members of the Kennedy family and Marilyn Monroe frequented the resort; in fact, Monroe spent her last weekend alive at the Cal-Neva in the cabin now named in her honor.

Tahoe gained a national reputation following the 1960 Winter Olympics at Squaw Valley, and neighborhoods blossomed significantly. Professional skiers and developers built the town of Incline Village in the 1960s as an exclusive resort community, and the south shore evolved from being mostly mom and pop hotels to a gambling mega-destination, complete with nightclubs, live music and the pedestrian-friendly village area at the base of Heavenly Mountain Resort. Movies like *The Misfits*, starring Clark Gable and Marilyn Monroe; *The Godfather Part II*; and Stephen King's *Misery* were filmed at the lake. In the last thirty years or so, the popularity of "extreme sports" like rock climbing and mountain biking have helped continue to fuel tourism and development around the lake.

While tourism may be Tahoe's primary industry, it's hard to say what the future holds. Global warming poses a risk to the ski industry and could soon interrupt the region's famous "November to July" ski season. And rising costs of living threaten to turn the area into an enclave more suited to the West Coast elite than the average outdoor enthusiast.

For now, however, the trails, towns and businesses around Tahoe offer the perfect blend of low-key luxury, outdoor recreation and small-town

charm that first spurred the 1900s-era tourism boom. As naturalist John Muir—who lobbied to make the basin a national park in the late 1800s—once wrote of Lake Tahoe:

> *As I curve around its heads and bays and look far out on its level sky, fairly tinted and fading in pensive air, I am reminded of all the mountain lakes I ever knew, as if this were a kind of water heaven to which they all had come.*

I hope everyone reading this book can find their own personal paradise in the mountains, valleys and towering pine forests surrounding the Jewel of the Sierra.

The Trails of Lake Tahoe

Trail Name	Trail Location	Trail Difficulty	Trail Length	Elevation Gain
1. Donner Memorial State Park	Truckee	easier	1.5 miles +	30 feet +
2. Judah and Donner Summit Loop	Truckee	more difficult	5.7 miles	1,340 feet
3. The Lost Cabin Mine Trail	South of South Lake Tahoe	more difficult	4.8 miles +	1,140 feet
4. Carson Pass to Round Top Lake	South of South Lake Tahoe	more difficult	7 miles +	900 feet
5. Round Top Lake to 4th of July Lake	South of South Lake Tahoe	most difficult	4 miles	1,130 feet
6. The Beckwourth Trail	North of Truckee	easier to more difficult	13.6 miles	350 feet
7. Petroglyphs, China Wall and Railroad Tunnels	Truckee	easier	.4 miles	150 feet
8. Donner Summit Canyon	Truckee	more difficult	5 miles +	850 feet
9. Boca Townsite	Truckee	easier	.5 miles	30 feet
10. Kyburz Flat	North of Truckee	easier	1.8 miles	280 feet
11. Marlette-to-Spooner Flume	Incline Village	more difficult	9.8 miles	1,500 feet
12. Tunnel Creek to Twin Lakes	Incline Village	most difficult	8 miles	2,000 feet
13. The Incline Rail/ Incline Flume	Incline Village	easier	5 miles +	557 feet
14. Hobart Mills	Truckee	more difficult	7.9 miles	850 feet
15. The Church Trail	West/Nevada City	easier	.6 miles +	35 feet

Trail Name	Trail Location	Trail Difficulty	Trail Length	Elevation Gain
16. The Marten Ranch Trail	West/Nevada City	easier	1.4 miles	180 feet
17. The Hiller Tunnel Trail	West/Nevada City	more difficult	.6 miles +	60 feet
18. Lam Watah Nature Trail	South Lake Tahoe	easier	2 miles +	120 feet
19. Cave Rock	South Lake Tahoe	easier	.8 miles	220 feet
20. The Lighthouse Trail	South Lake Tahoe	easier	1.6 miles +	380 feet
21. The Rubicon Trail	South Lake Tahoe	more difficult	7.2 miles +	700 feet
22. Fallen Leaf Lake	South Lake Tahoe	easier	.5 miles +	100 feet
23. Tallac Historic Site	South Lake Tahoe	easier	1.8 miles +	flat
24. Snowflake Lodge at Diamond Peak	Incline Village	more difficult	2.6 miles	650 feet
25. Sugar Bowl to Squaw Valley	Truckee	most difficult	14.5 miles	2,500 feet
26. Snowshoe Thompson Trail	South of South Lake Tahoe	easier	1.2 miles	400 feet
27. Mount Lola	North of Truckee	most difficult	10.4 miles	2,600 feet
28. Sierra Buttes Fire Lookout	North of Truckee	most difficult	4.8 miles	1,540 feet
29. Hope Valley to Scott's Lake	South of South Lake Tahoe	more difficult	8.2 miles	1,150 feet

HIKING IN TAHOE

TRAIL RATINGS

The trails in this book range from easy "hikes" that most people wouldn't think twice about doing in sandals to high-elevation, long-distance hikes best tackled over the course of a weekend.

Each hike includes relevant trail information as well as a rating—"Easier," "More Difficult" and "Most Difficult," relative to other trails in this book. A trail designated as "Easier" is easier than most other hikes in this book, but it may not be easy if you're coming from a low elevation. Conversely, the "Difficult" hikes may be no more than a warm-up for someone who spends their weekends running marathons. Be sure to know your limits and ability levels before starting any hike.

While all the trails in this book are rated based on hiking difficulty, many are mixed-use. Mountain biking is extremely popular, and many trails are also equestrian friendly. While winter weather generally rules out hiking from around December to May, it also creates perfect opportunities for scenic snowshoe trips.

Some day hikes in this book require a permit, which you can fill out for free at the trailheads. You'll need to secure a permit in advance for overnight camping anywhere around Lake Tahoe; be sure to do an online search of the trail name followed by the phrase "camping permit" before setting out.

A note about dogs: most trails in the area, whether they officially allow dogs to be off-leash or not, will have off-leash dogs. However, dogs still need to be under the verbal control of their owners. If you have a fear of dogs (or don't love them the way Tahoe locals do), just ask the owner to put their dog on a leash as you pass by. Conversely, make sure your dog is under your verbal or physical control while hiking, and always clean up after your pet.

Each route's stats were measured using either the Gaia smartphone app or a GPS-enabled Garmin tracking device. Accuracy may vary based on service windows and tech limitations, although I've taken every effort to track as accurately as possible. Trails are also occasionally rerouted, which can affect the distance and total elevation gain.

TAHOE WEATHER

Truckee and the towns in the Tahoe basin have significant weather fluctuations throughout the days; it's not unusual for the temperature to swing forty or fifty degrees Fahrenheit between day and night.

From December through April, expect full-on winter. Massive snowstorms depositing a foot or more of snow around Tahoe are common, although it's usually sunny and around thirty to forty degrees Fahrenheit when it's not snowing. Overcast days are rare; if it's not snowing, it's probably sunny (although that doesn't mean it's warm). Near the lake, most hiking trails will be accessible on snowshoes or cross-country skis only.

Depending on the year, snow on lower-elevation trails starts melting in April, although it could be as late as May or June. May is an excellent month to start hiking (but be sure to dress in layers, as mornings are still very cold).

June through September are warm. While it starts getting chilly during the evenings toward the end of September, it's still usually hot during the days. Tahoe residents often call September "local's summer," as there are fewer tourists in the area and everyone who worked long hours over the summer gets a chance to have some outdoor fun. Rain is rare in the summer, and daytime temperatures can creep into the eighty-degree range, although it's not unusual to have a small heatwave of ninety degrees Fahrenheit or warmer in July or August.

October and November mark Tahoe's short-lived autumn season. Snow can start as early as mid-October or not arrive until Thanksgiving. Most

trails will still be accessible during these months. Temperatures swing the most on autumn days; it can easily reach the mid-seventies during the day and dip below freezing at night. Pack accordingly if you plan to camp.

TERRAIN

The terrain around Tahoe varies nearly as much as the weather. In general, the trails are not smooth dirt paths; this is not a national park. Most dirt trails will be a least partially rocky, and even fire roads often have uneven sections. Trails can get extremely dusty and dry in the summer or extremely muddy with snowmelt in the spring. Frequent hikers will not find Tahoe's offerings to be anything out of the ordinary, but trekking poles can help create peace of mind.

The exception to this statement are the trails maintained by state parks, like the Tallac Historic Site or the D.L. Bliss State Park trails. Those trails are often better maintained, with hazards better marked.

Remember that out-and-back trails can be any length you want. What's important is enjoying the hike (or bike), not how far you go.

RISKS AND CHALLENGES

Most trails in Tahoe are fairly well marked and heavily trodden by mountain standards; after all, hiking is a popular pastime. For most people, the most significant challenges are elevation and exposure.

Lake Tahoe is at an elevation of 6,200 feet, and most trails are much higher than that. Some trails in this book cross past 9,000 feet. Breathing at higher elevations can be harder on your respiratory system and make some people feel lightheaded. It also makes it much easier to get dehydrated, so be sure to bring far more water than you think you'll need on every hike. And while the three hundred days of sunshine each year in Tahoe are wonderful, they also make it much easier to get sunburned, especially since both snow and water reflect UV rays on your skin. Use a higher sunscreen than you usually would and be sure to reapply frequently.

While it's not impossible to encounter them, poison ivy and oak are extremely rare at high elevations. You might find these at lower-elevation

hikes outside the basin, but as long as you don't stray too far from the trail, you're unlikely to have serious issues.

When it comes to wildlife, most hikers needlessly worry about bears. While black bears do live in Tahoe, they're very skittish and will likely move away before you see them. The exception to this are bears with cubs, which won't walk away if you're in between them and their cubs. If that happens, stop and slowly move out of the way to make space for mom to reconnect with her cubs. Tahoe's bear population is high, but it's still relatively rare to see one, so consider yourself lucky if you do. There's never been a fatal bear attack in California or Nevada. If you're camping, remember that bears are most active at night. Research appropriate bear precautions, including the use of bear-safe containers and bags.

The rarest sighted animals are mountain lions. They live in Tahoe; however, estimates suggest there are fewer than twenty around the entire region. If you do see a mountain lion, don't run. Make yourself look as big as possible by lifting your backpack or jacket over your head, stay close to any small children or dogs and make noise to scare it away. Trail encounters with mountain lions are extremely infrequent. If forest rangers spot a mountain lion, they'll post signs at the trailheads with friendly reminders on what to do if you see it (most of which aim to keep the mountain lion safe from you, rather than vice versa).

Other wildlife you may see include deer and coyotes. The latter is skittish and usually only active at dusk and dawn. Coyotes are no threat to humans, but if you're with a small dog, keep it on a leash if you do any early-morning hiking. Otherwise, you're likely only to encounter squirrels, chipmunks, many species of native birds, the occasional marmot and even a bald eagle or two if you're lucky (there's been a nesting pair near Emerald Bay for the last decade).

AUTHOR'S NOTE: *If you need help on the trails, call 911 and you'll be routed to the appropriate search-and-rescue team. But remember that you won't have cell service on many Tahoe trails. Have a first-aid kit, know how to use it and consider carrying a satellite communicator if you're very concerned about accidents. Make sure someone knows where you're hiking and when you'll be back.*

LEAVE NO TRACE AND HIKING ETIQUETTE

If you're not familiar with "Leave No Trace" principles, be sure to review them before hiking. If you carry something past a trailhead, you need to carry it back. Do not leave food scraps, trash, cigarette butts or toilet paper in the woods. Irresponsible re-creators are a growing problem in Tahoe. It's not okay to leave trash at trailheads or on top of bear bins, and you can be steeply fined if you litter or otherwise damage the environment.

Try to minimize your impact, which means not straying far from the trails, marking or otherwise defacing rocks or trees or "blazing" your own routes. And remember: there's nothing wrong with leaving it better than you found it—you can carry out trash even if you didn't put it there.

Backpackers have an even stricter set of regulations to follow; ignorance isn't an excuse for damaging the environment. Your permit usually clearly outlines the most important trail rules.

Chapter 2

THE CALIFORNIA TRAIL

The three-thousand-mile-long California trail was the largest mass migration in American history, driven by a combination of a desire for gold, promises of a better life and a general sense of Manifest Destiny. For about forty years, more than 250,000 migrants came from the United States—then a small but growing collection of states in the eastern part of North America—to the western frontier. Thousands more traveled west via the Santa Fe and Oregon Trails.

By the 1820s, miners and explorers who had made it to the Mexican territory of Alta, California (usually via months-long sailing voyages), began to spread word of the riches of the West Coast. It quickly became too much for the many East Coasters and homesteaders to resist, and enterprising parties set their sights on Sacramento.

In 1841, members of the Western Emigration Society of St. Louis, Missouri, decided that it was time to make their riches out west. They formed a party led by John Bartleson, society captain; and John Bidwell, society secretary. They packed up their wagons, their families and their possessions and set west for California from Missouri. They'd been swayed by a letter-writing campaign from a well-known rancher in the California Territory who believed that bringing more settlers west would help secure his ownership of the land.

The Bartleson-Bidwell group planned to follow the route laid out by Joseph Walker, a rancher and trapper hired in 1833 to find a way to Sacramento through the unknown lands west of Wyoming. Walker

TAKE NOTICE.
Ho! for California!

A Meeting of the Citizens of
the Village of Canajoharie and its vicinity, will
be held at the house of T. W. Bingham, on

FRIDAY EVENING,

the 19th inst., at early candle light, for the pur-
pose of taking into consideration the propriety
of forming a company to proceed to California,
and mining for GOLD. All who feel interest-
ed on the subject are requested to attend.
 MANY CITIZENS.
Canajoharie, Jan. 16, 1849.

Ads encouraging westward migration flooded the East Coast, and the promise of gold drew hundreds of thousands to the West Coast. *A. Honeyman (Robert B. Jr.), Collection of Early Californian and Western American Pictorial Material, BANC PIC 1963.002:1802, Bancroft Library, University of California–Berkeley.*

found that route soon after being commissioned, although he traveled with a small party on horseback—not with dozens of wagons and family members in tow. Despite this, the Bartleston-Bidwell group decided to attempt this same route. Surprisingly, their trek was uneventful, and they successfully made it from St. Louis to the Sacramento area over five months and fourteen days. They became the first westward settlers to successfully travel to California on this route, although they weren't the first to cross the Sierra with wagons. That honor belongs to the Stephens-Townsend-Murphy Party, as the Bartleston-Bidwell party abandoned their wagons before reaching the Sierra Nevada and instead traveled on

Joseph Walker, one of the country's most well-known "Mountain Men."

horseback through the mountain passes. And Washoe and indigenous travelers likely forged the first routes through the mountains well before Walker's party arrived.

The Bartleston-Bidwell route followed the Oregon Trail (established in 1836) from Missouri to Fort Hall, Idaho. From there, travelers on the Oregon Trail would move north, roughly following the route of the 1806 Lewis and Clark Expedition. Mormons migrating took the eponymous Mormon Trail, which led them south to Salt Lake City, a region away from the watchful eye of the U.S. government. But those looking for gold continued through the Grand Tetons north of Salt Lake City to eastern Nevada, then through the deserts and then up and across the treacherous Sierra Nevada. Once through the Sierra, it was a quick journey to Sacramento and the gold fields beyond.

Owing to the California Trail's difficulty, several alternate routes popped up in many of the more challenging segments, most born of an explorer's desire to find an easier route. The most famous of these might be the Hastings Cutoff through the Salt Lake Desert. Taking

A typical emigrant wagon. *Library of Congress, LC-USZ62-56404.*

this route infamously spelled the beginning of the end for the Donner Party—perhaps because the route led through dry, inhospitable desert, overtaxing their resources and pack animals.

But most of these diversions took place around the Sierra Nevada, certainly the most challenging part of the trip both geographically and because it came at the end of an already challenging four-month journey. The first established route across the Sierra was the Truckee Trail, crossing the mountains just below the current-day Donner Summit. There were a few passes over which settlers could lift their wagons, all of which were within a mile of one another. This was the Truckee Trail's main route, although there were variations within it. Some settlers traveled via Henness Pass Road, a few miles to the north, which would eventually become a popular toll road, rendering the trickier Donner Pass route unnecessary.

In 1850, explorer and trapper Jim Beckwourth developed the Beckwourth Trail, diverting from the primary California Trail east of Truckee and moving northwest through the northern Sierra Nevada foothills. Of all the routes along the California Trail, the Beckwourth Trail had the lowest high point (Beckwourth Pass, at an elevation of 5,220 feet), making it the least difficult. Like nearby Henness Pass Road, it quickly became a popular option for avoiding the challenging passes near Lake Tahoe.

Emigrants who wanted to pass south of the lake could take the Carson Trail, developed for wagon travel by emigrants in the 1840s and the only segment of the California Trail established in a west–east direction. That trail followed the route made by the Frémont Expedition, which followed migration and hunting routes already developed by indigenous Americans. This was perhaps the most challenging route, as it required climbing more than 1,600 feet from Hope Valley to Carson Pass, the highest-elevation pass of any route on the California Trail. The Carson Trail also had several variants, most of which met in Hope Valley to allow emigrants to resupply before crossing the summits.

Just 34 emigrants entered the California Territory in 1841 via the California Trail, all of whom were in that first migration of the Western Emigration Society. But the following decade brought more than 200,000 additional settlers and their families out west, a migration that partially led to the Mexican-American War, which claimed California as the thirty-first state.

The route was treacherous, and while no party suffered more than the Donner Party, death on the trail was common. Disease, starvation and hypothermia could weaken even the hardiest of travelers. Encounters with Native Americans were common, and while many early settlers found their

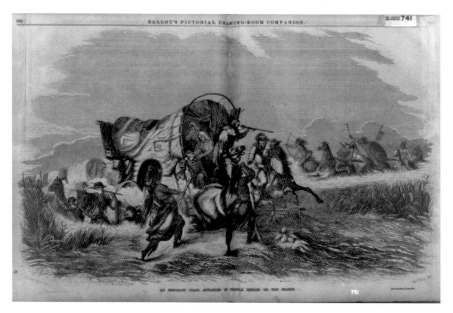

Illustrations and articles in the 1850s often demonized Native Americans to help justify the United States' westward expansion, like this one in *Ballou's Pictorial Drawing-Room Companion*. *Library of Congress, LOC LC-USZ62-741.*

help invaluable, encounters began to turn more violent by the 1850s, as it became more evident that the pursuit of Manifest Destiny didn't include room for indigenous peoples.

By the 1860s, companies and towns had begun to build better-maintained roads to ensure that they could reliably move mining supplies and spoils between mines and cities. These routes were also safer and quicker for emigrants, and the traditional California Trail routes fell out of use. The completion of the transcontinental railroad in 1869 created a far faster and safer method for moving people and supplies, and by the early 1900s, auto roads through the Sierra Nevada had made the crossing far shorter and safer (though still not short or safe by any modern standards).

Today, the California Trail is dotted with historical sites, although many others are lost to time. In some places, entire memorials mark crossings, while in other areas, the only evidence of wagon train crossings is the occasional rusty wheel mark on a boulder. Fortunately for hikers in Tahoe, the trails crossed by early settlers across Donner Summit are easy to find, thanks to extensive historical records from the emigrants of the 1800s.

DONNER MEMORIAL STATE PARK TRAIL

Tahoe locals may not give a second thought to the fact that so many sites in Truckee are named after the ill-fated Donner Party. But for visitors, the town's reverence for a party synonymous with tragedy may seem a little odd—after all, why would you name your schools, roads and parks after cannibals?

But at Donner Memorial State Park, you'll learn that there's far more to the Donners' story than most people learn—the true story is one of survival and perseverance (mostly). Their ordeal is perhaps one of the most misrepresented and embellished tales from the early days of western exploration. And while they made difficult choices to survive, the context is less "Hannibal Lecter" and more "desperate times call for desperate measures."

Lured by the Hastings Cutoff

The story of the Donner Party begins well before 1846, the year they were stranded at current-day Donner Lake. By the early 1840s, western migration was in full swing, and nearly all migrants followed the same

path: they'd take the California Trail from Missouri to Fort Hall, Idaho, at which point they'd branch north for the Oregon Trail or continue west to stay on the California Trail.

The Donner Party members were not all Donners; rather, it was a combination of two families: the Donner family, led by patriarch George Donner, and the Reed family, led by James Reed. The immediate party totaled about thirty people, although they traveled with other wagon trains during parts of the journey from Illinois to Fort Laramie, Wyoming. However, the Donner Party went on their own again when they opted to head south rather than following the established path north to Fort Hall—a decision that would mark the beginning of their end.

In 1845, a former Confederate general named Lansford Hastings traveled to California and published a book of his exploits entitled *The Emigrants' Guide to Oregon and California*. Hastings's goal in publishing was to encourage migration to California to take control of the West Coast from native and Mexican populations. Hastings proposed a new route through Utah, across Nevada and into California that he claimed would be quicker and easier than taking the current route. With the ultimate goal of bringing settlers to California and getting himself elected to high office, he sent letters to wagon trains moving west telling them of this new direct route—although he neglected to mention that he hadn't traveled it himself. Sold by the promise of a shorter route (which wasn't actually shorter), the Donner Party took his advice and broke ranks with the rest of their wagon train. In mid-July 1846, Donner, Reed and their new party of eighty-seven people and twenty-three wagons headed south.

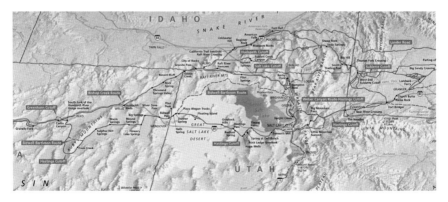

A close-up of the Hastings Cutoff, famously taken by the Donner Party. *National Park Service.*

The route took them across the dry and resource-depleted Great Salt Desert, taxing their pack animals and food rations, so they progressed slower than they would have through the northern route. They reached Nevada—still some three hundred miles from the challenging Sierra summits—near the end of September, already having lost a few wagons and cattle. Between eastern Nevada and the foothills of what would become Donner Summit, they moved slowly, thanks to challenging terrain and unfortunate encounters with locals. The challenges forced them to abandon some of their supplies and wagons, piling only the bare minimum on their remaining wagons as they continued west. Without the appropriate numbers of livestock or rations, and later in the season than anticipated, they approached the mighty Sierra Nevada.

A Late Arrival to Truckee

They arrived at Truckee Lake (now Donner Lake) in very late October, a time when snow is usually underway in Truckee. The Reed family settled on the east shore of the lake, while the Donner family, delayed by disease and fatigue, set up camp a few miles behind them near Alder Creek (present-day Donner Historic Camp Site at Alder Creek). There were roughly sixty people in the Reed camp at Truckee Lake and another twenty with the Donners at Alder Creek.

The parties decided to stay at the lake for a fortnight, expecting the snow to melt enough to make the Sierra crossing possible. They were already low on food upon arrival and were forced to let some oxen die of starvation before using them for food soon after setting up camp. They attempted to hunt, but most wildlife were hibernating or had moved to lower elevations and fishing was likely not possible as the lake and Truckee River would have been partially frozen. In mid-December, realizing how dire their situation had become, a group of fifteen members fashioned makeshift snowshoes and attempted to cross the summit to bring help back from Sutter's Fort.

Progress for the party, known later as the Forlorn Hope Expedition, was slow. They didn't know how far it was to Sutter's Fort, nor did they have appropriate provisions or supplies. Although the entire Donner Party was in dire straits, the Forlorn Hope Expedition marked the beginning of life-or-death survival choices. They left on December 16 and had lost several party members to hypothermia, starvation and disease by Christmas Day, including one member who stopped to rest and never woke up. One day

Trees showing the height of the snow during the Donner Party disaster, as evidenced by the height at which they cut trees that winter. *Library of Congress, LOC LC-USZ62-27607.*

later, on December 26, the expedition made what must have been a difficult decision: they stripped and cooked flesh from their deceased compatriots to avoid their own deaths by starvation.

It would take another month for the Forlorn Hope Expedition, then down to seven members, to find help. In actuality, help found them: a Native American guide found them in the snow and led them to a camp where they could send word of their situation. They had eaten the hide from their snowshoes and preserved meat from their fallen party members—although later accounts from survivors suggest that they may have killed and consumed the two Miwok guides who led them across the summit.

A rescue party was assembled, and they expected to find the Donner Party moving west as the rescue party moved east. However, the Donner Party hadn't moved at all in the heavy snow and was still in Truckee. The

Artist Joseph Goldsborough Bruff's rendering of hardships on the California Trail.
Huntington Digital Library, Huntington Library, San Marino, California.

rescue party, having to make the difficult crossing through the Sierra Nevada themselves, didn't arrive at Truckee Lake until early February 1847. The members of the party had been starving since October.

Even with flawless preparation and plenty of supplies, an unexpected four-month delay in brutal winter conditions would have been challenging. But the members of the Donner Party, already weakened and underprepared from the journey to reach Truckee Lake, were in poor health when the rescue party arrived. Thirteen people had died at Truckee Lake, and only seven remained at Alder Creek. It took a total of five rescue parties over the next months to evacuate the survivors, with each party bringing supplies and food to those remaining at the lake.

Of the eighty-seven members of the Donner Party split between Truckee Lake and the Alder Creek site, forty died, likely due to a combination of starvation, exposure, disease or accident.

At the time, newspapers and journals around the country printed accounts of the Donner Party and rescue attempts. In California particularly, where news of arriving emigrants was a common topic, the Donner Party saga was heavily sensationalized—after all, papers needed to sell, and what was yet another emigrant story without a shocking angle?

However, there's no proof of anyone being murdered for food. The families made every effort to eat everything else—including leather, hide, bark and animal bones—before resorting to more drastic measures. Journal entries show that they had to start killing their animals by November 5, partially because the livestock were too weak to stand. This sustained the group for a few weeks, and on November 14, the men of the party were able to kill a grizzly bear. They were able to freeze most of the meat to ration as they continued to wait at camp.

The earliest account of cannibalism doesn't appear in journal entries until December 27, according to statements from *What I Saw in California*, a book of firsthand accounts from travelers with the Donner Party. That was from the Forlorn Hope Expedition, whose members reported "stripping the flesh" from the dead. According to a journal from James Frazier Reed, they waited as long as possible to eat the flesh, going without food from the day they stripped it to the day they ate it—December 29, 1846.

Back at camp, the remaining survivors continued to make do with what they had. According to Virginia Reed's *Across the Plains in the Donner Party: A Personal Narrative of the Overland Trip to California*, published in 1891, they were forced to kill Cash, their dog, eating everything from his feet to his skin. She wrote that they pulled the hides off their homes' roofs and boiled them, which unfortunately allowed snow to fall in their cabins and rendered little to eat. Virginia Reed later claimed that the Reeds were the only family to not resort to eating human flesh, but were that true, that would have been a radically long time to go without food.

Other families at the Truckee Lake and Alder Creek camp were eventually more forthcoming about how they survived. Surviving members of the Donner family recounted memories of parents shamefully serving cooked human flesh to the youngest and weakest members of the party, without telling them what (and certainly not whom) they were eating.

Lewis Keysberg

The story of Lewis Keysberg (sometimes spelled "Keseberg") is well documented as a tale of violent cannibalism and often associated with the entire Donner Party rather than just one person. Keysberg, considered the first to eat his fellow campers, was also the last rescued from the ordeal. He joined the Donner Party closer to Salt Lake City, having already developed a reputation with his first wagon train for being cruel to his family and

prone to violence. He likely acted the same way within the Donner Party, so some of the tales later told about him may have resulted from him already being unpopular within the ranks.

Rather than venturing out with the Forlorn Hope Expedition, as many able-bodied men did, Keysberg stayed back at camp with his family. When rescuers found him, he didn't deny eating flesh, confessing that he had eaten Tamsen Donner, wife of George Donner—but only after she'd died of natural causes. They also found the few remaining valuables of George Donner in Keysberg's possession, although he claimed to have taken them on behalf of Tamsen. Conveniently, she wasn't alive to contradict his account. Keysberg was the last person to be rescued from the Alder Creek site, and reports at the time indicated that he was quite irrational and acting suspiciously when the rescue party returned. Noted the August 16, 1847 issue of the *Hartford Courant* about the rescue party finding Keysberg:

> *He was suspected, threatened, and finally preparations were made to hang him up and then he finally disclosed the place where the money was to be found. To add to the enormity of his offense, he is said to have to have boasted of having lived, for a time, upon the dead body of Mrs. George Donner, even when provisions were within his reach. Other enormities are told of this devil incarnate.*

As Keysberg was one of the few surviving members of the party willing to confirm acts of cannibalism, he became the face of the horrors within the Donner Party. There was little proof to show that Keysberg waited for anyone to die before he began eating them; however, there was little evidence to prove otherwise either. He was found innocent of the murder charges later brought against him in May 1847.

At the Emigrant Trail Museum, on the east end of Donner Lake, visitors will find themselves walking in the path of the Donner Party, hearing from survivors along the way. Just outside the museum is the monument to the Donner Party, dedicated in 1961. The sculpture's base is twenty-two feet high—the same depth the snow was when the party was forced to winter there. Not much remains at the Alder Creek site of the Donner camp, although there is a small plaque marking the spot where George Donner built his makeshift cabin.

How to Hike It: Donner Memorial State Park Trail

Why I Like It: A beautiful early morning walk, quick jog or winter cross-country ski trail
Type of Hike: Out-and-back
Total Mileage: Variable; 1.5 miles to China Cove
Elevation Gain: 30 feet
Difficulty: Easier

Getting There: Parking is on the east side of Donner Lake. From Truckee, head west on Donner Pass Road; the park entrance is just past the highway interchange. Parking is five dollars or ten, depending on season. Start at the Pioneer Monument, with the museum to your right. (To the left is a very short, flat nature trail.)

Trailhead Address: 12593 Donner Pass Road, Truckee, CA 96161

Start: Follow the sidewalk and cross the parking lot just behind the entrance kiosk. Take the paved path ahead that curves into the woods.

0.3 mile: Cross a bridge over a small dam; the footpath picks up immediately on the other side on the right. Follow it past the small canal. There are nature and history signs posted every so often between here and China Cove.

0.8 mile: Pass a small beach area with picnic tables and watersport rentals (summer only).

1.4 miles: Arrive at China Cove, a popular swimming and beach area and a great spot for a picnic.

From here, either return to the start or continue for a longer loop around the entire lake. To make the entire loop, keep going forward until you reach a small gate. Pass through the gate and you'll be on South Shore Drive, which eventually hits West End Beach on the other side of the lake. Make a right on Donner Pass Road, and you'll eventually return to the Donner Memorial State Park entrance. The total loop is 7 miles, with 300 feet of elevation gain.

JUDAH AND DONNER SUMMIT LOOP

The hike from Old Highway 40 to Judah Summit and Donner Summit is one of the most popular in the area, for good reason. In addition to fantastic views of the Sierra—the lowest point of the trail is more than seven thousand feet above sea level—it's loaded with history. It goes by not one but two historical sites that offer the chance to see what the Sierra crossings would have been like for westward emigrants in the mid-1800s. Hikers will be able to stand on the very top of both Roller Pass and Coldstream Pass, the two most physically demanding and intimidating segments of the entire California Trail.

The Donner Party is certainly the most (in)famous group of travelers that headed out "a Californie way," as was said at the time, but they weren't the first. Although most emigrants took the same general route westward from St. Louis, there were a few places to part ways: travelers could go north or south around Salt Lake in Utah (the Donner Party infamously went south) and split again in eastern Nevada. Those who stayed on the California Trail headed toward Lake Tahoe. They could take the Carson Route south of the lake, but the primary route went north, through the summits just west of Donner Lake. Donner Lake was the final place to rest before the final push through the summits. Once crested, it was (literally) all downhill to Sacramento, but the trek to the top was no easy feat.

The first route through the summits was discovered around 1844, just two years before the Donner Party's attempted crossing. Passing through the mountains required settlers to reach an elevation of 7,850 feet—quite the gain from Donner Lake's 5,936-foot elevation. Emigrants would have been traveling for months, likely exhausted and low on food before they even reached this point. Even under the best conditions, it was a massive physical challenge, likely made worse by the tease of having the gold fields of Sacramento so close on the other side.

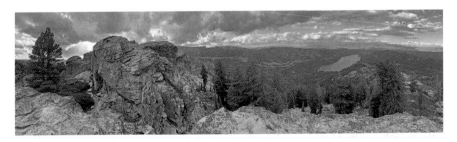

Donner Summit (*left*), with Donner Lake in the distance. *Photo by author.*

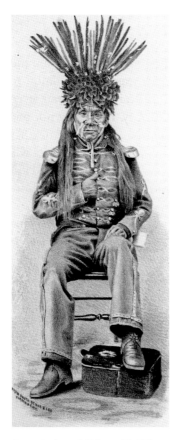

A rendering of Paiute chief Tro-Kay (Truckee).

The first emigrant train to take the trail was part of the Stephens-Townsend-Murphy Party, who traveled westward in 1844. The group didn't know which way to proceed from Carson Valley but were fortunate to get some local guidance from a Paiute chief whom the emigrants called "Chief Tro-Kay." Emigrants mistook this for his name, but it was actually a Paiute word that loosely translated to "it's okay" (or "it's all good," as current-day Truckee locals like to say), something the chief likely repeated while trying to explain the safest route. Because "Chief Tro-Kay" showed them the way, the emigrants named the nearby river in his "honor": the Tro-Kay (or Truckee) River. A few years earlier, the chief had already met John C. Frémont, who made the same mistake with his name. The town of Truckee might be called something else entirely if either group had had a capable translator. "Chief Tro-Kay" would continue to assist emigrants for many years, learning both English and Spanish and fighting for the United States in the Mexican-American War.

In 1844, most of the Stephens-Townsend-Murphy Party headed into Donner Canyon, intent on finding the best route through the mountains. Eventually, they found a route they thought would be passable, but certainly not easy. The path went through the area known today as Coldstream Canyon before making an extremely steep climb up to current-day Donner Summit—a climb so steep, in fact, that it required scrambling with both hands to reach the top.

At this point, the Stephens-Townsend-Murphy Party faced a dilemma: how to get their wagons up a rock face so steep that the oxen couldn't walk it? Eventually, they reached an obvious solution: they'd have to lift the wagons over the rock face.

The process was challenging. First, men would disconnect the oxen from the wagons and herd the oxen up a steep path as the men carried heavy chains (a no-doubt demanding process on slick rock, loose dirt or snow).

Once the oxen made it to the top, men would wrap chains around rocks and trees, connecting the other ends to the wagons below. Using the oxen (and whatever remaining strength they had), they'd haul the wagons up as additional men pushed from below, often completely pulling the wagons up the slopes when it was too hard to roll them.

The exact spot the Stephens-Townsend-Murphy Party first made this crossing is easy to find today: it's the top of Donner Summit (also called Donner Peak), where there's a gap in the rocks. Emigrants later tweaked the route slightly to avoid passing through the rocky gap by cresting a few hundred feet south at Coldstream Pass, although it's mostly the same route save for the final push to the top. (A historical sign marks it as the highest point on the original Truckee Trail). From this location, hikers can peer down Coldstream Pass, getting the same view the emigrants would have had as they looked down on their wagons, wondering if they'd make it to Sutter's Fort in one piece.

If you look down and think it looks incredibly intimidating, you're not alone: more than a few emigrants had the same thought, and by 1846, parties were already looking for alternate routes in the area. The first to find a new route was Joseph Aram, of the eponymous Aram Party. Rather than following the Stephens-Townsend-Murphy route, Aram's party stopped at the foot of Donner Summit for few days in September 1846. He eventually found an alternate place to pass, although it was nearly eight hundred feet higher than Coldstream Pass. However, it wasn't as steep, which meant emigrants didn't need to lift the wagons at all. Instead, they'd double and triple the number of oxen per wagon, attaching roughly ten to each wagon and parking another ten at the top of the pass. The oxen on the summit would be connected by rope to the oxen pulling the wagon, and the team would slowly roll the wagons up the hill as men stood on either side to prevent the wagons from tipping over. This crossing became known as "Roller Pass" as the ropes ran over horizontal logs at the top ("rollers") to keep them from getting caught and frayed on sharp rocks.

Despite the effort to find these routes, emigrant trains used Roller and Donner Passes for only a few years. With the discovery of gold and silver in nearby Virginia City, quick and reliable access between eastern Nevada and Sacramento became of paramount importance, and the treacherous routes across the passes just wouldn't cut it. Mining and logging companies built roads through the mountains; Henness Pass Road and the Tahoe Wagon Road (modern-day U.S. Route 50) had become the primary routes across the Sierra Nevada by 1860.

How to Hike It: Judah and Donner Summit Loop

Why I Like It: A high-elevation hike passing two historic passes on the
 California Trail
Type of Hike: Out-and-back
Total Mileage: 5.7 miles (with Donner Summit offshoot)
Elevation Gain: 1,340 feet
Difficulty: More Difficult

Getting There: Parking is off Old Highway 40 in Truckee. From Truckee, head
 west on Donner Pass Road, continuing past the lake. Drive approximately
 3 miles past the lake, up Donner Pass Road (Old Highway 40). Parking is
 on the left at Summit Haus, immediately after the road closure gate. No
 fee to park. In the summer, there's a small snack bar at the parking area
 and portable restroom at the trailhead.

Trailhead Address: 96161 Old Donner Summit Road, Truckee, CA 96161

Start: If you walk up the rocks behind the Summit Haus, there's a great view
 of Donner Lake, Rainbow Bridge and the railroad tunnels.

Walk downhill through the parking; the trailhead is on your left. Take the trail
 just to the left of the "Donner Summit Trail" sign. Almost immediately,
 you'll have great views of Lake Mary on your right.

0.2 mile: Expect rocky, steep switchbacks at the beginning (this is the hardest
 part of the hike).

0.6 mile: The trail becomes less steep and switches to more of a dirt path
 before turning into the woods.

1.2 miles: Reach the split for the Pacific Crest Trail (PCT). Go right, crossing
 the ski trails of Sugar Bowl Ski Resort. Cross the fire road, continuing on
 the dirt trail and passing trees with angular trunks on the downslope side
 at around 1.8 miles, shaped by heavy snow and wind.

2 miles: The trail splits again near the "Mt. Judah Loop" wooden sign posted
 on a tree. Walk straight to reach Roller Pass, where there's a historical
 marker, an informational sign and a spot to peer down the pass. Backtrack

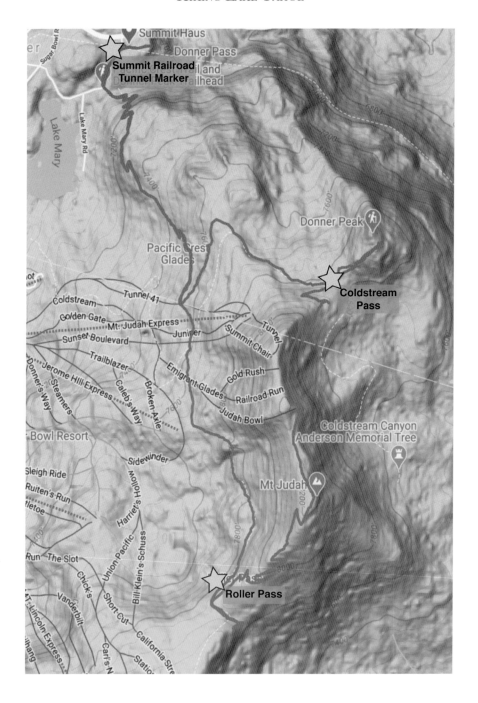

to the "Mt. Judah Loop" tree sign and take the other path. The trail gets more exposed, and the terrain switches to loose rock. Tighten your hat and prepare to climb another 350 feet or so over the next 0.6 mile to reach Judah Summit.

2.7 miles: Reach Judah Summit. When you're ready, keep going, heading right (downhill) when the trail splits in another 0.1 mile. Expect snow patches in the shade here through the summer.

3.5 miles: Reach a clearing with a historical rail marker; this is the site of Coldstream Pass. From here, you can make the 0.2-mile scramble across the exposed rock to reach Donner Summit (+0.2 mile, 100 feet of elevation) or turn left to head downhill. To return, continue on the trail, in opposite direction from which you came.

4 miles: Two nice lookout points on the right, ideal for a snack break.

4.3 miles: Back at the first intersection with the PCT. Turn right, retracing your steps back to the parking lot.

5.7 miles: Return to parking.

When you return to the parking lot, look for the rock just left of the triangle-shaped building in front of you (it's sometimes covered by plants). The sign on the rock marks the location of the longest railroad tunnel blasted through the summit.

THE CARSON TRAILS

One of the most popular offshoots of the California Trail was the Carson Trail, running south of Lake Tahoe. The route offered an alternative to the steep passes around Donner Summit. It parallels PCT in this area and is an excellent spot for a long day hike or overnight trip to get a feel for what it's like to spend the night on the high elevations of the PCT.

The Life of Kit Carson

Kit Carson may be one of the most well-known frontiersmen of the mid-1800s, but what may surprise people is that he was in the public eye for most of his life, not just after his death in romanticized retellings of the Wild West. He traveled as a guide for the Frémont Expedition, which sent reports back east that newspapers and journals reprinted. In turn, many writers of the day began writing tails of Kit Carson's exploits, including tales of him fighting Native Americans and battling grizzly bears. Expedition leader John Frémont likely embellished the group's reports before they arrived to publishers, who probably further embellished them before they went to print.

Tales of his adventures continued well into the 1900s with the film *Kit Carson* (1940) and again in the 1950s, almost a century after his death, with the show *The Adventures of Kit Carson* (1951–55). However romanticized Kit Carson's story became in the public eye, his true story has humbler roots.

Christopher Houston "Kit" Carson was born in Missouri in 1809 but didn't stay there long. As one of ten children of a single mother, his time in school was short, and he began an apprenticeship with a saddle maker in his early teens. But by then, the rumors of glory and adventure in California had spread to the Midwest, and at age seventeen, Carson began fur trapping, eventually making his way to New Mexico.

For the next decade, Carson continued to trap while developing other essential mountain skills. He learned to cook, scout, treat field wounds, hunt and work in the mines, and he also picked up basic fighting techniques as his outfit encountered more Native Americans while slowly moving west.

During this time, Carson and his various trail companions had frequent encounters with indigenous people. Although the tales at the time would have framed Carson and his men as the heroes, modern historians know that several of his encounters were nothing short of massacres. Stories from the day recall Carson and his men murdering most of the members of a Crow camp in Montana in retribution for stealing horses. And in his own journals, Carson wrote of disliking certain tribes, taking pleasure in killing them and often seeking to murder entire groups of Native Americans in exchange for the smallest perceived infraction.

Kit Carson became a household name after a chance 1842 meeting with John C. Frémont, who was leading a military expedition to the West. Having spent many years out west already, Carson agreed to be the expedition's guide. Their first trips together were a series of voyages to map segments

FROM THE PLAINS.

Death of Kit Carson—Indian Troubles—Nav
igation of the Yellow Stone River.

The Omaha Republican announces, on the authority of persons just from Fort Kearney, the death of Kit Carson, the famous mountaineer, which occurred at Taos, New Mexico, where he was Indian agent.

Major Schoonover, agent for the upper Missouri Sioux Indians, arrived at St. Joseph's on Monday. He reports that the Sioux have sworn vengeance against all whites found in their country.

Major Schoonover says that the Yellow Stone River is navigable for steamers for nine hundred miles above its confluence with the Missouri, and that goods can be landed within four hundred miles of Salt Lake City, and very near several forts in that region.

Newspapers were so eager for news of Kit Carson that they often printed incorrect information, like this clip from the November 29, 1859 edition of the *Lancaster Intelligencer* announcing his death a decade before he died.

of the Oregon Trail, and the dispatches sent home by Frémont were enough to make Carson somewhat of a folk hero to newspaper readers. During this time, Mexico controlled the territories that would eventually become California, Nevada, Arizona, Utah, Colorado and New Mexico, and the Frémont Expedition was one of the first to traverse these unknown parts of the continent. This meant that many of Carson's and Frémont's experiences—from "attacks" by Native Americans to robberies and brushes with death—were among the first tales of the Wild West read by audiences in the eastern United States.

By 1846—the first year of the Mexican-American War—Frémont's men had established themselves as leaders in the California Territory, and Frémont himself took a leading role in California politics, eventually becoming a U.S. senator. Carson served as a messenger between the American government in D.C. and the local government in the California Territory, carrying everything from negotiations between Mexico and the United States to news about the discovery of gold. Both Carson and Frémont played a role in talks between the U.S. and Mexican governments, setting the basis for the 1848 Treaty of Guadalupe Hidalgo (in which Mexico sold most of California and the Southwest to the United States for $15 million).

Carson spent the next decade of his life as an Indian agent, a vaguely defined position with the U.S. government tasked with easing tension between western settlers and indigenous Americans. While this often

involved trade, negotiations and communication, it could also involve violence, as the government's ultimate goal, of course, was to annex the land in use by western tribes. There are significant records of his time as a government employee, likely as issuing dispatches and reports was a job requirement. Reports from the time show that he was paid $1,500 per year in the role—$45,000 in today's U.S. dollars.

But by the start of the Civil War, Carson had quit his job with the U.S. government. He enlisted with the Union, leading troops in the New Mexico territory on behalf of the North.

Kit Carson's Death

After the Civil War, tales of Carson's exploits continued to spread, but he retired to a quieter life. He took up ranching in Colorado in 1865 and had several children with his wife, Josefa, whom he had married in 1843 at age thirty-four (she was fourteen). His previous two wives had both been Native American women; he married Waa-Nibe of the Arapahoe Tribe in 1836 (she died during childbirth in 1841) and Making-Out-Road, a Cheyenne woman, in 1843. They were separated when he met Josefa less than a year later. Josefa died in childbirth in 1868, and Carson died of a heart aneurysm just a month later in Colorado, at age fifty-eight.

Kit Carson's life was serialized into books for children and adults.

Although newspapers didn't print tales of Carson's exploits as often in his later years, by his death, the facts of his life had become so entwined with legends and rumors that he had become a beloved figure of the western frontier. While Carson certainly deserved much of the praise, his tendencies toward unprovoked violence and cruelty toward Native Americans weren't part of the story until recently. In the last few decades, history has begun to acknowledge Carson's complicated legacy, understanding him as both an adventurer and notable statesman as well as an unapologetically pro-American expansionist, no matter who or what stood in the way.

Unfortunately, disdain for Native Americans was the prevailing sentiment among many

Americans in the mid-1800s, so his violent encounters did little to damage his reputation—in fact, they likely glorified it. Writers wrote "true" stories about his exploits on the frontier, and magazines published clips and excerpts from *The Life and Adventures of Christopher Carson* (1861), a biography by Charles Burdett. More modern accounts do a more accurate job of fairly portraying the lives of Carson, Frémont and other historical figures.

The Carson Trail and Carson Pass

The Carson Trail is actually not named after Kit Carson—at least not directly. It's named after the Carson River, which runs parallel to parts of the trail. However, the Carson River is named in honor of Kit Carson—as are Carson City, the Carson Range, Carson Pass and plenty of streets and roads throughout the region.

Despite the name, it's unclear whether Kit Carson ever actually crossed in at this exact point. The closest he likely came was during his 1844 expedition with John Frémont. The quick version of the story is that Frémont, Carson and their crew crossed the mountains south of Lake Tahoe that winter before arriving at Sutter's Fort in Sacramento. But the longer version of the story doesn't specify precisely where they crossed, although journal entries do reveal that it wasn't an easy journey.

Crossing through the Sierra Nevada is no easy feat in the winter, and the Frémont-Carson group stopped in the Carson Valley to resupply before moving west. But instead of waiting for spring, the expedition attempted crossing the Sierra Nevada. Rather than taking the lower-elevation route to the north, they followed a Washoe trading path through the mountains south of the lake. Despite being warned by the Washoe that the route was impassable in the winter, the group forged on.

According to Frémont's own journal entries, the route was long and morale was low. Frémont wrote that the group crossed through perilously deep snowdrifts and across frozen rivers, noting that they had to kill and eat the team's dog when they depleted their food resources. The men had to walk in front of their pack animals, packing the snow down enough with each step to allow the oxen and horses to make it through safely.

Leaving from the Carson Valley at 4,800 feet above sea level, the group followed the Washoe trail, hiring a few Washoe as guides. Fremont's journals speak of summiting mountains to attempt to see the way west. Their exact path is unknown, but Frémont's journal shows that they traversed Red Lake

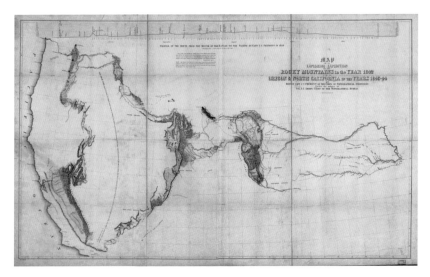

A map created by John C. Frémont on the 1842–43 Frémont Expedition to Oregon and Northern California. *Library of Congress, G4051.S12 1844.F72.*

Peak, one of the highest points around Carson Pass, on February 14, 1844. From the peak, they had their first glimpse of Lake Tahoe. On that day, Frémont wrote in his journal:

> *With Mr. Preuss, I ascended the highest peak to the right from which we had a beautiful view of a mountain lake at our feet, about fifteen miles in length, and so entirely surrounded by mountains that we could not discover an outlet.* [Lake Tahoe is 21.75 miles long.]

From Red Lake Peak, Frémont was able to see the best place to attempt a crossing: Carson Pass, at an elevation of more than 8,600 feet. They crossed near the pass on February 21, 1844, and made it to Sacramento by early March. Frémont named this crossing Carson Pass and called the river the Carson River, but the Carson Trail didn't come into existence until 1848, four years after that first crossing.

By 1848, a year after the end of the Mexican-American War, many soldiers who came to fight on behalf of the United States started returning home. And that included soldiers from Utah, many of whom were Mormon.

Options for returning to Salt Lake City via the Sierra Nevada were slim. There was a route through the north (which would become the Beckwourth Trail), as well as the Truckee Trail, although it had been just a year earlier that the famous Donner Party tragedy occurred. As such, the Mormons

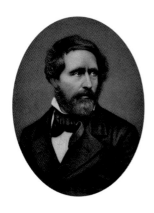

John C. Frémont. *Miriam and Ira D. Wallach Division of Art, Prints and Photographs, Print Collection, New York Public Library.*

returning home opted instead to follow a southern path, tracing the Frémont Expedition's footsteps. Smartly, they decided to cross in July, rather than February. Because the trail followed the Carson River, this route became known as the Carson Trail.

The first group to make this west–east trek was approximately forty-five people with wagons, and they widened the trail as they went to allow their wagons to pass through. Some Mormons later settled near Genoa (the Mormon Station area), although most returned to Utah. The route would become an alternate option for gold rushers coming to California for the following decade.

The trail's western stretch goes past the infamous Tragedy Springs, where Mormons found three eastbound scouts mutilated and buried, surrounded by (presumably) Native American arrows. Ironically, the area is now a lovely picnic site, with several picnic tables tucked under shady trees. There's a historical plaque, and the graves of the three scouts are well marked. The actual spring is currently covered by a locked building.

The trail to Round Lake below doesn't pass Red Lake Peak (elevation 10,069 feet), but it does provide a fantastic view of it at around the one-mile mark. If you look to the northeast, in the direction of the trailhead, you'll see the peak rising in the distance, close to Red Lake and almost due east of Caples Lake.

The Lost Cabin Mine Trail

The Lost Mine Trail can be done as an out-and-back day hike to Round Top Lake or as a return route from Round Top Lake if you started at the Carson Pass Trailhead or 4th of July Lake. Somewhat frustratingly, little is known about the mine, but it has an impressive collection of artifacts scattered about if you know where to look.

According to the U.S. Geological Survey Mineral Resources Data System, the Lost Cabin Mine produced gold and silver in the 1930s. Records show that the mine produced 3,542 grams of silver, 9,639 grams of copper, 40 grams of gold and 32,663 grams of lead.

But as with many Alpine County mines, the Lost Cabin Mine was short-lived and the recordkeeping shoddy. The mine was probably shut down without much fanfare and possibly in a hurry, judging by what was left behind. Hikers will find the remains of an old car, likely used to transport men and materials around the mine. A bridge once crossed the river, but it's long gone; now the river flows directly over what would have been a primary mine entrance. Across from the old car are an old door frame, hundreds of vintage bottles and soda cans and scattered tools and nails in a debris pile; this may indicate there was once an additional entrance nearby. It's easy to imagine miners emerging from the mine via the old door frame and leaving their bottles on the nearby rock after having lunch in the sun.

On the other side of the river—which hikers shouldn't cross if the water is at all flowing—are the remains of an old shelter, complete with a tin roof. There's another dilapidated building just up the trail to the left in a clearing.

Interestingly, there's a second Lost Cabin Mine in California, although it's farther north, near the Oregon border. That mine—supposedly found by accident in the 1870s when miners chased a grizzly bear into a ravine filled with gold dust—wasn't rediscovered until the 1930s, according to an October 24, 1904 article in the *L.A. Times*. Why this mine today is called the Lost Cabin Mine Trail is anyone's guess; claim records show that it was called the Woods Lake or Old Woods Lake mine while it was active.

How to Hike It: The Lost Cabin Mine Trail

Why I Like It: A moderately difficult hike past an abandoned mine, complete with old mining equipment
Type of Hike: Out-and-back
Total Mileage: 4.8+
Elevation Gain: 1,140 feet
Difficulty: More Difficult

Getting There: The trail starts at the Woods Creek Parking Area, off CA-88 (Carson Pass Highway). If you're driving west, go 1.8 miles past the Carson Pass Trailhead and make a left on Woods Lake Road. The parking area is 0.8 mile ahead.

Trailhead Address: Woods Lake Road, Markleeville, CA 96120

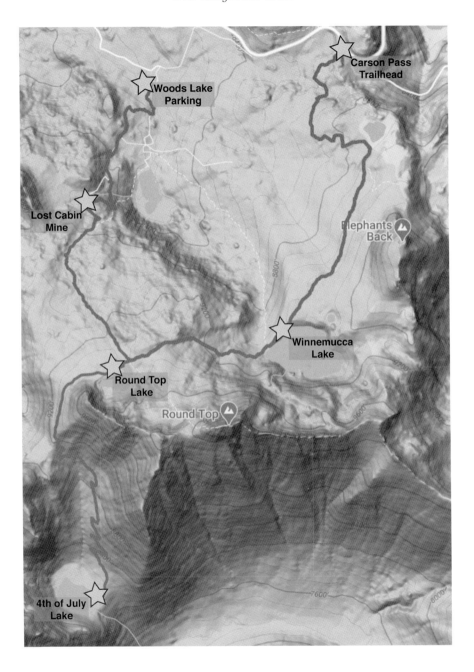

Start: Start at the Woods Creek parking area. With the parking lot behind you, walk across the paved bridge. The trail starts just past it on the right.

0.15 miles: The trail splits; stay to the right (the left goes to the Winnemucca Lake Trail).

0.9 mile: Pass a trail sign with the Lost Mine Trail listed on top. Go left.

1.25 miles: Reach the site of the mine. You've climbed 550 feet at this point. Feel free to turn around or continue uphill to Round Top Lake. If you keep hiking, you'll gain another 700 feet of elevation in the next mile. It's gradual but steady. Expect to traverse a few small snowfields well into July and mud around the stream crossings year-round.

2.4 miles: Arrive at Round Top Lake.

If you backtrack, you'll return to your car at 4.8 miles. Otherwise, from Round Top Lake, you can take the Lake Winnemucca Trail to the Carson Pass Trailhead (+3.5 miles, 310 feet of elevation) or continue to 4th of July Lake (+2.2 miles, 30 feet of elevation).

How to Hike It: Carson Pass to Round Top Lake

Why I Like It: An easy backpacking route to several alpine lakes and year-round skiing
Type of Hike: Out-and-back (or half of a point-to-point)
Total Mileage: 7 miles (as an out-and-back)
Elevation Gain: 900 feet
Difficulty: More Difficult

Getting There: The trail starts at the Carson Pass Trailhead and Information Station, off CA-88 (Carson Pass Highway). If you're driving west, the trailhead will be on your left. If you pass Woods Lake Road, you've gone too far.

Trailhead Address: CA-88, South Lake Tahoe, CA 96150

Start: From the Carson Pass Trailhead, take the trail by the log cabin visitor's center. The trail begins with gently undulating terrain.

0.5 mile: Just pass the Mokelumne Wilderness Boundary sign, the trail begins to climb more steadily.

1.1 miles: By now, you've gained 300 feet of elevation. At the split, stay to the right—or head left to add a 1-mile-long loop around Frog Lake (+90 feet of elevation).

1.25 miles: Intersection with the PCT. Stay right.

2.3 miles: Arrive at Lake Winnemucca. There are a few unofficial trails here to the right; stay on the main trail, toward Round Top Lake. Look for backcountry skiers in midsummer on the slopes across the lake. The next mile is steeper across mostly rock.

3.4 miles: Reach Round Top Lake. Take the trail to the left to climb Round Top Summit (+1 mile, 1,000 feet of elevation), take a snack break or continue to the Lost Cabin Mine or 4th of July Lake Trail.

How to Hike It: Round Top Lake to 4th of July Lake

Why I Like It: A short leg-burner to a hidden alpine oasis
Type of Hike: Out-and-back
Total Mileage: 4 miles
Elevation Gain: 1,130 feet
Difficulty: Most Difficult

Getting There: You'll start at Round Top Lake, which you can access from the Carson Pass Trailhead or Woods Creek Trailhead.

Start: From Round Top Lake, take the short, flat trail on the western end of the lake.

0.5 mile: The trail begins a steep downhill section. The rock can be slippery and loose. Walk carefully and consider using hiking poles near this top

section. A right turn here will take you to 4th of July Peak (+0.4 mile, 300 feet of elevation).

The next 1.5 miles is all downhill, dropping just over 1,000 feet. The trail is exposed the entire way; bring plenty of water.

2 miles: Reach 4th of July Lake. Makeshift trails lead around the lake on either side. Backtrack.

4 miles: Return to Round Top Lake. From here, return to the Carson Pass Trailhead or take the Lost Cabin Mine trail (from Round Top Lake) to reach the Woods Creek Parking Area.

THE BECKWOURTH TRAIL UNDER LAKE DAVIS

James Beckwourth's story starts like many others in the late 1700s. He was the son of an English landowner and an African American woman kept in slavery. But Beckwourth's story ends in a way no others have: he was one of the few men to develop a new route west to California, establishing what became known as the Beckwourth Trail. It's the only segment of the California Trail established by a Black man.

James "Jim" Beckwourth was raised primarily by his father, apprenticing in a few domestic trades during his teen years. At age twenty-two, he began a series of adventures that led him west of his native Virginia. After serving stints as a trapper, miner, trader and explorer, and even spending several years living with the Crow Nation in Montana, he returned to the Midwest, settling in St. Louis at the age of thirty-nine. He would continue to return to St. Louis over the next few years as he jumped from job to job, using the city as a base camp for his trips through the West.

In the late 1830s, Beckwourth's working relationship with Native Americans and knowledge of the fur trade helped him get hired by two traders interested in doing business with the Cheyenne. Negotiations went well, and Beckwourth eventually was able to open a trading post to assist other trappers and pioneering families moving west. Unfortunately for Beckwourth, his success made him a target for larger outfitters unwilling to let someone new take a share of their profits, especially a Black man. According to Beckwourth, hostility from those business

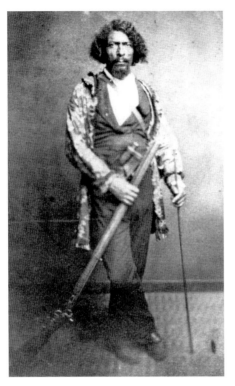

Left: James P. Beckwourth, circa 1850.
Smithsonian Institution, Washington, D.C.

Below: Town of Beckwourth, circa 1890.
*California State University, Chico, Meriam
Library Special Collections.*

owners—and the increased danger from being near the battlegrounds of the Mexican-American War—are what convinced him to leave the Southwest for California.

Beckwourth signed on as a mail carrier in California in 1848, although the role was short-lived, and he was soon prospecting for gold in Northern California by 1850. While on a survey expedition about one hundred miles north of Sacramento, he spotted what he thought was a low point through the northern Sierra Nevada mountains. Soon after that prospecting mission, he returned to the area and made a deal with the nearest town to build a road through that pass to Reno, Nevada. The town of Marysville helped finance the road, as it drove many prospectors into the area's saloons and mercantiles.

It didn't take long to build the road, likely because Native Americans had already been using the route for trading and seasonal migrations. Beckwourth finished the wagon road in 1851, and for the next four years, it served as an alternate route to the Truckee Trail segment of the California Trail, allowing wagons to cross the much lower 5,216-foot Beckwourth Pass instead of Donner Pass, nearly 2,000 feet higher.

The Beckwourth Trail's terminus was in Oroville, California, where it met back up with the primary California Trail route to Sacramento. Jim Beckwourth, age fifty-three by the time the route opened, put down permanent roots just west of the pass named in his honor. He lived at his ranch near the California-Nevada border (in the modern-day town of Beckwourth) until he moved to Colorado in 1860. He spent the following years working in trading posts and as an Indian scout before dying of unknown age-related circumstances in the mid-1860s at a Crow outpost near Denver. Owing to his years spent living with the tribe and aiding their trading efforts, he was given a traditional burial in the Crow Indian Settlement Burial Ground in Wyoming.

Emigrants heavily used the route for only a few years, as it became a toll road in 1855, perhaps in an attempt to cash in on the booming logging and mining industry just to the south near Truckee. The toll element made the route too expensive for most travelers, and the road began to deteriorate. With the introduction of the railroad through Truckee in 1868, wagon travel fell out of fashion, and the road ceased to be a primary route.

Not many men were so successful in the burgeoning gold and trapping industries, let alone Black men born into slavery. Add to that the fact that illiteracy was common in the West in the mid-1800s, and it's clear to see why the accounts dictated by Beckwourth in *The Life and Adventures of James P. Beckwourth: Mountaineer, Scout, Pioneer and Chief of the Crow Nation* (1856) are

some of the only accounts remaining of Black men in the western frontier. In the last century, Beckwourth's story has brought attention to the general whitewashing of the United States' western expansionist history.

Of course, as with many western pioneers, Beckwourth's story isn't without its share of scandals and objectionable decisions. In the 1830s, Beckwourth acted as a hired gun in a series of battles with Seminoles in Florida. The confrontations started when the U.S. government cited a series of one-sided "legal" decisions as justification for annexing Florida, fully aware that the Seminoles didn't recognize the U.S. legal system. And despite Beckwourth's self-reported friendly relationship with tribes in the 1830s, he later led violent raids against Native Americans in the Colorado Territory in his role as an Indian agent.

Today, much of the Beckwourth Trail is inaccessible or was paved with the advent of automobile travel. Much of the route follows the Feather River Scenic Byway (Highway 70). Because of the updates and reroutes over the years, the exact route early settlers would have taken through valleys or around hillsides is unknown. However, historians do know that the trail went under Lake Davis, a man-made lake created by the town of Portola for recreational opportunities in 1967. While current-day hikers, equestrians and bikers can't walk in Beckwourth's exact footsteps, the views, distant scenery and terrain look much the same as they would have for westward settlers (minus the lake, of course).

How to Hike It: The Beckwourth Trail under Lake Davis

Why I Like It: A fun and flowy trail for beginner cross-country mountain
 bikers...or an easy all-day hike when Tahoe is too crowded
Type of Hike: Out-and-back
Total Mileage: 13.6 miles
Elevation Gain: 350 feet
Difficulty: Easier to More Difficult (flat, but very long)

Getting There: The starting point is easy to miss. If you're driving north
 on Lake Davis Road, the parking area will be on your left, across from
 Wintergreen Road. You'll see a stone with a plaque that says "Lake Davis
 Trail." Parking is limited, but you can park on the shoulder across the
 street. There are no facilities at the trailhead.

Trailhead Address: Lake Davis Road, Portola, CA 96122

Start: Take the dirt path just to the right of the "Lake Davis Trail" sign.

0.4 mile: Pass through a livestock gate. There are a few flat bridges; otherwise, the trail is very smooth.

0.7 mile: Continue straight; the path to the left heads to a small fishing area.

1.7 miles: Reach Lake Davis Road. Turn left on the road, crossing over the Grizzly Valley Dam. The trail picks up on the left side of the road immediately after the dam. At the split immediately after this, stay right (the left is a very short path down to the lake).

2.4 miles: Trail crosses the road and turns left. It crosses a few ATV and fire access roads, but stay on the main trail, running parallel to Beckwourth-Taylorsville Road for the next 2.6 miles.

5 miles: Trail turns left, crossing Beckwourth-Taylorsville Road, and then turns right (north). The trail feels like a poorly maintained vehicle road but turns back into a single-track dirt trail soon after. Keep following up until you reach the boat ramp.

6.6 miles: Reach Lake Davis. Hang out on the beach or head up to the Lightning Tree Campground to use a picnic table or the restroom. You can leave a car in the boat ramp parking area and drive back to the start, but otherwise, retrace your steps to return to the start.

11.2 miles: Back at trailhead.

Chapter 3

HISTORICAL TRUCKEE

While Truckee is perhaps best known for the Donner Party tragedy of 1846–47, the region's history goes significantly farther back. First occupied by the early Mesoamerican Martis Complex Tribe (to roughly 500 CE), then by the Northern Paiute Tribe and later by a thriving Chinese immigrant population, the area is rich in history not related to western expansion (or cannibalism, for that matter). The trails below explore that history, from the various petroglyph trails (estimated to date from around 200 BCE) to the Basque camps at Kyburz Flat and the now-abandoned Western Pacific Railroad tunnels, built by Chinese and American laborers.

But before you can dive into Truckee's modern history, you have to study the years beforehand. Take just one look at Truckee's annual snowfall totals, and it's easy to understand why the region wasn't inhabited year-round until the relatively recent past. But that doesn't mean no one was here; the Truckee area served as a summer home for members of the Northern Paiute Tribe. While most of the Tahoe region was a summer home for the Washoe, this area north of the lake was primarily Paiute, although they likely were in contact with other nearby tribes. Like much of the Tahoe area, Truckee was rich with resources and was a great place to grow food in the summer.

As in most of California in the 1800s, the increase in white emigration and the growth of Native American populations were inversely related, and settlers began to both violently and nonviolently encroach on Paiute land and resources.

This likely started with the first permanent settlement: Gray's Station, established in 1863. The building still stands in Truckee (10030 Church Street). White encroachment had pushed nearly all native populations by the early twentieth-century tourism boom, although the Washoe are still active in the area. Gray's Station served settlers heading west during the summers but was soon put out of business by competing Coburn Crossing, which is what the area was known by for several years. However, the large lake in town and river flowing through town had already been named "Truckee Lake" and "Truckee River," respectively, in honor of Chief Tro-Kay. Eventually, the name stuck for the entire town.

Truckee became a key station on the transcontinental railroad when it first ran through the town in 1867. Many nearby mining and logging operations found success in the forests around Truckee and made their impacts on the landscape, cutting down many of the old-growth trees. Entire towns boomed (and later busted) around the logging, ice mining and lumber industries. After the railroad's completion, many Chinese workers who built the rail moved to town, ushering in a shameful part in Truckee's history defined by

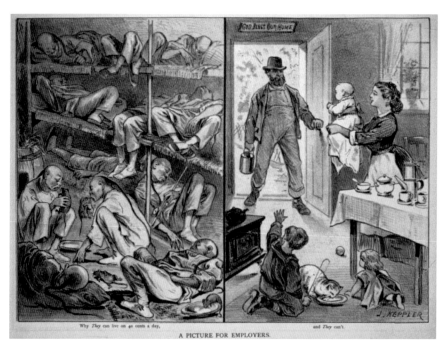

Chinese laborers faced constant racism and accusations that they were stealing jobs from white Americans, as seen in this 1878 *Puck Magazine* cartoon. *Library of Congress, LOC LC-USZC2-1242.*

intolerance toward anyone who wasn't white. Settlers from Spain's Basque region also faced their share of stereotyping and discrimination.

Eventually, these towns and companies built their own rail lines to transport logs and mining riches to and from the Truckee railroad station. Once tourism out of the San Francisco Bay Area grew in the very late 1800s, travelers would take the train to Truckee, passing through the massive granite tunnels (and hopefully not getting stranded by snowfall or derailment in the process). Once in Truckee, they'd take a small-gauge train built by lumber baron D.L. Bliss to Tahoe City, at which point they'd board one of several steamships to reach various resorts around the lake.

Saloons popped up in town to accommodate the men from nearby mining and logging camps. Truckee's Hurd's Saloon (also known as the Capital Saloon, still standing at 10072 Donner Pass Road) was a popular spot for hardworking men to blow off some steam, although violence wasn't uncommon, and sometimes the sheriffs and deputies themselves were known to be part of posses of ill repute. During the end of the 1800s, Truckee had a reputation for being tough—if you were going to gamble at a saloon, you better be prepared to defend yourself if something went wrong.

However, some guests from San Francisco stayed in Truckee, and that number grew with the advent of passable roads across Donner Summit and the creation of ski resorts in the area. Sugar Bowl Resort became a

The town of Truckee built enormous ice palaces and ski jumps during its official and unofficial winter carnivals. Circa 1880. *California History Room, California State Library, Sacramento, California.*

Downtown Truckee, circa 1920. Many of these buildings still stand. *California History Room, California State Library, Sacramento, California.*

popular area for the developing sport in the early 1930s, and Truckee's Winter Carnival included a massive ice palace, ski jumping competitions and town-wide winter activities and celebrations that became famous throughout California. Professional skiers and athletes stayed in the area and began developing extensive outdoor recreational opportunities. Skiing boomed, and the 1960 Winter Olympics put Truckee on the map. When the interstate highway opened in 1964, it made weekend ski trips possible for Californians in Sacramento and San Francisco. While it managed to stay a sleepy "ski meets railroad" town for a few more decades, it's now one of the most popular ski and mountain destinations in the country, with the prices and crowds to prove it. Today, it still retains much of its charm of yesteryear in the historic downtown area near the original (and still active) Truckee Station.

AUTHOR'S NOTE: *Readers interested in more tales of scandal and history from Truckee should visit the websites of the* Sierra Sun *newspaper (SierraSun.com) or the Truckee-Donner Historical Society (TruckeeHistory.org). Not all of the rumors about Truckee are verifiable (Did Charlie Chaplin perform here? Did mobster "Machine Gun" Kelly get locked up in the Truckee jail?), but they're definitely incredibly interesting.*

The Petroglyph, China Wall and Truckee Railroad Tunnels Hike

One of Truckee's easiest trails—and most at risk of disappearing—is the Petroglyph Trail, just north of the Donner Summit Canyon. The short hike heads to three interesting sites and can be done in half an hour for most hikers.

The Martis Complex Petroglyphs

Rock etchings line the short trail, most of which are abstract shapes. Unfortunately, archaeologists know very little about the people who made them: the Martis Complex. No records from that period remain.

What is known about the Martis Complex comes mostly from research in the 1950s and 1960s; not much new evidence has been discovered since then. The Martis Complex (named for the Martis River) occupied an area running from northeastern Nevada to north-central California. The Washoe would later inhabit a smaller but similar range.

The Martis Complex existed from roughly 4,000 BCE to 1,500 BCE, although some research suggests that the timeline should shift forward by about one thousand years. The Martis would have been hunters and gatherers, as evidenced by artifacts like knives, prehistoric hand augers and sharpened projectiles. Archaeologists have found many more low-lying sites in the area than sites at high elevations. As shown by the state of the petroglyphs on Donner Summit, heavy snow likely destroyed most evidence closer to the mountains. The only way most researchers can tell the Martis were in this area is through matching the petroglyphs with other better-preserved Martis Complex sites. No one knew much about the Donner Summit petroglyphs until 1954, when two University of California researchers noticed the similarities between the Tahoe art and other established sites.

What became of the Martis Complex is another unanswered question. Researchers have theorized that the Martis Complex gave way to the modern-day Washoe People, based on similarities between their cultures, while other studies draw compelling connections between the Martis Complex and the little-studied Maidu People of the Feather River Valley. It's also possible there were other groups of people after the Martis and before the Washoe, or perhaps that they connect in some way to the Paiute Tribe near Truckee.

As with everything about the Martis Complex, not much is known about the petroglyphs at the summit, including why anyone carved them. However, the geography and geology are likely the same as today: a large, flat and rocky slope with room to accommodate dozens of people. It's easy to imagine it serving as a convenient gathering spot, especially with the stream through Donner Canyon just a few minutes away.

Most of the petroglyphs in this area are abstract—spirals, wavy lines, triangles and more. The identifiable markings look like a sun and perhaps bear paws, although that's looking at them through a modern lens. There are more than two hundred petroglyphs at the site, and many are weather-worn and difficult to see. A sign at the bottom of the rock face helps visitors identify some of the more high-contrast etchings. Over time, the petroglyphs are fading, becoming hard and harder to see after each snowy winter. Eventually, they won't be visible at all—hopefully, researchers will find more evidence to paint a more complete picture of the Martis Complex before they're permanently lost to history.

Building the Railroad

The Petroglyph Trail overlaps with another historical site in Truckee: the hand-built stone China Wall monument. It's also the same trail you take to get to the abandoned railroad tunnels, although the Union Pacific Railroad owns them. Hiking through them is technically trespassing, although there are no signs or gates preventing entry.

The transcontinental railroad history has been immortalized in everything from art to literature to Hollywood for decades, from 1939's *Union Pacific* to the more recent TV show *Hell on Wheels*. And it's a compelling subject—building the railroad, especially through Donner Summit, was one of the most impressive engineering feats of the nineteenth century in

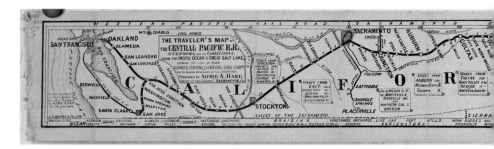

the West. Unfortunately, it was also a dark period for many in the area, including the Chinese laborers assigned the most dangerous tasks, despite being compensated less than their white peers.

In 1862, Congress decided that a transcontinental railroad was essential to the country's economic success. It authorized three companies to build the railway between San Francisco and Iowa: the Western Pacific Railroad Company to build from the West Coast to Sacramento, the Union Pacific Company from Iowa to Utah and the Central Pacific Railroad to connect the two. This meant that the Central Pacific would be responsible for crossing Donner Summit and eventually nailing in the final "Golden Spike" at Utah's Promontory Summit.

With an elevation change of nearly 5,800 feet between Sacramento and Truckee, the segment across the summit was one of the most challenging in the country. Fortunately for the railroad engineers, they weren't developing the route from scratch, as emigrants through Donner Pass had already found the path of least resistance through the mountains. Theodore Judah, the railroad's chief engineer (and eponym of Truckee's nearby Mount Judah), mapped the area and eventually landed on the best route for laying rails across the summit.

However, the easiest path was still steeper than anywhere else along the line, and it took years to map precisely how to route the rail. Ultimately, engineers decided that they'd need to blast more than two miles of tunnel out of the granite on Donner Summit. The technique for carving the tunnels wasn't high-tech, although it was labor-intensive. Using hand drills, workers cut holes in the rock and then fill them with gunpowder. They'd

A map of the western side of the transcontinental railroad, complete with stage routes to nearby cities available at each stop. *Claremont Colleges Digital Collection—Honnold/Mudd Library map collection, m385 C333 no.8(b), folder 3:6.*

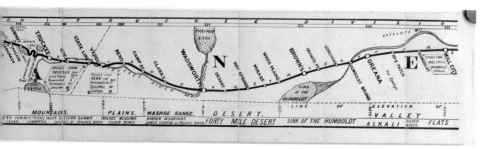

The Central Pacific Railroad built more than forty miles of snowsheds across Donner Summit. *Library of Congress, LOC HAER CAL,31-DONPA,1—1.*

detonate the blast, carry the rock and dust out of the tunnel in buckets and then start the process over again. Records show that the efforts were able to expand the tunnels by less than a foot each day in the more difficult sections. They began building in 1865 and didn't reach Truckee until late 1867, connecting to Reno in 1868.

Unfortunately, railroad engineers underestimated the winter weather, and sections of the newly built tracks were damaged just a few years after their completion. In 1870, snowfall and avalanches destroyed the tracks across Donner Summit multiple times. Soon after, engineers built more than forty miles of barn-like sheds (called snowsheds) to cover the tracks. However, as the snowsheds were wood, they required plenty of maintenance to survive the harsh winters, as well as around-the-clock firefighting crews and essential support personnel to keep employees based at the summit year-round. Eventually, the Central Pacific Railroad built a hotel (the Summit Hotel) nearby, although most workers lived in more humble homes down the hill. Most hotel guests were travelers stranded on the summit when snow blocked the trains.

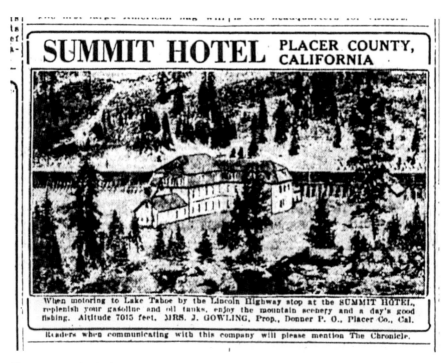

Newspaper ad for the Summit Hotel from the June 29, 1919 edition of the *San Francisco Chronicle.*

Eventually, technology for clearing the tracks improved, and the companies sent what amounted to snowplows on train cars ahead of passenger and freight trains to clear the tracks. This kept the snow from piling up on the tracks and meant that trains were delayed far less often, or at least for less time. That's probably why the Summit Hotel wasn't rebuilt after it burned down in 1924—the fact that drivable roads existed through the summit by then didn't help either. The fire started in the kitchen and burned more than sixty feet of snowshed tunnels, the entire hotel and several surrounding buildings. The estimated loss at that time was $50,000, according to an article in a 1924 edition of the *Sacramento Bee*. It wasn't the first fire near the snowsheds, but it would be one of the last. The Central Pacific eventually removed the wooden snowsheds and replaced some of them with concrete tunnels, which still stand today. The tracks were rerouted to their current-day route in 1993, and the company removed the rails through the tunnels.

Nothing remains of the hotel, but you can still see the site where it once stood, very close to Tunnel number six (of eight) through the summit. If

you're coming from Truckee, take a left on Sugar Bowl Road, across from Donner Ski Ranch. Take your first right onto Old Donner Summit Road. The hotel once stood about two hundred feet down on the left.

China Wall

The railroad was an impressive engineering marvel, but it came at a cost. Because construction started in the mid-1860s, labor was scarce. Many able-bodied men already had jobs in nearby silver and gold mines, and many of the men who hadn't worked in mines were injured or worse from the Civil War.

According to the 1870 census, California was home to 49,310 Chinese immigrants in 1870, up from 35,000 in 1860. Aside from Nevada and Oregon, no other state reported more than 100 Chinese residents either year. When the amount of gold pulled from the mines began to dwindle, Chinese laborers were the first to be let go, and suddenly, thousands of men in California were out of work. The Central Pacific Railroad recruited nearly ten thousand former Chinese miners to work on the dangerous tunnel projects. It was technically employment, but it was also taking advantage of the men's lack of options and, often, lack of English skills—there weren't many other jobs available on the West Coast.

The Central Pacific paid Chinese workers similarly to their white peers (twenty eight to forty dollars per month), but their tasks were much more dangerous. And for a portion of the workers, especially those who worked in San Francisco immediately upon their arrival, a large part of their salary went to a third-party broker (called a boss) who would liaise with their English-speaking employers on their behalf. And as Chinese immigrants, disparagingly called "Celestials," were already blamed for many of society's woes, they received poor treatment from their employers and were expected to pay for their own food, lodging and equipment, unlike their white peers, who received that in addition to their monthly salary.

Unfortunately for these Chinese workers, their ability to save the little money they did make was hamstrung by the Foreign Miners' Tax Act of 1850. It leveled a twenty-dollar-per-month fee on non-American miners, with exemptions for Mexicans and Native Americans; in practice, it was a tax on Chinese laborers. (It was replaced by a smaller three-dollar-per-month fee in 1851.) Because the Chinese were seen as less valuable than American workers, they were usually assigned the most dangerous

construction tasks—and dangerous tasks abounded when it came to blasting tunnels through solid granite.

While there aren't formal records of who performed what jobs or exactly how many workers the Central Pacific employed at any given time, oral reports indicate that Chinese workers performed the least desirable tasks, occasionally dying in the process. Those risks aside, workers living in poor, cramped conditions on the summit were subject to additional threats like disease and avalanches. A *Sacramento Bee* newspaper article from March 4, 1867, reported more than thirty Chinese workers killed in a single avalanche in late February. None of their names was printed.

On the job, Chinese workers were often the first in and last out when it came to laying explosives. It was almost always Chinese workers sent in to retrieve delayed explosives, and delayed explosions could mean death. The Chinese were also tasked with climbing across slippery snowfields on the cliffs and climbing into small, unstable openings to place TNT, often as loose rock fell around them. Reports from workers tell of being hoisted against rock faces or lowered down ravines in buckets to dig away at the rock—a dangerous task in the best of conditions but occasionally made deadly by the intense storms and freezing weather just below Donner Summit's more than seven-thousand-foot-high pass.

What became of many of the workers or how many perished around Donner Summit is anyone's guess. Recordkeeping was shoddy, and given

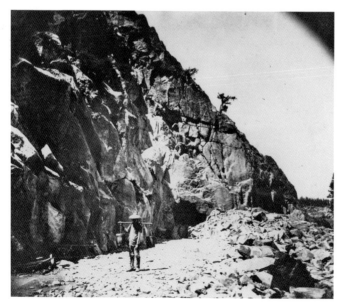

A Chinese worker hauling debris on Donner Summit. *Chinese in California Virtual Collection, BANC PIC 1905.17500 v.29:130—ALB, Bancroft Library, University of California–Berkeley.*

the way managers and the general public devalued Chinese workers, many deaths likely went unrecorded. In some cases, deceased workers were sent back on trains to San Francisco, where they could be claimed by their families or returned to China (although rumors abound that Donner Lake contains the remains of many railroad workers).

After the railroad's completion, many Chinese laborers moved to Truckee, where a thriving Chinatown existed around current-day Jibboom Street. However, the town of Truckee wasn't welcoming to them, and everything from robberies to intentionally set fires were common. The local paper frequently published slanderous articles blaming Chinatown for all the region's ills, and an 1886 town-wide boycott against Chinese businesses and white-owned businesses that hired Chinese workers caused many immigrants to leave Truckee. An 1888 article from the *Santa Cruz Surf* newspaper in California reported that the last few Chinese residents refused to leave until they were paid for their homes, and the residents of Truckee pooled their money to pay nowhere near a fair rate. As soon as the men and women left town, residents tore down their homes to make it impossible for them to return.

To get a sense for the craftsmanship and hard work that went into building the tunnels, just take a look at the memorial known as China Wall. Built entirely of stacked stones (likely blasted from the tunnels), the wall fills in a ravine between two tunnels to create solid ground for the tracks. The wall has survived more than 150 years of harsh winters and heavy snowfall and still stands sturdy just a few hundred feet uphill from the petroglyphs.

If you're standing below the China Wall looking up at it, take a look at the small underpass just to the right of the wall, cut through the rock. This is the first vehicle underpass in California, created as part of the Lincoln Highway to eliminate the dangerous railroad track crossing that resulted in more than a few close calls between trains and cars.

How to Hike It: Petroglyph, China Wall and Truckee Railroad Tunnels Hike

Why I Like It: A short walk for when you only have an hour to spare
Type of Hike: Out-and-back
Total Mileage: 0.4
Elevation Gain: 150 feet
Difficulty: Easier

Getting There: Coming from Truckee, drive west on Donner Pass Road (Old Highway 40). The parking area is on the left, just before the Donner Lake viewpoint. If you cross over the Donner Summit Bridge (also called the Rainbow Bridge), you've gone too far.

Trailhead Address: 18460 Donner Pass Road, Truckee, CA 96161

Start: You can turn this into a hike, but otherwise, it's a short-but-steep walk. The petroglyphs and information sign are only 100 feet or so off the side of the road.

To reach the railroad tunnels and China Wall, head left from the petroglyphs, up the rock face. There's a makeshift route outlined with small rocks on either side. Try to stay on this route to avoid stepping on any fading petroglyphs.

0.2 mile: Reach the China Wall, tunnels and site of the former Central Pacific route. The tunnels are quite dark and longer than they appear.

DONNER SUMMIT CANYON (THE LINCOLN HIGHWAY) TRAIL

In the early 1800s, the view of Donner Summit Canyon would have looked quite different. Highway 40—the windy road that passed over Donner Summit and was eventually replaced by Highway 80—didn't exist. Nor did any evidence of human impact, save for the occasional Native American artifact.

But by the early 1910s, Congress had decided that the country needed a drivable route from New York City to San Francisco. Car ownership was growing in popularity, and there were more than 500,000 privately owned cars in the United States by 1910, many of which were the famous Model T Ford (which retailed for $600). No longer was travel by train the only way to traverse the western states. However, while the East Coast already had a useable road network, roads were fewer and farther between in America's interior and western frontiers.

Organized by a coalition of early nineteenth-century automakers and industry leaders, the Lincoln Highway Association began fundraising and building the cross-country road in 1913. Concrete posts were placed at

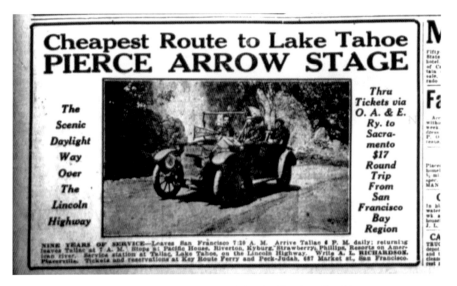

Advertisement from the June 20, 1918 edition of the *San Francisco Chronicle*.

various points along the route, numbering around three thousand in total, or roughly one per mile. (The marker along the Donner Summit hike is one of a small minority left in their original locations.) The road was laid primarily on existing dirt and wagon roads, covering the Sauk Trail in Indiana (first blazed by Native Americans), the Pony Express route in Wyoming and, in Tahoe, the Truckee Trail of the California Trail. While following the Truckee route likely wasn't the easiest way to go (in fact, it ended up being the highest point on the Lincoln Highway), it was the most direct, as routing north around the Sierra would have added days to the journey. And since travelers already knew Truckee as an established railroad town, it could serve as a rest point and refuel station before people made the crossing.

With the route's opening, local newspaper ads did their best to draw travelers to Tahoe, advising travelers that Lake Tahoe was "a world wonder, the highest lake in existence." (It is not.) Companies like the Pierce-Arrow Stagecoach advertised round-trip journeys to Tahoe via the new highway for seventeen dollars. The trip from San Francisco appears to have taken roughly eleven hours each way, averaging eighteen miles per hour.

And just like today, crossing the summit in the winter wasn't without risk. At an elevation of more than seven thousand feet, the area around Donner Summit can receive anywhere between three hundred and six hundred inches of snow each winter. Icy roads, avalanches and snowbanks too high to cross were common hazards along this section of the Lincoln

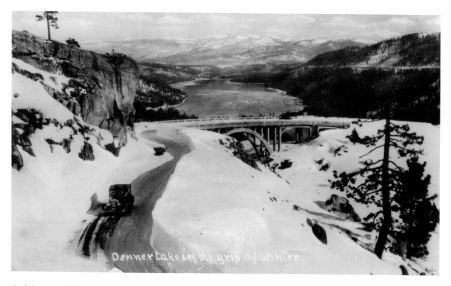

A driver on Donner Summit, likely in the late 1920s. *Courtesy of the California History Room, California State Library, Sacramento, California.*

Highway. During the highway's early years, local newspapers would publish daily reports advising on the road's status and whether cars could make it through. Some vehicles even drove up the summit backward to get better traction on the steep, icy roads.

A second hazard was the train line running across the road, an active rail line until it was rerouted in 1993. From the 1860s to the 1940s and 1950s, wooden snowsheds covered more than forty miles of track. Before crossing through the tunnels and across the tracks, drivers had to ensure that no trains were barreling toward them. The process involved exiting one's car; opening the large door to the snowshed; looking, listening and feeling for any train sounds or movement; crossing the track on foot to open the exit door; returning to one's car and driving across the tracks before stopping again on the other side to close both doors. It was risky for both car and train passengers. The original wooden snowsheds were eventually destroyed or replaced by concrete, although you can still see the spot where cars made the crossing (just to the right of the underpass tunnel).

The trip's danger also made it exciting, and soon after the Lincoln Highway opened, crossing the snowsheds became a badge of honor for local travel and adventure enthusiasts. A 1910 issue of the *San Francisco Chronicle* published a feature story about the San Francisco Motor Club's harrowing journey through the tunnels:

This climb is one of the steepest in the country, and the last 50 yards of the stretch was so bad that only by having the gasoline tanks full to the brim did the motorists succeed in getting over the summit.

It also tells of a driver's near collision with a passing train:

[H]*e attempted to cross the railroad track through the snowshed and only slowed down a trifle when the train, rounding a sharp curve, hove* [heaved] *in sight. Only by reversing his engine and jumping out and pushing the car back was the machine saved from destruction. The car was not five feet away from the train when it passed. After this happened, a guard was furnished from each machine to stay and warn the next car approaching the crossing.*

But because of the danger, plans soon started on rerouting the highway to avoid the crossing. In 1914, the snowshed crossing was replaced with what many historians consider California's first underpass. The safety update brought far more travelers to Tahoe. It also allowed tourists to more reliably reach Tahoe with less risk, allowing more and more people from Sacramento and San Francisco to travel east without worrying about safety or getting delayed on a snowed-in train. It was the beginning of the rise of private car travel and the decline in train travel.

Today, the Lincoln Highway is a winding three-mile hike that follows the topography of Donner Summit Canyon. Hikers can walk along the original Lincoln Highway route the entire way or take the "Later Lincoln Highway" back for a portion of the return trip. Because of weather, terrain and train traffic, road authorities tweaked the road's exact route several times over its short lifespan. The Later Lincoln Highway became the main route around the same time the underpass was constructed. However, the entire highway was replaced by Highway 40—a safer, more modern road that allowed passengers to pass through Donner Summit without crossing the railroad tracks at all—in 1928.

If you take the newer route down, look for the remains of a crashed car just a few feet off the trail on the left. This is one of several cars that slid off Highway 40 in the road's early years, although perhaps the most famous crash is the turkey truck that crashed in the 1950s. According to a *Reno Gazette-Journal* article from November 4, 1955, a truck carrying frozen Thanksgiving turkeys careened off an icy Highway 40, sending the truck sliding down the embankment. Although the driver was unhurt, the

turkeys were scattered down the canyon. Officers eventually arrived on the scene, but not before enterprising Truckee locals managed to steal most of the scattered cargo for their own Thanksgiving celebrations. Plenty of cars skidded off the twisting road of Old Highway 40 before the invention of all-wheel drive (and better highway safety standards), so it's unknown exactly when this particular crash happened.

You can connect this trail with the Petroglyph, China Wall and Railroad Tunnel hike, or use Highway 40 as the turn-around point. Although parts of the trail are tight, other areas are wide and flat, making it easy to see what parts were sections of the Lincoln Highway.

How to Hike It: Donner Summit Canyon (the Lincoln Highway) Trail

Why I Like It: A half-day hike along what was one of America's most dangerous roads
Type of Hike: Out-and-back
Total Mileage: 5 miles +
Elevation Gain: 850 feet
Difficulty: More Difficult

Getting There: Coming from Truckee, drive west on Donner Pass Road (Old Highway 40). The parking area is on the left, just past the west end of Donner Lake. You'll see informational signs posted at the trailhead.

Trailhead Address: 16395 Donner Pass Road, Truckee, CA 96161

Start: The trail starts in the woods, crossing a small wooden bridge.

0.2 mile: Arrive in a small clearing with great views of Donner Peak (it can be wet and buggy in the spring). You're now on the route of the Old Lincoln Highway. Keep going straight on the main trail, ignoring the side trails.

0.6 mile: You'll come to a metal sign that reads, "To Scenic Overlook and Donner Summit." Go straight at the intersection.

0.9 mile: Pass a small hillside/embankment on the left. A quick scramble will take you to nice views and a spot for a snack break.

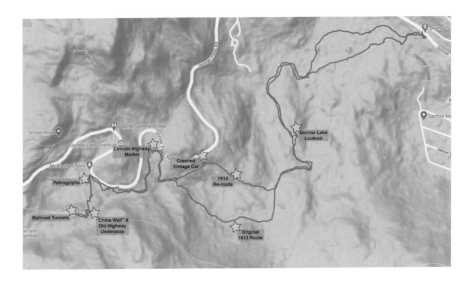

1.2 miles: The trail splits (and you'll get your first peak at the railroad tunnels). Go left. The trail after this point can be wet in the spring, and you may have to step carefully across a few very shallow stream crossings.

1.7 miles: Reach a gap in the rocks with water flowing in the spring. Rather than attempting to cross here, look left through the bushes and you'll see the trail (although overgrown plants can sometimes obscure it). Crossing via the trail is much easier and safer. Just after the waterfall, when you hit an intersection, go left (you'll return via the trail to the right).

1.8 miles: The trail makes a large loop to the left but can be a little hard to follow. Stay to the inside of Highway 40. Next to the highway, just before it loops to the left, is the old red-and-white Lincoln Highway marker.

2 miles: The trail can get hard to find as you'll need to cross a boulder/rock field. Look up and find the steep rock face, which usually has rock climbers on it in spring and summer. Head in that direction, keeping Highway 40 on your right.

2.3 miles: Arrive at the parking area for the Donner Summit Petroglyphs. Continue up to the railroad tracks or turn around here. If you turn around, backtrack to the intersection just after the waterfall/break in the rocks. Instead of turning right, in the direction you came from, go

straight, taking the other trail. This is the newer reroute of the Lincoln Highway. (You'll return to this intersection after about 2.7 miles if you turned around at the petroglyphs.) The wrecked car is about 0.1 mile up on the left, next to a smooth boulder.

3.1 miles: Go left when you intersect the main trail. You're now back on the original route.

3.8 miles: Back at the metal "To Scenic Overlook and Donner Summit" sign. For the return, feel free to take either trail to the right or left. They both reconnect with the main trail. The trail to the left occasionally has beaver dams. Head east (toward the road) when you intersect the main trail to return to your car.

5 miles: Back at trailhead.

BOCA TOWNSITE

Today, the Boca Townsite is one of the least visited trails in Truckee, probably in all of Tahoe. Were you to ask a Truckee local about it, there's a good chance they wouldn't have heard of it, or at least wouldn't know where it was. But that wasn't the case 150 years ago, when the town of Boca dwarfed Truckee in population and served as the center of the area's logging and, interestingly, ice mining industries.

The town of Boca was founded in 1867 to support the railroad—it was the stop after Truckee and the final stop in California. But the town wasn't a railroad stop because it was so large—it was large because of the railroad. Building the Central Pacific Railroad required thousands of workers, and Boca began as a workman's camp. It was in a critical location since railroad construction required massive amounts of lumber, and Boca sat in a clearing surrounded by pines ideal for logging. The railroad needed wood on Donner Summit to build nearly forty miles of snowshed over the tracks, and the mines in nearby Virginia City needed wood to support the mine shafts and power equipment. Boca was equidistant between the two.

But soon, the residents and workers at Boca discovered that their location on the river was good for something besides logging and rail transport: ice. By damming the river, they created a pond that froze over every year. It helped Truckee become the center of California's ice harvesting industry, and in

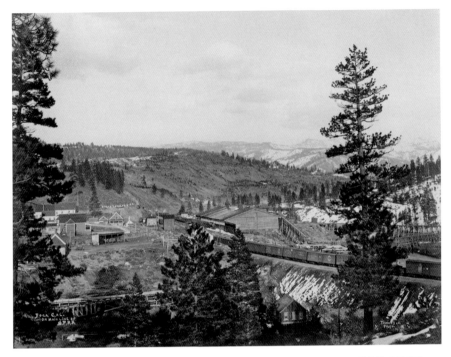

The transcontinental railroad in Boca, circa 1906. *Library of Congress, LC-USZ62-118699.*

1869, the two sectors combined to form the Boca Mill and Ice Company. The two industries paired well: the railroad needed wood to power the trains, while the ice was used to insulate railcars to keep meat and produce fresh on the way to markets. Before the invention of insulated cars, using ice blocks was the only way to keep produce and meat cold enough to arrive at markets in sellable condition.

The company boomed and so followed the town, offering all the major trappings of a lively railroad town by 1870. It had essential services like a mercantile, post office and hotel (rooms for just nine dollars a week!), plus a school, a saloons and even one official brothel (although perhaps there were more). This attracted more people to town and created another class of residents not affiliated with mining: teachers, shopkeepers, farmers, coopers, farriers and more. Since logging and ice harvesting were seasonal opposites, the town stayed busy year-round without major population changes between summer and winter.

Another major employer in Boca (perhaps because of the ice industry) was brewing, and Boca Brewing Company began producing Boca Beer (also

Boca Beer was popular around the world. Two current breweries (Anchor Steam in San Francisco and the Good Wolf in Truckee) make similar current-day versions. *From the* San Francisco Chronicle, *December 25, 1883.*

called Sierra Export Lager Beer) in 1875. It was the first lager brewed in California. With an endless supply of clean water, a railroad steps away and German brewmaster Leonhard Friedrich's leadership, the beer was a hit not just in California but worldwide. It won several beer awards at the Paris Exposition Universelle (World's Fair) of 1889, a competition entered by more than 240 breweries from twenty-six countries. By that same year, Boca Brewing Company was shipping anywhere between twenty-five thousand and thirty-five thousand barrels of beer across the country each year via the transcontinental railroad.

Unfortunately, the brewery burned down in 1893 and wasn't rebuilt, which put an end to the company. And it wasn't the only fire for the town, as another broke out in 1904, burning down the Boca Hotel, the train depot and part of the ice factory. According to an article in the April 4, 1904 edition of the *Santa Cruz Surf*, the total damages were estimated at $45,000. That, combined with the decreased demand for lumber from the mines, led to the town's decline. However, beer enthusiasts on the West Coast can still try the lager, or something similar to it, at least: Anchor Brewing Company in San Francisco re-created the recipe and began brewing Boca Beer again in 2013, and as of the time of writing, Truckee's own Good Wolf Brewery has a version on tap too.

Ice harvesting was a fairly straightforward if challenging task. Men used a horse and plow to scratch a grid onto the ice's surface, which they'd then cut into blocks with handsaws. The blocks were put in a cool storage space

Men used a plow and horse to cut a grid pattern onto the ice. *Library of Congress, LC-DIG-det-4a16342.*

Men use handsaws to cut the ice into blocks. *Library of Congress, LC-DIG-det-4a16343.*

A Boca Murder.

On Wednesday Jack Tallents, a hard-working, respectable man, engaged at work on the Little Truckee, near Boca, was mysteriously murdered, while hauling out timbers from the river. Two men near by heard him scream "Murder ! murder !" two or three times, and ran to him as rapidly as possible. He died in a few minutes after they reached him, having been shot in the back. They took him to Truckee and gave the above as all they knew of the tragedy. Deceased was about 35 years of age. There is no clew given as to the perpetrators.

Boca quickly earned a reputation as one of the most violent towns in California. *From the* San Francisco Chronicle, *April 23, 1877.*

(usually underground) before being loaded onto trains and shipped out. Since the area from which ice was harvested was much smaller than the area trees came from, the industry needed fewer men, and many workers found themselves sitting idly when the snow was too deep for logging. Combined with the town's brothels, saloons and lack of women, this meant that Boca had more than its fair share of fights and violence (which may be part of the reason nearby Hobart Mills, founded in the 1890s, didn't allow drinking or brothels). Boca developed an infamous reputation for murder, the most famous of which was the murder of Jack Tallan in 1877.

Tallan (or Tallents), a lumberjack, was shot on the job and died a few minutes later in the woods. A coroner later determined that he was shot not once but four times, all in the back. Since Tallan wasn't known to have a criminal past, and no one saw anyone else in the woods around the time of his murder, it was one of the biggest mysteries in town at the time. With no leads, other than rumors of a mysterious "tax collector" spotted in the woods, the investigation went cold, and the police offered a reward of nearly $2,000 for anyone who could point to a suspect. In May 1877, three weeks after the murder, sheriffs arrested three men. Eventually, just one—James Rahl, of Truckee, who worked with Tallan—was forced to stand trial, where he was acquitted due to a complete lack of evidence. Why these three men were arrested was never recorded, and no one was ever convicted. The case remains unsolved, and Tallan is buried at the Truckee cemetery.

Not much remains of the town of Boca. It was razed in 1927 to build the Boca Dam, and the few remaining structures were victims of twenty-first-century forest fires. However, one of the few remaining sites is an old cemetery, where a few preserved headstones remain. There are likely many more people buried in the area without headstones or markers. Of the marked graves, most are children. It's unknown why that is, but children might have been particularly prone to the challenges posed by Boca's harsh

Tombstones are one of the few pieces of the town still remaining. *Photo by author.*

winters, remote location and lack of medical care (the closest doctor was in Truckee, a destination nearly unreachable in heavy snow).

This trail is rarely crowded. Rather than being forested or exposed, like many of the hikes in this book, Boca Townsite feels more like a desert or canyon than an alpine environment (it's one of the closest trails in the book to Reno, which has a high desert climate). Wildflowers abound here in April and May, but by June, the site becomes very dry. There is no shade or water, and aside from a few trees, most of the landscape is knee-height brush.

How to Hike It: Boca Townsite

Why I Like It: A walk through the ruins of a logging town to a hidden 1800s-era cemetery
Type of Hike: Out-and-back
Total Mileage: 0.5 mile
Elevation Gain: 30 feet
Difficulty: Easier

Getting There: Coming from Truckee, take Highway 80 east to Exit 194 (Hirschdale Road). Go left after the exit and cross the railroad tracks. The parking area is on the right about a mile past the exit.

Trailhead Address: Boca, CA 96161

Start: Start at the parking area just off the road. While it's not technically wheelchair accessible, the entirety of the 0.6-mile path is a very flat gravel and dirt with no rocks or steps. The trail begins just across from the outhouse.

0.2 mile: Pass by a well-preserved sink, likely from a kitchen or wash house.

0.25 miles: The trail splits. It's a loop, so go whichever way you like. The route measured here goes left.

0.3 mile: The remains of the Boca Cemetery. This is the top of the loop; take the other path back down.

0.5 mile: Return to parking.

KYBURZ FLAT

Stepping into the area around Kyburz Flat is a step back in time—to three different periods, in fact. This valley was used by Native Americans in the distant past, by emigrants traveling to California in the mid-nineteenth century and as a ranch for Basque immigrants from Spain in the early twentieth century. Evidence from all three eras is preserved on site. Now, Kyburz Flat is a rarely visited historical site that makes a great place to escape the Truckee summer crowds. And if that wasn't enough, it's a surprisingly great area for bird watching, especially in the spring, when migrating birds return to nest in the valley's large marsh area.

Early Rock Carvings

The earliest evidence of human occupation on this site is the large petroglyph stone (now cracked into three pieces) near the Kyburz Flat trailhead parking

area. Unfortunately, aside from the stone itself, there are no records from the group of people who used this area. It could have been the Washoe, who spent summers around the lake at sites like Rabe Meadows, or the even earlier Martis Complex, who lived in the area until about 500 CE (predating the Washoe). It's unknown whether the Washoe are the Martis Complex's ancestors, probably because so little information about the Martis Complex exists. Researchers don't even know what the Martis would have called themselves; their moniker comes from the modern-day Martis River, which runs through the area they occupied.

The petroglyph (rock carving) in Kyburz Flat indicates that this was an important place for whatever tribe was here and that it was likely used year after year, rather than being a one-time location. While most people think of petroglyphs as drawings, akin to those on Donner Summit, a petroglyph is any unnatural marketing on a rock made by people. They're often through carvings and etchings, but they can also be small indentations or holes, like the ones at Kyburz Flat. The oldest petroglyphs found by researchers are "cupule" style, probably because indentations last longer than etchings, especially in areas with harsh winter weather.

Unfortunately, that's about the extent of the available information about this particularly abstract artifact.

More's Station and Henness Pass Road

The main road running through Kyburz Pass may be a sleepy dirt road now, but in the 1860s, it was part of a major thoroughfare between the West Coast and mines near Virginia City. The road was built in the late 1840s before the Comstock Lode, but it was used much more heavily in the 1850s and 1860s. It acted as both a wagon trail for transporting gold from the mines to buyers in California and as a primary route for post–Comstock Lode travelers moving west in the 1860s and 1870s. Today, the road runs north of Truckee, and while travel on modern roads like Route 89 is far quicker, many sections of Henness Pass are available for biking and off-road driving. If you explore Mount Lola, you'll drive for fifteen or twenty minutes on Henness Pass Road, passing a historical marker.

The mines drove the development of Tahoe's logging industry, bringing more people to the logging camps around Kyburz Pass. And Henness Pass Road was the route most of them took, creating heavy traffic, plus significant delays when weather rendered the road impassable. Many enterprising

Advertisements and cartoons like this one drew thousands of miners through More's Station, circa 1860. *California History Room, California State Library, Sacramento, California.*

homesteaders began to offer logging and meals to stranded travelers in their homes, which eventually developed into way stations like the one started here by Lysander More in the early 1860s.

More's Station, as it came to be known, covered more than three hundred acres in the Kyburz Valley. Weary travelers could book a room on the second floor of the hotel, have a hot meal on the ground floor and house and feed their livestock in the covered barn. An on-site well ensured that fresh water was readily available, and deep cellars cut into the earth ensured that meat and vegetables stayed cold. And plenty of meat and vegetables were needed, as reports of traffic and bottlenecks started from the very beginning of the road's use.

However, the More's Station's heyday was short-lived. With the railroad's completion in the 1860s and the Comstock Lode's quick decline, paying the toll to use Henness Pass road fell out of favor with travelers, who could move faster and more affordably on other routes.

Very little remains of the town today, although there are signs in place to indicate where buildings and barns once stood. The boardwalk-style trail is wheelchair and stroller accessible.

Basque Immigration

Given what a large state California is, it may not be surprising that the state has one of the largest Basque populations in the United States (the other is in Idaho). But what may be more surprising is that Basque immigrants have been in Tahoe since the gold rush, establishing a robust Basque community near the California-Nevada border. The towns in and around Reno have some of the country's best Basque restaurants.

Basque people lived near the Spain-France border and managed to stay isolated much longer than the rest of Europe. Because the terrain near the border is mountainous and remote, the Basque likely descended from people already in the area, rather than being the progeny from an invading people. (The Basque language, which is unlike the rest of the languages in Europe, supports this theory.) That remoteness served the Basque well during major European conflicts like the Roman conquest but also left them to act as a semi-autonomous isolated country for hundreds of years. Unfortunately for the Basque, the Spanish banned self-governance of any communities within Spain in the 1830s, just before the U.S. gold rush. Rather than becoming subjects of a leader many Basque had recently fought against, hundreds left

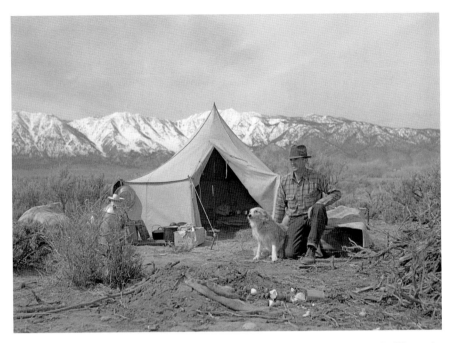

A Basque shepherd with his herding dog and basic camping supplies, circa 1930. *Library of Congress, LC-USF34-024115-D.*

Spain, heading to France, northern Africa and North and South America. With so many Basque fleeing Spain during the 1840s and 1850s, it's no wonder many came to California, where gold rush fever was at its peak.

However, because the Basque language is so distinct from others, it was hard for them to communicate with non-Basque-speakers while mining or working at logging camps. As such, many Basque instead looked to ranching, a self-reliant activity that required only a few sheep and a small plot of land—none of which were in short supply in California and Nevada in the mid-1800s.

Many Basque immigrants engaged in other professions, but sheepherding was undoubtedly one of the most popular. Basque coming from mountains in Spain were used to rugged terrain and cold weather, so herding the flocks through the Sierra Nevada wasn't the complete change of pace it would have been for urban men from New York or Chicago. However, many sheepherders did find the Sierra Nevada winters challenging, and that—combined with the growing demand for land for logging and development—drove many out of the Tahoe area. Many moved east, toward Nevada and Utah, or farther west, toward California's Central Valley.

Sheepherding was also a challenge considering the rough terrain and predators like bears and mountain lions that roamed in much higher supply than they do now. And camping back then wasn't like camping today. The average sheepherder was likely limited to a donkey or two, a shepherd dog and some heavy, rustic supplies. It probably wasn't a comfortable way to make a living, and by the 1930s, clashes between sheepherders and private landowners were becoming more and more frequent (much like current-day conflicts over public versus private lands in the western United States).

Sheepherders built the Wheeler Sheep Camp around 1920 in Kyburz Flat. It was an annex of the Wheeler Sheep Company, based in Reno, Nevada, and served as a place to keep sheep during the summers before shearing or selling to butchers. Once a week, a supply vehicle arrived from Nevada (likely along Henness Pass Road) to deliver food for the camp. The site had several barns and cabins at its peak, as well as a designated tent area, a bathhouse and a large outdoor kitchen with an oversized brick oven (which is the only structure still standing today).

The Wheeler Sheep Company used this meadow until the 1960s, at which point it fell out of use and was mostly dismantled. The brick oven was rebuilt in the 1990s and can be reserved for private events today.

While there are very few still-standing Basque camps left in the area, there's actually a second one in Truckee, although reaching it requires a longer and more strenuous hike. It's along the Pacific Crest Trail, in the Granite Chief Wilderness. More buildings still stand at the Whiskey Creek Camp (where camping is not allowed in the vicinity, despite the name).

To access the Whiskey Creek Camp, take the "Five Lakes Trail" in Alpine Meadows (not included in this book) to Five Lakes and then continue on the Pacific Crest Trail from behind Five Lakes, eventually departing from the primary trail to follow signs to "Whiskey Creek Camp." Expect stream crossings in the winter and full sun for the first half of the trail. The whole trail is eight miles round-trip, with an 1,800-foot elevation gain.

The name "Kyburz" comes from George and Minnie Kyburz, who owned much of the ranching land around Lake Tahoe in the 1940s.

How to Hike It: Kyburz Flat

Why I Like It: A never-crowded walk past three historical sites
Type of Hike: Out-and-back
Total Mileage: 1.8 miles

Elevation Gain: 280 feet
Difficulty: Easier

Getting There: Coming from Truckee, take CA-89 N for 13 miles. Turn right onto Henness Pass Road (S450). Most vehicles should have no problem on the bumpy road. In the winter, you can opt to park on the side of CA-89 N before the turn and snowshoe or cross-country ski to the site. The trailhead has one restroom and no running water.

Trailhead Address: Kyburz Flat, CA 96118

Start: From the parking lot, take the road to the left, across from the restroom. Follow the bumpy dirt road.

0.7 mile: Reach Wheeler Sheep Camp.

Most people here will want to retrace their steps, returning to the parking area. However, if you're keen to birdwatch, keep going into the marshy valley. It attracts plenty of migrating birds, and you'll almost always have the place to yourself. In addition to songbirds, it's possible to see blackbirds, wading birds like long-billed avocets or Wilson snipe, large woodpeckers, bright birds like the red-breasted sapsucker and even nesting bald eagles, which are found throughout the Tahoe basin. Other birds of prey also come and go from the area. There are more than two hundred acres in Kyburz Flat, so bring binoculars (and bug spray, if you visit in the spring).

1.4 miles: Return to parking area. Walk the fifty yards or so to the broken petroglyph, then down the road toward the site of More's Station. The boardwalk makes a loop around the site before returning to the starting point.

Nearly all the distance is going to the Wheeler Sheep Camp. If you skip that, the walk around More's Station is much shorter and nearly flat.

Chapter 4
MINING AND LOGGING

Although tourism is currently Tahoe's biggest draw, it's the mining and logging industries that first put Tahoe on the map. The trails here relate to the area's mining and logging industries.

At first blush, it may seem odd that Tahoe—an area whose hills are filled with dirt and rock, not gold and silver—would play such a vital role in the mining industry. But because of Tahoe's rich resources, it became a key supply station for the nearby mining operations.

Truckee (née Coburn Station) was a stop for emigrants on the California Trail, who would resupply in town before making the final push over Donner Summit. Due to that route's difficulty, emigrants looked for alternate routes and developed supply stations in the process near towns like Carson City, Genoa and Meyers. Those stations grew into towns, which were eventually connected by wagon roads, making travel around the lake much easier. So when mining boomed around the Comstock Lode and Virginia City's population doubled seemingly overnight, cities like Truckee and Carson City became essential as commerce centers. Companies shipped gold and silver to San Francisco via Truckee, and miners bound for Virginia City would take the railroad from San Francisco to Truckee or Carson City before heading to the mining towns.

The massive mines in Virginia City reached deep underground, and to buttress the ceilings and walls, mining companies needed significant amounts of timber. Beyond that, they needed lumber to build homes and businesses and to power the many trains on the (now dismantled) rail lines

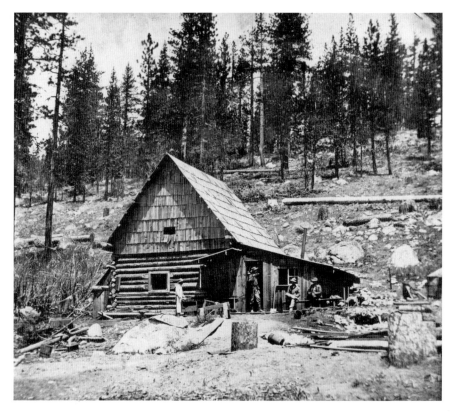

A traditional miner's cabin in the Sierra Nevada, 1866. *Library of Congress, LC-DIG-ds-04489.*

that connected the mines to the transcontinental railroad. Lumber was also used to build the flume systems that carried water from the Tahoe area to Carson and Virginia Cities. Logging was essential to the mining industry, and several mining operations in Incline Village, Stateline and north of Truckee are how enterprising businessmen made their fortunes. Because of the heavy logging, only a few areas of Tahoe National Forest are old-growth, mostly thanks to Washoe efforts to keep logging off their land and early environmentalists who recognized the touristic value of protecting the environment.

As the mining resources declined, so did the logging industry, and tourism became Tahoe's primary economic driver. Most companies dismantled their logging camps and sold anything they could to other towns and companies. Eventually, the forest regrew, barely showing signs of the deforestation that once left giant swaths of Tahoe's hillsides nearly bare.

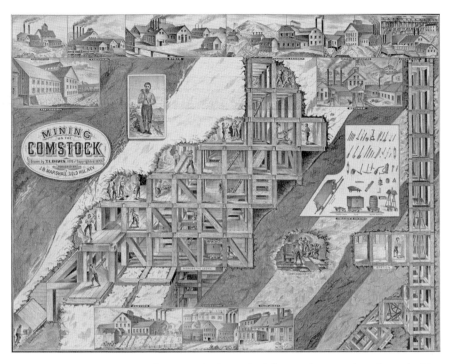

The mines and tunnels of the Comstock Lode reached deep underground, as shown in this 1876 map. *Library of Congress, LOC LC-DIG-pga-01999.*

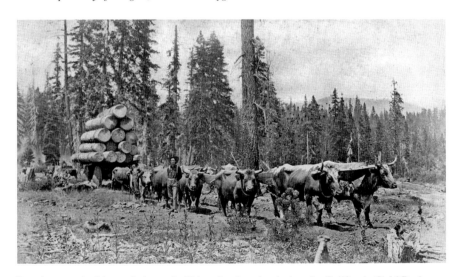

Logging was the biggest industry in Tahoe for decades during the California Gold Rush. *R.J. Waters, Berkeley, Cal'a, "Hauling Logs," A load of 11,200 Ft., No 33, Lake Tahoe Series, undated, General Subjects Photography Collection, PC-GS-Industry, California Historical Society.*

Marlette-to-Spooner Flume Trail

Most people know that the hillsides on Lake Tahoe's eastern shore once held flumes, but many may not know what the flumes were exactly or how extensive the flume system was. While some mining and logging operations had small flume systems to carry water to their camps and mills, the major flume network was all part of the Virginia and Gold Hill Water Company (V&GHWC), which built flumes from north of Incline Village south to Spooner Summit. The flumes appeared to be two separate systems on the Tahoe side of the ridgeline but merged farther to the east on the way to Carson Valley. On the Tahoe side of the summits, the pipes carrying water were raised off the ground, resting in V-shaped "flumes." Many sections also had wooden covers to keep snow out.

The flume supplied fresh water to Virginia City, Gold Hill and Silver City to the east, the hubs for mining activity in the region in the late 1800s. Virginia City is in the high desert and has no freshwater source, so the flume was a vital lifeline for the burgeoning town. While digging wells was enough when the city was just a small mining outpost, the Comstock Lode discovery in 1859 caused a massive population boom. Having access to water (and transportation) was vital to the mines' growth, so Henry Comstock hired German engineer Hermann Schussler to build a water system. Already well known in San Francisco for creating durable engineering projects, he began designing the system in early 1872, finishing it in 1873.

Although water would eventually come from Marlette Lake, the first iteration of the system pulled water from the Hobart Creek Reservoir, where the company built a small dam for that purpose. From the dam, water would flow to a site known as the "Red House," where a water company operator lived to control the flow. From there, it ran through a series of pipes, and the pressure of the water flow provided enough momentum to carry it the rest of the way to reservoirs and tanks near Virginia City—nearly 1,200 feet higher than the lowest point in the Washoe Valley. It was the largest pressurized (non-pump) water system in the world at the time of construction. Purchase orders from the time show that more than 950,000 rivets were used to build the flume and that the total iron weight for the flume and the pipes was about seven hundred tons. Thirty-five tons of lead were also used to seal the joints; fortunately, the lead was entirely removed many decades ago. A combined twenty-nine air valves and air blow-out valves helped prevent implosions in case the pressure created a vacuum within the pipes.

Men lived in houses near the flumes to tend to repairs and stuck logs. 1890. *California State University, Chico, Meriam Library Special Collections.*

However, soon after construction, the system began leaking, as the engineers hadn't considered that metal would expand and contract during the region's massive temperature swings. Fortunately, the fix was easy, and engineers added clamps to many of the leaky joints, which seemed to solve the problem.

But the V&GHWC soon had a larger problem: the reservoir didn't provide enough water for Virginia City. While snowmelt kept the reservoir full in the spring, it could come close to dry in the summer. As with many small lakes near the summit (including Twin Lakes, by the Tunnel Creek Trail), the water source was unreliable. And it could be underfilled for years if a few winters in a row failed to deliver enough snow.

Of course, the speed at which Virginia City was growing didn't help. The city's population went from 2,345 in 1860 to 10,917 in 1880 and likely as

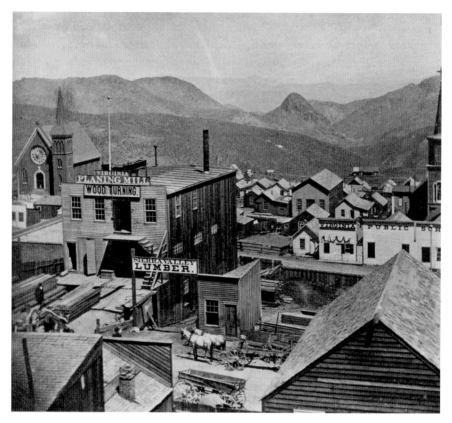

A bird's-eye view of C Street, Virginia City, 1866. *Library of Congress, LC-DIG-ds-04482 1866.*

much as double that in the years in between—supply couldn't keep up with demand. Newspaper articles from the 1880s report citizens being angry with the limited hours in which water was available, from 5:00 a.m. to 8:00 a.m. and 5:00 p.m. to 8:00 p.m.

Thus, in 1875, V&GHWC began an extension on the line to source water from Marlette Lake. At an elevation of 7,850 feet above sea level (and 1,600 feet above Lake Tahoe), Marlette Lake was an obvious source of water in the area. The expansion was so critical that the company even named the lake in honor of the first man to suggest using it: Seneca Hunt Marlette, a gold rush surveyor who helped plan the project. Before this point, the lake was more of a pond. It's entirely human-made, created and dammed in the 1860s to support logging operations. Marlette Lake's water level would rise if V&GHWC expanded the tiny dam, creating a reliable water source in the

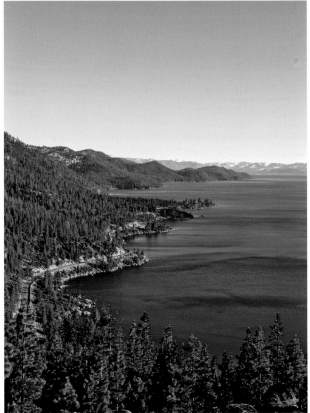

Above: Doolie
exploring Lake Mary
and Donner Summit.
Photo by Aren Saltiel.

Left: The east shore of
Lake Tahoe. *Photo by
author.*

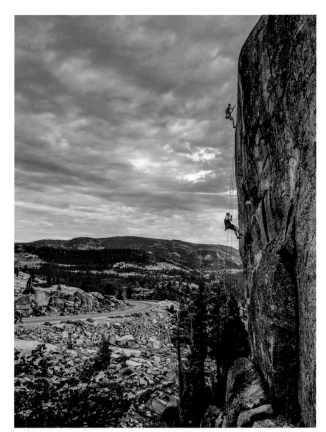

Right: Rock climbers near Donner Summit. *Photo by author.*

Below: You'll encounter dogs on many of Tahoe's trails. *Photo by Aren Saltiel.*

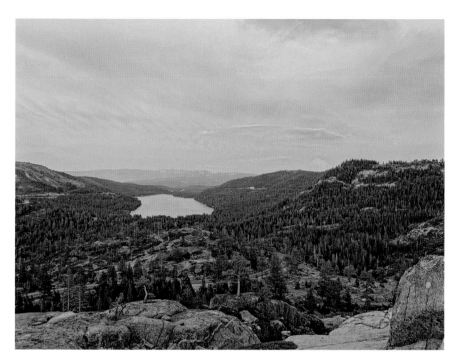

Donner Lake at sunset from Donner Summit. *Photo by author.*

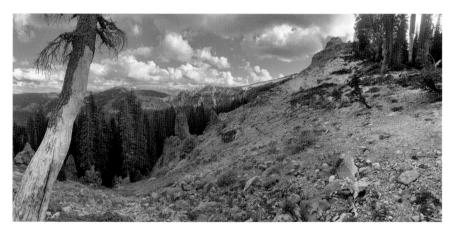

While at Roller Pass, take a moment to stare down the hillside and imagine what it'd be like to haul a heavy wagon up. *Photo by author.*

A vintage mural in downtown Truckee. *Jon B. Lovelace Collection of California Photographs in Carol M. Highsmith's America Project, Library of Congress, Prints and Photographs Division.*

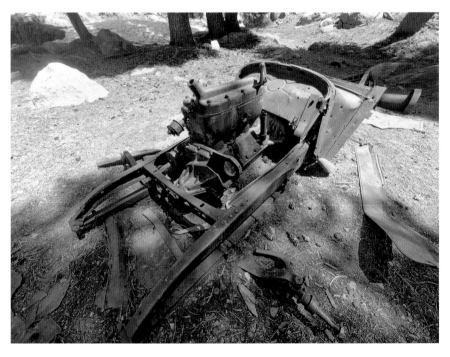

The Lost Cabin Mine seems to have closed in a hurry, as evidenced by the remains of this car left behind. *Photo by author.*

Donner Summit at sunset, looking uphill at the China Wall and petroglyphs. *Photo by author.*

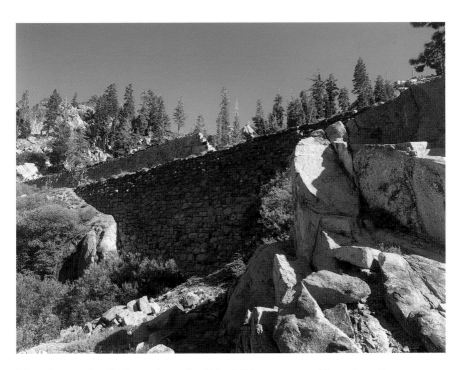

More than one hundred years later, the China Wall monument still stands on Donner Summit. *Photo by author.*

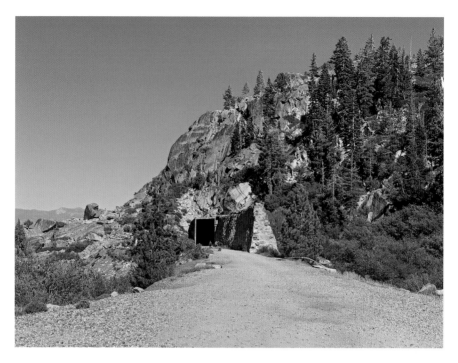

The railroad tunnels still stand, although the tracks were removed when the train was rerouted in the 1990s. *Photo by author.*

The oven at the Wheeler Sheep Camp. *Photo by author.*

Above: All that remains of the vacation home at Marlette Lake is this large chimney, but it's clear the home was in a prime spot. *Photo by author.*

Left: The views from the Tunnel Creek trail are some of the best in Tahoe. *Photo by author.*

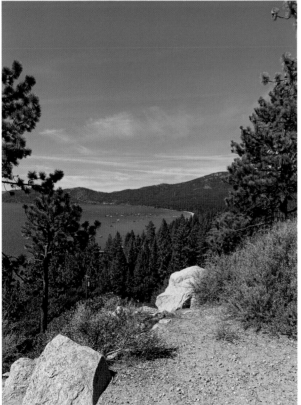

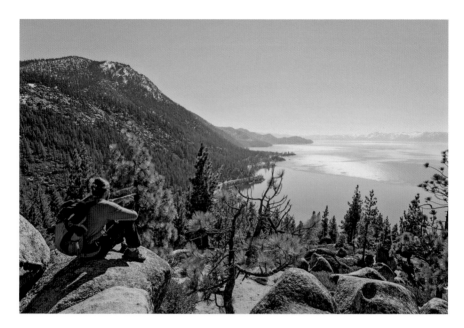

Tunnel Creek, looking down the eastern shore. *Photo by author.*

The "monkey" of Monkey Rock. *Photo by author.*

An old car left behind when the town closed still sits just a short distance off the trail at Hobart Mills. *Photo by author.*

Malakoff Diggins today. *Photo by author.*

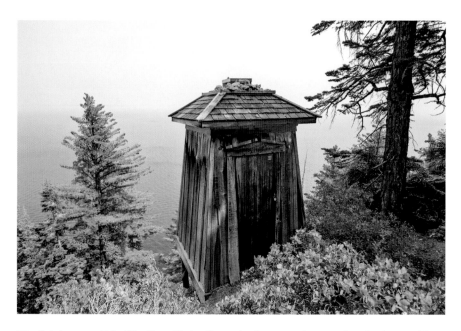

The lighthouse at D.L. Bliss State Park still stands after more than one hundred years. *Photo by author.*

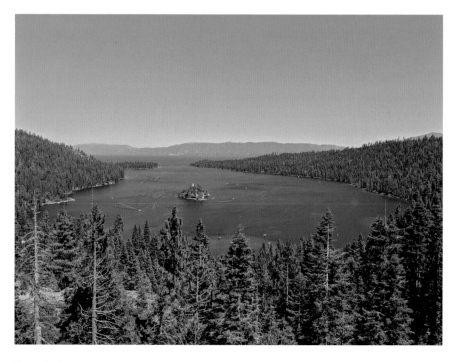

Emerald Bay has long been regarded as one of Tahoe's most beautiful sights. *Photo by author.*

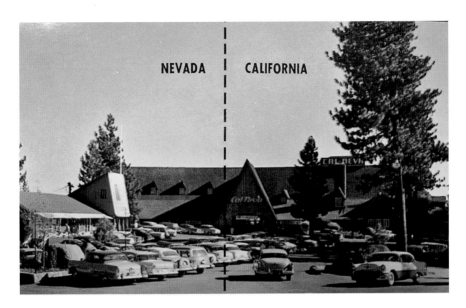

A postcard circa 1950 from the Cal-Neva Lodge.

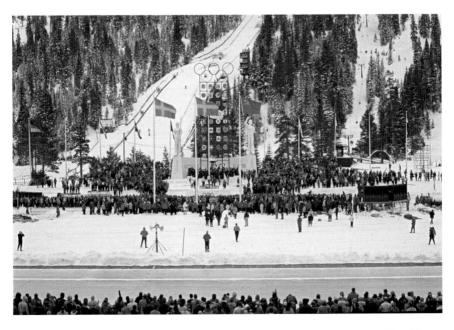

Squaw Valley Olympics, 1960 (near the base of the current Far East lift). *Robert M. Reid, Squaw Valley/Alpine Meadows.*

This cave is said to have been a basecamp for Snowshoe Thompson, who'd rest here when the snow was too deep to continue through the pass. *Photo by author.*

The Chollar Mine in Virginia City, current day.

The current-day site of More's Station; the boardwalk is the old route of Henness Pass Road. *Photo by author*.

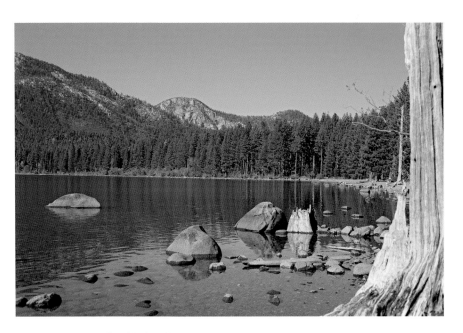

Current-day Fallen Leaf Lake. *Photo by author*.

Looking down the stairs from the top of the Sierra Buttes Fire Tower. *Photo by author.*

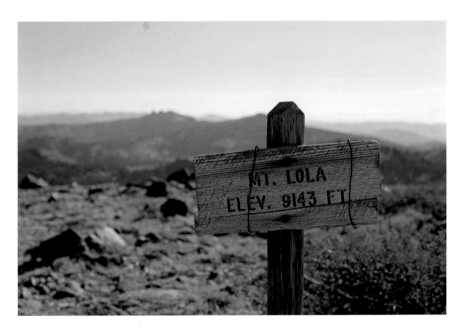

The summit of Mount Lola. *Photo by author.*

Spencer's Cabin near Spooner Summit. *Photo by author.*

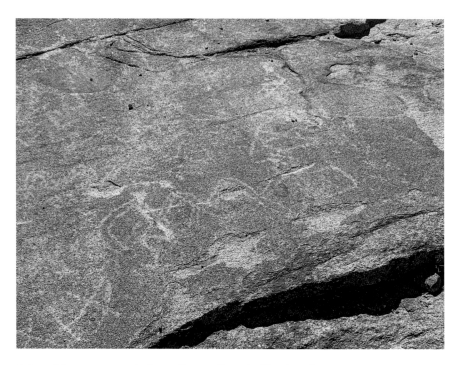

A few of the many petroglyphs on Donner Summit. *Photo by author.*

An old sink is one of the few remaining signs that a town ever existed at the Boca Townsite. *Photo by author.*

The Rubicon Trail runs parallel to Lake Tahoe, and great views start immediately after the trailhead. *Photo by author.*

mountains. Knowing this, the V&GHWC purchased the lake at the time of the flume expansion.

The flume system extension cost $600,000 to build, or nearly $12 million adjusted for inflation. While it was technically an expansion, in reality it was a completely new line—after all, the engineers couldn't pause the water flow from the existing system while they merged with the new one. As such, there were eventually two lines running side by side for much of the route.

The architect of this expansion first had to raise the dam at Marlette Lake and reroute the lake's existing flume apparatus, which the V&GHWC didn't own. Rather, it was a log flume owned by the Carson and Tahoe Lumber and Fluming Company. The company built the flume to carry logs, not water, from Marlette to Spooner Lake, where they'd then be shipped to Carson City. (The current hike between Spooner Lake and Marlette follows that flume's route.)

The V&GHWC needed to move water north, not south, so it constructed a 4.38-mile-long wooden flume running from Marlette Lake to current-day Tunnel Creek. The flume was thirty inches wide by seventeen inches deep. With the new flume and Marlette Lake's increased capacity, the V&GHWC could carry more than enough water for the mines in and around Virginia City.

Since then, the system had received significant upgrades, but it still supplies all the water for Virginia City and some of Carson City. The Marlette-to-Incline route was abandoned in 1957 when the Incline Tunnel collapsed.

The highlight of the new system was a nearly four-thousand-foot-long tunnel through the highest part of the ridgeline between Tahoe and the Washoe Valley. The tunnel carried the water from Marlette Lake (and the smaller Incline Lake) east through rock. The tunnel was seven feet high and shaped like an inverted triangle, about two feet wider at the bottom than the top. It was bolstered with wood from the nearby logging operations. This tunnel gave the much-loved Tunnel Creek hike its name, although many Incline residents may not even know the reason for the name, as the tunnel collapsed in 1957. Instead of rebuilding the tunnel, the company added pumps and rerouted water down the eastern side of Marlette Lake, no longer funneling it north through Incline Village. The remaining pieces of the flume were replaced with pipes. In 1963, the State of Nevada paid $1,650,000 for the water rights and roughly 5,400 acres from what was then the Marlette Lake Company.

How to Hike It: Marlette-to-Spooner Flume Trail

Why I Like It: A single-track hike through the woods to a lake high above
 Tahoe
Type of Hike: Out-and-back
Total Mileage: 9.8 miles +
Elevation Gain: 1,500 +
Difficulty: More Difficult

Getting There: Coming from Incline Village, take NV-28 S for 12 miles, turning
 left into Spooner Lake–Lake Tahoe Nevada State Park. If you reach the
 intersection with US-50, you missed the turn. Parking is ten dollars, and
 the parking lot has restrooms, picnic tables and running water. The lot
 can fill up very quickly on busy weekends.

Trailhead address: Spooner Lake–Lake Tahoe Nevada State Park, Carson
 City, NV 89703

Start: Walk through the trees to the east (away from the parking lot) to
 reach North Canyon Road, the starting point for the hike. Follow North
 Canyon Road.

0.6 mile: Pass Spencer Cabin on the left. The cabin was built by a cattle rancher
 in the 1920s and isn't connected to the fluming operations in the area.

0.8 mile: Reach an intersection where the road turns right. Mountain bikers
 should turn right to stay on the road. Hikers will want to take the dirt path
 into the woods to the left of the Marlette Information sign.

1.8 miles: Keep going straight at the intersection

4 miles: Cross Marlette Creek Road to stay on the trail.

4.3 miles: First views of Marlette Lake and the highest point of the trail.

4.5 miles: Reach Marlette Lake shoreline; turn right.

4.8 miles: Turn left and walk down the small peninsula into the lake. Still
 standing at the far end is a large stone chimney, built as part of a vacation

house for owners of the V&GHWC in 1933. The cabin was torn down in the 1960s. There's a backcountry outhouse just past this turn.

From here, you have options. You can backtrack and walk along the other side of the lake, eventually connecting to the Tunnel Creek Trail (+4.3 miles, 1,000 feet of elevation). Alternatively, you can continue along the east side of the lake on Marlette Lake Road. At the 6.5-mile mark, go left and take the short trail up to Marlette Peak for amazing views of Marlette Lake and Lake Tahoe (+2.6 miles one way, 900 feet of elevation).

Backtrack to return to Marlette Lake and take the same trail back to the starting point.

9.6 miles: Return to parking area.

Tunnel Creek Trail (the North Flume)

The northern section of the V&GHWC flume may be in Incline Village, but it's not actually the Incline Flume—that's a much lesser-known part of the system that carried water from Incline Lake, near current-day Diamond Peak Ski Resort.

This trail, which many locals are referring to when they mention the "Incline Flume," is actually the North Flume of the Virginia Gold Hill Water System—part of the same aforementioned system. Most of the system's water came from Marlette Lake, flowing north before making a sharp turn to travel through the tunnel and toward Carson City. That route of that flume intersects this trail at the 3.2-mile mark.

Along the Tunnel Creek trail, named for the tunnel near the top, hikers can still see pipes and parts of the system as they climb. And depending on how far up hikers want to go, they can eventually reach the Red House Flume Trail. Part of the first flume system (before the Marlette Lake addition), the trail carried water from a few small lakes around Incline Village to the Hobart Creek Reservoir. Today, it's a shared-use biking and hiking trail.

The hike up Tunnel Creek to the flume trail is one of the prettiest hikes in Tahoe, delivering great views for relatively little effort. That also makes it one of the most crowded trails in Tahoe, especially on summer weekends. However, hikers and bikers willing to go beyond the intersection of the Flume Trail will find the trail less crowded, especially past Twin Lakes.

Fantastic views of the lake start less than 0.5 mile in. At the base of the trail is Tunnel Creek Café, where mountain bikers can rent bikes or reserve a shuttle to drive them to the top, eventually returning to the café.

How to Hike It: Tunnel Creek Trail (the North Flume) to Twin Lakes

Why I Like It: A long hike with great views starting less than a half-mile in.
Type of Hike: Out-and-back
Total Mileage: 8 miles
Elevation Gain: 2,000 feet
Difficulty: Most Difficult

Getting There: The trailhead is in Incline Village, just north of the intersection of NV-28 and Lakeshore Drive. There's paid parking along the side of Route 28. Parking in the Tunnel Creek Café lot is for business patrons only. Restrooms are available near the parking area.

Trailhead Address: 1103–71, Tahoe Boulevard, Incline Village, NV 89451

Start: The trail starts on the road directly behind the Tunnel Creek Café.

0.2 mile: The trail turns to sand just past the Spooner Backcountry sign. There are a few very short trails past this on the right that lead to small lookouts.

0.7 mile: Walk past the closed gate. Go straight at the split immediately after the gate. (The path to the right leads to Hidden Beach).

0.9 mile: Keep going straight. The small path to the left leads to Monkey Rock; you'll come down this way on the return. The road makes a left and gradually climbs. It's uphill the whole way, but at a very gentle grade.

1.4 miles: Large boulder stack on the right. This is a great spot for a snack or a good turn-around point for anyone with tired legs.

2.7 miles: Stop at the sign about the lumber industry, posted on the right. If you look toward the streambed just past the sign, you'll see the remains of

the old pipes that were part of the flume system, before it was rerouted to flow east from Marlette Lake.

3.3 miles: Reach the intersection with the Marlette Flume trail. (Going straight would take you to Marlette Lake.) Instead, turn left, following the road as it curves. You've gained 1,500 feet by now.

3.6 miles: Reach another clearing. The road continues straight; instead, go right, on the thin dirt path through the woods. This is the Tahoe Rim Trail.

4 miles: Arrive at Twin Lakes (which can be nearly dry in the summer). From here, you can scramble up the loose rock pile to the right for views toward Carson City or keep going on the road to reach the intersection with the Red House Flume Trail in another 1.5 miles. Backtrack when you're ready.

On the way back down, you'll have views across the whole north shore, including Diamond Peak Ski Resort on the right and Squaw Valley and Martis Peak across the lake. The peninsula on the middle of the north side of the lake is Crystal Bay, where Frank Sinatra once owned the Cal-Neva Lodge.

For your return trip, take the shortcut past Monkey Rock. After about 2.5 miles on the main road (just over a mile before the trailhead), you'll notice a dirt path on the right, just before the road makes a downhill turn to the left. (There's a knee-height boulder just to the right.) After a few minutes, you'll reach a boulder pile with great views of Tahoe. Look north toward the Incline Village beaches and you'll notice a 6-foot-tall rock that looks exactly like a gorilla carving standing as a totem over the lake. The natural boulder is a great place for photos.

From there, you can take a semi-loose, short sandy path down to the trail (which cuts off about 0.4 mile) or just retrace your steps back to Tunnel Creek Café.

8 miles: Back at trailhead.

THE INCLINE RAIL/INCLINE FLUME TRAIL

Although many people think the Tunnel Creek hike is the Incline Flume, it's not. The Tunnel Creek Trail leads to the North Flume of the Marlette Water System. The actual Incline Flume was a different system that ran through current-day Diamond Peak, connecting with the Marlette system near the top of the Tunnel Creek hike. It also passed under another noteworthy engineering feat that gave the town its name: the Incline Railway, which ran from just above lake level up the summit toward Carson Valley.

In 1880, the need for lumber was as robust as ever, and the Sierra Nevada Wood and Lumber Company (SNW&LC) started an ambitious logging operation on the northern shore of Lake Tahoe around Crystal Bay, then known as Overton Bay. The massive trees in the area were ripe for felling, and the open lakeshore provided plenty of space for the operation to park equipment and livestock and pitch tents for workers.

Of course, the obvious question remained: how do you get massive trees from Lake Tahoe to Carson City, considering that there's a 1,500-foot elevation gain to cross the ridgeline between the two? For SNW&LC owners,

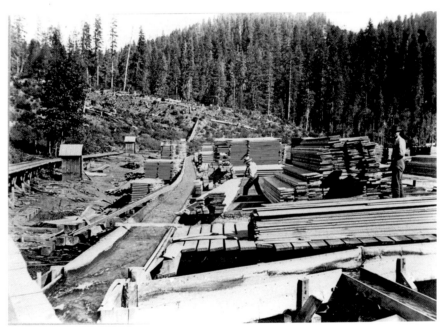

Men with cut wood at a mill near a log flume in the Sierra Nevada. 1895. *California State University, Chico, Meriam Library Special Collections.*

the answer was obvious: build a railroad. And that's just what they did. But unlike other railways in the area, this one would have to navigate extremely steep terrain, more akin to an elevator than a railroad.

The SNW&LC would cut trees around the north shore and use wagons and livestock to bring them to the mill in Incline Village, near Mill Creek (just south of Diamond Peak Ski Resort). From there, the trees were cut into lumber planks and carried up a railroad track in large cargo containers. The steep side-by-side rails carried the lumber up on one side and brought empty cars down on the other. Once at the top, the lumber was sent via log flume down the hill toward Carson City, where it could be loaded onto trains. The rail was nearly 4,000 feet long, and a full cart climbed up the nearly 1,500-foot-tall hillside in about twenty minutes. The workers would try to send empty carts down while a full cart came up to help balance the weight, as pulling the cars taxed the steam engine at the top. Men also had to help haul the carts up, and records show a few incidents where the carts accidentally went screaming back down to the bottom, men occasionally in tow.

The rail operated for about fifteen years until the entire operation was dismantled when the SNW&LC moved its logging efforts north to Hobart Mills. However, the steep railway was the only defining characteristic of the region for some time, giving the town its name: Incline Village.

Nothing remains of the log flume on the other side, but there are a few remains of the water flume system that crossed under the rail (and which gives this trail its name). That flume ran from Incline Lake (west of Mount Rose Highway, beneath Tamarack Peak) across the hillside to the Virginia & Gold Hill Water Company's Marlette Flume System. The two connected near the top of the Tunnel Creek Trail.

There's not much left of the Incline Railway either, save for the occasional piece of timber buried under bushes. But it's quite an experience to stand along where the rail once ran and imagine what it'd be like to be a worker on the rail, riding the log car up while hoping a loose chain didn't send you flying back down.

Hikers on the Incline Flume Trail have a few options. It can be done as a loop from the starting point on Mount Rose Highway or as a point-to-point trail by leaving a car at the base of Diamond Peak Resort. Hikers interested in a longer hike can continue to the Tunnel Creek Trail and eventually end at Tunnel Creek Café or Hidden Beach. Mountain bikers can also explore parts of this trail by taking the Tyrolean Downhill Trail, which starts farther up Mount Rose Highway and crosses the Flume Trail before ending at Diamond Peak Ski Resort.

How to Hike It: The Incline Rail/Incline Flume Trail

Why I Like It: A mellow downhill hike passing an old railway camp and Diamond Peak Resort
Type of Hike: Point-to-point
Total Mileage: 5 miles (8 miles as a loop)
Elevation Gain: 557 (-1,443)
Difficulty: Easier

Getting There: The trailhead is on the right off NV-431 (Mount Rose Highway) in Incline Village, about 0.4 mile past the scenic lookout point. There's parking for about eight cars. Unless you're doing this as a loop, you'll need to leave a second car at Diamond Peak Ski Resort.

Trailhead Address: Incline Flume Trail, New Washoe City, NV 89704

Start: Follow the trail into the woods, on the same side as the parking area. The first section is very gently undulating single-track through the woods.

0.7 mile: Turn left at the split.

1 mile: Reach a trail intersection. This is the very popular Tyrolean Downhill mountain biking trail, so be aware that bikes may be coming down very fast from the left. Continue across the trail, and in about 0.15 miles, you'll come to a medium-sized clearing in the trees. This was the Folsom Camp, where more than four hundred Chinese workers lived while working on the area lumber operations. Not much remains, although it's possible for hikers with a keen eye to find old nails and scrap metal.

1.2 miles: Pass through the clearing, staying on the Incline Flume Trail, rather than heading right toward the Tyrolean Downhill trail. There are a few trails in this area that seasonally change as mountain bikers carve new routes to avoid muddy areas and stream crossings, so just backtrack if you find yourself on a different trail.

3.1 miles: Cross into Diamond Peak Resort, traversing across a few ski runs (including one called "The Great Flume").

3.7 miles: Intersection with the Diamond Peak Snowflake Lodge trail. Going left here will keep you on the flume, eventually connecting to the Tunnel Creek Trail and Hidden Beach. Go right to follow the fire road and reach the base of Diamond Peak Ski Resort.

5 miles: Reach the Diamond Peak Ski Resort parking.

To make this into a full loop, turn right on Ski Way/Tyrol Drive and walk up the road for 0.2 mile. The trail picks up on the right, just after the road begins to turn left. Take this trail for 2.2 miles (all uphill) before making a left when you hit the Flume Trail to return to your car. This section is popular with downhill mountain bikers.

HOBART MILLS

Sure, Truckee may be the primary town north of the lake, but for much of the nineteenth and twentieth centuries, Truckee was just one of many bustling towns in the area. One of those other towns was Hobart Mills, established by the Sierra Nevada Wood & Lumber Company (SNW&LC) as a base camp for the ever-growing timber industry. The company was established in 1878 by Walter Hobart and Sam Marlette, both of whom were also investors in the Virginia and Gold Hill Water Company. Their logging operation was one of the largest around the lake, supplying wood to mining towns, railroad companies and the teams building the extensive flume system.

The nature of logging operations required the company to continuously expand to new terrain, and the SNW&LC bought a huge swath of land around the little Truckee River, just north of Truckee. By the late 1800s, the operation had logged most of the forests near the lake, and Hobart and Marlette began relocating their operation to the new property. They removed the buildings, machines and mills from Incline Village and Crystal Bay and slowly moved them across Brockway Summit toward Truckee, rebuilding at what would become Hobart Mills. Originally named "Overton," the tiny town changed its name to Hobart Mills when the local postmaster objected, claiming there were already too many towns called Overton.

The first task at the townsite was to establish a small railroad to carry felled trees to Truckee so they could be moved on the transcontinental

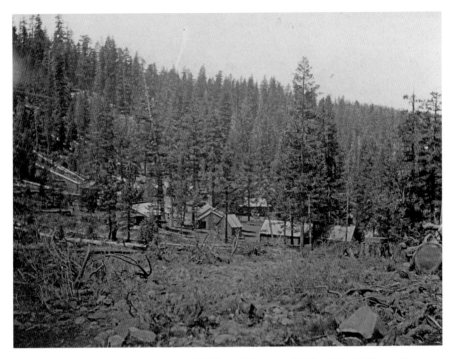

Logging operations in the forest around Hobart Mills, circa 1910. *California History Room, California State Library, Sacramento, California.*

railroad. The SNW&LC finished that small rail in 1896. By the end of 1897, the company was ready to start milling in the new forest—and the newly expanded town was ready to begin welcoming lumberjacks, cooks, workmen, railroad workers and the livestock needed to ensure the site's productivity. The town had anywhere between 1,000 and 1,500 residents at its peak, making it much more populous than Truckee, the tiny town down the road known primarily for uncivilized saloons. Truckee was well known for its friendly "female companions"; Carrie Pryor (also known as the "Spring Chicken") was among the most popular, possibly because she was known to hold her own in bar brawls and shootouts.

Hobart Mills was extremely productive, and it became one of the largest-scale logging towns in the West. The multi-story sawmill became something of a tourist attraction, and since it was connected by railroad, tourists could reach it easily. SNW&LC personnel built a hotel to accommodate tourists coming to see the massive operation before they headed south to one of Tahoe's lakeside resorts. The mill was likely an impressive sight; an article in the *Marysville Evening Democrat* from June 9, 1899, reported that the mill

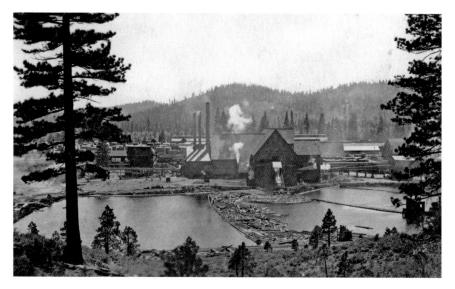

The large mill at Hobart Mills attracted tourists from around California. *California History Room, California State Library, Sacramento, California.*

could cut more than 150,000 feet of lumber per day for a season total of nearly 30 million feet.

Hobart Mills was one of the few towns mostly unaffected by the decline in mining of the late 1800s since the company shipped to so many buyers. It milled wood for shipping, making paper, furniture, flooring, walls for homes and just about anything else. The town flourished into the early 1900s with everything from a well-reputed school to lodging for families to social halls. It was even home to the first hospital in the region, while Truckee's medical care was limited to a local doctor and a few midwives.

The SNW&LC banned all saloons in Hobart Mills, perhaps because of the reputation for violence earned by the nearby town of Boca. Worried that unemployed men would fall victim to vices, the mill demanded long hours of all workmen and discouraged any activities seen as undesirable. Men caught drinking in town would be eventually be fired, which is likely why so many men went down the street to Truckee, where unruly saloons welcomed miners traveling through town on the railroad.

Although it's hard to believe now, as the town has all but disappeared, Hobart Mills was once the epicenter of a large railway system that moved lumber and supplies between the mills, Truckee and various logging and rail camps around the lake. Everywhere from Incline Village to lumber camps north of Hobart Mills were connected by narrow-gauge railroads.

Men outside a cookhouse in Hobart Mills, circa 1910. *California History Room, California State Library, Sacramento, California.*

Their railroad wasn't as permanent as the Central Pacific Railroad—in fact, it was designed to be rerouted in a matter of days to move with the camps—but it was quite a feat, especially considering the steep grades and rocky terrain the lines had to traverse. At the town's peak (in about 1920), anywhere from twenty-five to thirty-five miles of track weaved through forests on the north shore.

Hobart Mills thrived until the mid-1930s, declining in population as Truckee grew. Once most of the timber was logged, the SNW&LC began selling off parts of the town to other logging operations. A *Sacramento Bee* article from September 3, 1938, reported that most of the buildings were sold to a "wrecking company" in Los Angeles. The land was also sold; fortunately, the U.S. Forest Service bought a huge section of the land just north of the lake, about forty thousand acres. (San Francisco playboy and billionaire George Whittell of Thunderbird Lodge bought another twenty thousand acres around Incline Village.)

The town had been entirely removed from the landscape by the mid-1950s, save for historical markers and what amounted to a few refuse piles. Today, there's a historical plaque at the trailhead to the Emigrant Trail, which crosses past the former townsite for the first half mile. The plaque sits near where the schoolhouse would have been. The trail curves past Sagehen Creek, which provided power and water for the town. It's easy to see why the large, mostly flat valleys would have been a convenient place to build the

town. No buildings or foundations remain, but there is an old car abandoned just off the trail, as well as an old rusted tea kettle hanging on a tree. Other than a few piles of tin cans, that's all that remains of the once-booming town of Hobart Mills.

How to Hike It: Hobart Mills (Emigrant Trail)

Why I Like It: An excellent beginner mountain bike route or gentle hike
 through an old townsite
Type of Hike: Out-and-back
Total Mileage: 7.9 miles
Elevation Gain: 850 feet
Difficulty: More Difficult

Getting There: The trailhead is on the right off CA-89 N. Make a right turn
 onto Hobart Mills Road about five minutes north of Truckee immediately
 after you cross a small bridge. Make another right immediately after the
 turn to pull into the parking area. There are no amenities at the trailhead,
 although there's occasionally a portable restroom in the summer.

Trailhead Address: Hobart Mills, CA 96161

Start: Walk to the far end of the parking lot (toward the road) and take the trail
 by the commemorative cement marker.

0.6 mile: Go right when you reach the fire road and then take the immediate
 path to the left (up the hill). It's popular with mountain bikers, so expect
 to share the trail.

1.2 miles: Just before the trail dips down into a valley, there is a clearing to
 the left. This was the easternmost end of the town of Hobart Mills. If you
 walk down one of the dirt roads in this direction, you'll see an abandoned
 vintage car on the right, probably left over from the town's final days.

The trail drops down into a valley with a small bridge crossing before climbing back up through the trees.

1.5 miles: Look for the rusty kettle hanging on a tree on the first switchback.

1.8 miles: Cross Old Reno Road. From here, the trail meanders through the woods, crossing a few small fire roads. Stay on the trail.

3.9 miles: Come to a clearing with a bench—this is the highest point on the trail. This is a good turn-around point, although you can go down the other side. The trail crosses Hobart Mills Road (in 0.8 mile) before eventually leading to Stampede Reservoir (another 3.4 miles past Hobart Mills Road).

Backtrack.

7.9 miles: Return to parking.

THE MALAKOFF DIGGINS TRAILS

Malakoff Diggins is one of the least-known mining sites in California, which is surprising, considering the impact it still has on California's—and the United States'—environmental policies. Malakoff Diggins was one of the largest gold mines in the Sierra, as well as the poster child for the environmental degradation caused by America's endless search for gold.

Hydraulic Mining: An Environmental Disaster

In the 1850s, the California Gold Rush was in full swing, and miners traversed through the most remote places in California looking for gold. And the Yuba River, which runs from the western Sierra foothills to the Sacramento River, had been heavily drained of its gold resources. So when miners searched the remote areas north of the Yuba and returned with gold in their pockets, most prospectors were surprised. But they were even more surprised when they went to where the miners said they'd been (the area that would become Malakoff Diggins) and found nothing. That disappointment led to the town's first name: Humbug. But by 1851, enterprising miners had started searching beds around Humbug Creek, and luck was on their side: they found gold flakes and small nuggets in the water.

By 1852, a small handful of miners were living and working in Humbug, with each miner assigned a small section of the creek to mine using traditional

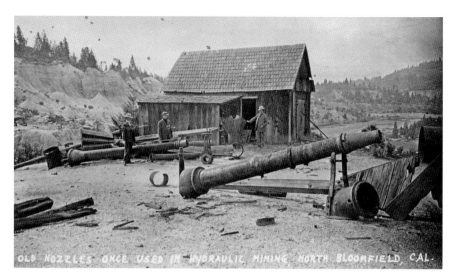

Hydraulic cannons outside the diggins at Malakoff Diggins, circa 1880. *California History Room, California State Library, Sacramento, California.*

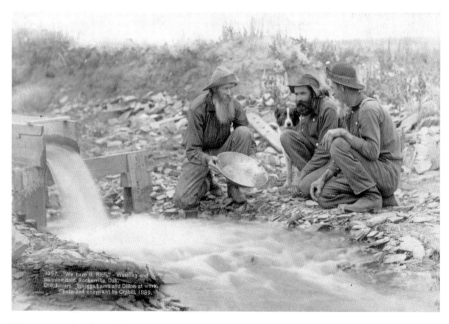

Miners panning for gold with hand tools. 1886. *Library of Congress, LC-DIG-ppmsc-02669.*

methods: with scoops and pans, knee-deep in the river. But they could only sift a small amount of dirt at a time, and the process was inefficient. It didn't take long to create a better system using "sluice boxes," which used water pressure to trap gold at the bottom while all other substances ran through to the other end. It was faster than mining by hand, but the miners knew that they were only scratching the surface.

The miners tried different techniques, and in 1858, they created a new method of removing gold from the hills: hydraulic mining. Using a pressurized hose, miners blasted the hillsides with water. The impact broke the hills apart, sending water, rock, dirt and (ideally) gold, funneling down into a massive sluice box. The new method was wildly successful, and realizing that "Humbug" was no longer a fitting name, the miners changed the town's name to North Bloomfield in 1858.

By then, Malakoff Diggins was the world's largest hydraulic mine. More than one thousand miners and their families from around the world lived in the town, which had several hotels, beer halls, groceries, restaurants, a school, a post office and everything else a wealthy town would have in the mid- to late 1860s.

North Bloomfield in the 1940s. *Library of Congress, HABS CAL, 29-BLOOM.N,1—1.*

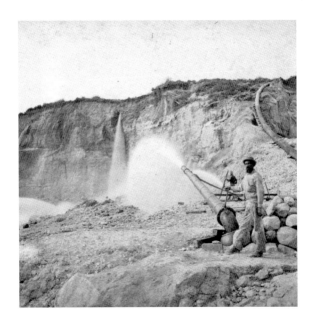

Men used massive, high-pressure cannons to blast away at the landscape, sending rock and gold scattering down. *New York Public Library.*

Interestingly, many miners working in the Diggins (short for "diggings") were French. Estimates are that more than ten thousand French-speaking men were working in the pits by the mid-1850s. For many years, French was a primary language in the mines, which was likely a shock to some American miners. There was also a large contingent of Chinese miners, plus the usual blend of immigrant settlers from Europe and transplants from the East Coast looking to make their fortunes out west.

Hydraulic mining was effective, producing almost $200,000 per year in gold on average, but it also gnawed away at the landscape. Within a few years, the mine site looked like a modern-day quarry, complete with underground tunnels to carry the waste and water away from the pit. The North Bloomfield Mining Company built a system of more than one hundred miles of piping to carry water to the water cannons, and the tunnel to carry debris from the mine into the nearby river was more than six hundred feet long (and cost nearly $500,000 to build). The water that funneled through that tunnel, completed in 1874, is likely what caused the flood in the nearby Marysville Valley a year later. Considering the company was using upward of ten thousand gallons of water per minute of digging, the tunnel dumped far more water than the river through the valley could ever handle. Water flowing over the banks destroyed nearby homes and farmland, redistributing dirt and debris in the process. And since Humbug Creek flowed into the Yuba River, which flowed into the Sacramento River and eventually the

San Francisco Bay, water quality across the entire state declined as growing amounts of sediment entered the waterways.

In the early 1880s, concerned residents throughout Northern California began lobbying for increased mining regulations. And in 1884, the court ruled in Woodruff's favor in *Woodruff v. the North Bloomfield Gravel Mining Company*: mining operations could no longer dump debris in public waterways. It was one of the state's first pieces of environmental legislation (and one of the earliest in the country). The lawsuit was brought by Marysville farmer Edward Woodruff, under the support of the ad hoc Anti-Debris Association. Similar legislation passed on a national level, which became the federal Rivers and Harbors Appropriation Act of 1899.

The Diggins continued to operate until 1910, but the cost of abiding by the new environmental regulations negated the mine's profits. It shut down, and nearly all residents moved out by the following decade. Although the population once peaked around two thousand in the 1870s, there are now only a few longtime residents living in the remaining homes around the park.

North Bloomfield Wasn't the Only Town in the Area

The Bloomfield Gravel Mining Company oversaw a massive operation, operating mines and digs across nearly 1,200 acres. The Malakoff Diggins site alone is more than six hundred feet deep and almost seven thousand feet across at its longest point. And considering how high-tech its mining methods were for the time, it also needed an extensive management and operations center close by. This spurred the growth of the town of Malakoff, just a mile west of North Bloomfield, which became the operation's administrative center in 1866. Before then, it was just a sleepy mining camp with a few modest amenities. Almost certainly due to French miners living nearby, the town was already called "Malakoff," in honor of the Bataille de Malakoff, a French victory against the Russians during the Crimean War. The village went bust soon after the state effectively banned hydraulic mining. Now nothing remains of the town, short of a few flattened clearings where buildings once stood.

The three thousand acres around the Diggins became a state park in 1965. Although nothing remains of the town of Malakoff, there are still a handful of buildings standing in North Bloomfield, one of which is a visitor's center and museum. The remaining structures include a former hotel, a saloon, a barbershop and a general store. There are also large cannons and pieces of

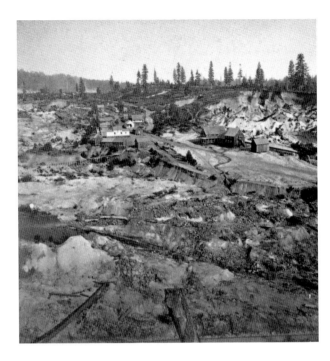

The small, mostly French town of Malakoff turned into the center of operations for the rich gold mine next door. *New York Public Library.*

mining equipment salvaged from the mines. Free self-guided walking tours of the former town are available from the visitor's center. It's still quite easy to see the damage caused by the blasting and the rock walls at the actual site of the Diggins; erosion and runoff are ongoing issues.

Getting There: From Truckee, take I-80 W to Exit 161. Go right on CA-20 W for about 26 miles. Make a right onto CA-49 N and follow it to Foote Road/Tyler Foote Crossing Road. Follow the road until you start seeing signs for Malakoff Diggins State Park. Park entry is five dollars or ten (varies seasonally), paid at the visitor's center. Restrooms are available.

Trailhead Address: 23579 North Bloomfield Road, Nevada City, CA 95959

How to Hike It: The Church Trail at Malakoff Diggins

Why I Like It: An easy walk to historic buildings (or the first half of a mining-themed adventure)
Type of Hike: Out-and-back
Total Mileage: 0.6 mile (+2.7 to add the Diggins Loop)

Elevation Gain: 35 feet (+260 for the Diggins Loop)
Difficulty: Easier

Start: From the main road, walk behind the blacksmith's shop, where you'll see a sign about the town's French history. Look toward the woods, where you'll see a small footbridge. Cross it and follow the wooded trail.

0.2 mile: Reach the North Bloomfield cemetery on the right. It's still in use and has been since 1852. While most people buried here are miners (one of whom was shot for stealing gold from the Diggins), there are some more recent additions.

Keep following the path to pass by the old North Bloomfield schoolhouse (on your right) and the town church (on your left).

0.3 mile: Cross the road and walk to the overlook area. This is the Le Du Mine, which operated from 1857 to 1912.

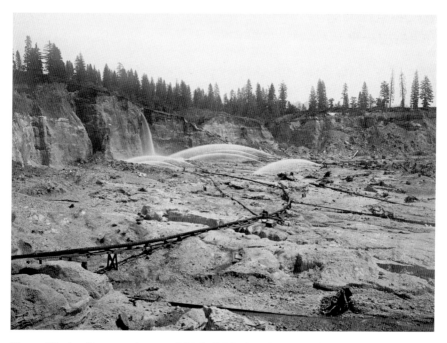

Photo of hydraulic canons in use at Malakoff Diggins, circa 1870. *California History Room, California State Library, Sacramento, California.*

Backtrack; for a longer hike, walk past the cemetery on the opposite side of where you walked in. You'll see a sign pointing you toward the Diggins. This will hit the eastern side of the Diggins Loop Trail. If you connect the two, it's best to hike the Diggins Loop Trail in a counterclockwise direction, looping around the Malakoff Diggins mining site. Stay on the Diggins Loop to eventually return to your starting point near the cemetery. It adds 2.7 miles and 260 feet of elevation. Wear boots or tall socks—while the trail is easy, vegetation can be overgrown on the northern part of the loop.

How to Hike It: Marten Ranch Trail at Malakoff Diggins

Why I Like It: A gentle walk through the woods to a well-preserved ranch home
Type of Hike: Out-and-back
Total Mileage: 1.4 miles
Elevation Gain: 180 feet
Difficulty: Easier

Start: Walk down Relief Hill Road. Take note of the cornerstone on the building at the intersection; it's the old Smith & Knotwell drugstore, built around 1876.

0.2 mile: Take the trail through the woods on the right. This section can get a bit muddy and overgrown.

0.7 mile: Reach the old Marten Ranch home. It's open, but the integrity of the structure isn't guaranteed, so tread carefully. Not much is known about the building other than the fact that there was a sawmill nearby in the 1850s, so it might be a home from a rancher or logger that predates the nearby mining operations.

Backtrack. Turn left when you hit the road again.

1.4 miles: Back in North Bloomfield.

How to Hike It: The Hiller Tunnel Trail at Malakoff Diggins

Why I Like It: An adventurous walk through a pitch-black, rocky mining tunnel
Type of Hike: Out-and-back
Total Mileage: 0.6 mile
Elevation Gain: 60 feet
Difficulty: More Difficult

For a truly unique look at the Malakoff Diggins site, arrive via the Hiller Tunnel Trail, which carried water and debris out of the dig site (and eventually flooded the nearby rivers). An alternate dirt trail is available, but the far more interesting route is to walk through the tunnel.

Start: From North Bloomfield, drive down North Bloomfield/Graniteville Road for 1.3 miles. The small parking area will be on your right. Take the path away from the parking area, and you'll immediately see the tunnel on the right. Because it was built 150 years ago, it's not a smooth drainage tunnel like you'd expect today. The floor is uneven with many rocks and boulders, and while most people won't have to duck, it does require some creative maneuvering to avoid the occasional knee-deep puddle. It's also pitch black, so bring a headlamp, flashlight or at least a cellphone. You might want to bring a pair of shoes to change into afterward. Remember that the water is likely to be highest (potentially up to knee-high) in the late spring. It's not steep, but it is important to watch your steps and use your hands as you move along the rock.

Once you're through the tunnel, you'll have to scramble a few feet up a steep rock pile to reconnect with the trail, which loops back over the tunnel. Follow the path for a few minutes away from the tunnel and you'll arrive at the Diggins. You can walk the Diggins Loop from here, return through the tunnel or take the dirt trail back to the parking area, which is well marked. (The trail through the tunnel is subject to close for restoration in the next few years and may or may not reopen to foot traffic.)

Chapter 5

SOUTH LAKE TAHOE

O f the towns around the lake, South Lake Tahoe is the most populous. Combined with the other towns near South Lake Tahoe like Stateline and Zephyr Cove, the southern part of the lake seems downright cosmopolitan, at least compared to the rest of Tahoe. South Lake Tahoe is where travelers will find nightclubs, chain restaurants, casinos, concerts and everything from magic shows to celebrity poker and golf tournaments. It's often compared to Las Vegas, but on the shore of a stunning lake.

Despite South Lake Tahoe's size, it's the youngest of the lake towns in modern development. However, like the north shore, it was used for thousands of years by Native Americans. The Washoe were the primary summer inhabitants here, using the meadows around the lake as summer homes and fishing and hunting in the nearby forests. The Washoe were mostly forced out of the area when white settlers arrived and appropriated their land, although the tribe is still active in the South Lake Tahoe area.

While the towns north of the lake grew out of necessity to support the logging and mining industries, South Lake Tahoe's earliest landowners developed the area with tourism in mind from the start. The first resorts at the lake (the Tallac Hotel, Emerald Bay Camp and Hotel and Bijou Lodge) were welcoming guests on the south shore by the early 1900s.

By 1910, gambling was illegal throughout the United States. So when Nevada approved gambling again to help rebuild its economy after the Great Depression, the south shore of the lake—split between Nevada and

The Tallac Hotel, late 1890s. *L. Tom Perry Special Collections, Harold B. Lee Library, Brigham Young University, Provo, Utah.*

California—became a popular place for West Coast elites. Wealthy families built homes around the south shore, and casino developers built larger resorts near Stateline, just past the California-Nevada divide. Successful developers like Harvey Gross of the Harvey's Casino chain opened gaming establishments, as did Bill Harrah, of the Harrah's Casino chain.

The middle of the twentieth century brought rumors of mob influence around the south shore. Nugget Casino owner Richard Chartrand was killed in a car bombing, supposedly tied to unpaid mob debts, and Frank Sinatra Jr. was kidnapped from his hotel room at Harrah's Casino. (Frank Sinatra eventually paid the ransom and the perpetrators were caught soon after.) A failed blackmail attempt at Harvey's Casino in 1980 resulted in a massive bomb explosion on the gambling floor, although no one was injured.

However, by the 1990s, South Lake Tahoe was more focused on ski trips, outdoorsy bachelor and bachelorette parties and Tahoe family vacations. The restaurants and hotels on the south shore are more affordable than those on the north shore, and there's a wider variety of activities and amenities for tourists. Gambling is still a huge draw, but so are paddleboat cruises on the lake, mountain biking tours, live outdoor concerts and more than a dozen local breweries and coffee roasters. There's a lot to see and do on the south shore.

LAM WATAH NATURE TRAIL AT RABE MEADOWS

Rabe Meadows is one of the best public-use spaces on the south shore. It leads to Nevada Beach, as well as a sprawling campground and plenty of mixed-use space for biking, running, dog walking or tossing a football in the sun. Although the actual paved trail is relatively new, the meadow was a summer home for the Washoe for thousands of years.

A Washoe Summer Home

The Washoe's ancestors have lived in Tahoe far longer than anyone else, with a history going back at least six thousand years. In fact, the name Tahoe comes from a bastardization of the Washoe phrase *da ow aga*, which means "shore of the lake." As the story goes, when early white settlers first arrived, they misheard the word as "Tahoe." A stretch for sure, but not as much of a stretch when you consider the general lack of respect most pioneers would have had for correctly preserving a native language at all. Different subgroups of early Washoe People lived in various areas around the lake, and historians named most of those groups after those current-day locations (the Martis Complex, King's Beach Complex and so on).

For centuries, this meadow was used by the Washoe, as it was ideal for summer living. It had a small stream that provided plenty of water, and the low-lying valley had plenty of space for multi-generational families to live together. The lake was perfect for fishing (not to mention beautiful). And native plants grew abundantly in the area, watered by the heavy snowmelt in April and May. The Washoe could grow everything from root vegetables to berries to plants useful for making clothing and tools. Of course, hunting was an essential summer activity, and wildlife ranging from bears and coyotes to rabbits and deer provided a wide variety of food. Most Washoe moved east to the warmer and lower-elevation valleys closer to Carson City in the winter.

Lam Watah loosely translates to "grinding rocks by water," and when strolling through the area, you'll see why that's the name the Washoe chose for the meadow.

Unfortunately, the California Gold Rush nearly destroyed the Washoe culture and lifestyle when it brought an unprecedented number of people to the region in a short amount of time. And most of them were singularly focused on stripping the Washoe land of as many of its resources as

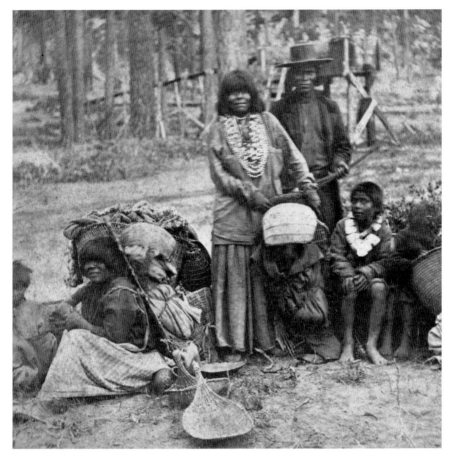

A Washoe chief with his family, 1870. The photo was likely taken near South Lake Tahoe. *Miriam and Ira D. Wallach Division of Art, Prints and Photographs, Photography Collection, New York Public Library.*

possible. Add to that the rapid takeover of the Washoe territory to support the booming logging and tourism industries, and the Washoe's numbers declined at an alarming rate. Even the Washoe who didn't face active conflict with white settlers found their traditional ways of living affected by the developments, which strained their ability to hunt, fish and lead semi-nomadic lifestyles around the lake.

While some Washoe assimilated into a pioneer lifestyle via ranching, trading or guiding, most tribes were completely forced off their land. Currently, there are fewer than two thousand registered members of the Washoe Tribe of Nevada and California. Fortunately, we have records of

the Washoe culture and histories, thanks mostly to the Washoe Tribe's preservation efforts.

Because Lake Tahoe served as the center of the Washoe culture, both metaphorically and literally, it's logical that their origin story also centers on the lake. According to the Washoe Tribe, the early Washoe (called Wašiw) were led to the lake by a coyote. On the shore, they were blessed by the goddess Nentašu, who imparted on them a responsibility to care for the land around the lake. In exchange, the land would stay plentiful and provide all they needed to live year after year.

Logging in Rabe Meadows

By the late 1800s, the Washoe were no longer the primary inhabitants of the meadow. Miners, loggers, ranchers, traders and early tourism pioneers started realizing the lake's economic value—and the monetary value of this clearing near the lake.

With the Comstock Lode discovery in 1859, the need for lumber to support mine tunnels, carry water and fuel the trains that carried ore grew even more extensive, and lumber companies set their sights on old-growth trees in the Lam Watah meadow. In 1859, logger Gilbert Folsom opened a mining camp in the valley that would operate here for nearly a decade before Gilman moved the operation to Incline Village. You can still see the site of the logging camp, although nothing remains of the operation. As with other operations in the area, loggers moved the machines and buildings to new camps rather than leaving them behind. In the one hundred years or so since logging ended, the forest has grown back, and while the clearing is there, it's difficult to tell what trees are new versus old growth.

When the logging operation moved on, most of the land was sold to a ranching family, the Rabes, who owned it until 1970, when the Nature Conservancy nonprofit bought it for $3,650,000. The U.S. Forest Service bought it in 1978, and it's been a public use space since then. (Incline Village's George Whittell purchased the actual beach for $100,000 in 1942.)

The Pony Express Comes through Rabe Meadows

The Lam Watah area is one of a few sites around the lake through which the short-lived Pony Express traveled, coming through the area between

1880 and 1881. Since the meadow was easy to traverse and loggers had already built roads in the area, it was a logical addition to the Pony Express route—especially since the nearby mines' success caused a population boom in the area. Pony Express Riders came through on their way to Friday's Station at present-day Harrah's Casino (where there's a Pony Express memorial statue).

Friday's Station served as a drop-off point where riders from the east would drop their mail and switch horses before returning to their original station. Pony Express riders had to meet stringent requirements to get selected for service, including weighing less than 125 pounds and being willing to ride at least seventy-five miles through potentially dangerous territory, often carrying no more than a sack of mail, a canteen and a revolver. One rider would travel back and forth on the same route constantly, carrying westbound mail until they reached their assigned end station and then returning with eastbound mail. Friday's was one of roughly 190 stations along the 1,900-mile-long route, which ran between Missouri and the San Francisco Bay area. Distances between stations varied based on the difficulty of the route between them; mountainous terrain like the landscape around Tahoe meant that stations needed to be closer together. Riders could cover up to one hundred miles per day, but horses were limited to ten or fifteen while running at full speed, so riders would stop and exchange horses several times during their shift.

The Pony Express operated for only eighteen months, eventually going out of business in 1861 after frequent clashes with Native Americans and high business expenses rendered the operation unprofitable. Of course, the developing railway's ability to carry mail safer and quicker didn't help. While the contract for mail carrying expired, the U.S. Postal Service instead awarded the contract to "Stagecoach King" Ben Holladay, who promised to move mail faster than the ten days it took the Pony Express. Holladay became even more prosperous and eventually bought hundreds of acres around Tahoe and built the first private home at Emerald Bay. He also bought several of the Pony Express's assets, turning many stations into stagecoach hubs. He had sold most of the stagecoach and Pony Express assets to Wells Fargo by 1870, further adding to his net wealth.

Since many of the Pony Express stations were in use only briefly, there are no formal records of precisely what buildings riders may have stopped at on their journeys. But around Tahoe, official stops included Friday's Station, Woodford Station in Markleeville (now the Mad Dog Café) and Yank's Station, in Meyers. Owing to Tahoe's difficult crossings, two routes were

Left: An advertisement for the Pony Express showing rider "Buffalo Bill" Cody. *New York Public Library, Rare Books Collection.*

Below: A wagon outside the Wells, Fargo & Company's Express Office on C Street in Virginia. *Library of Congress, LOC LC-DIG-ds-04481.*

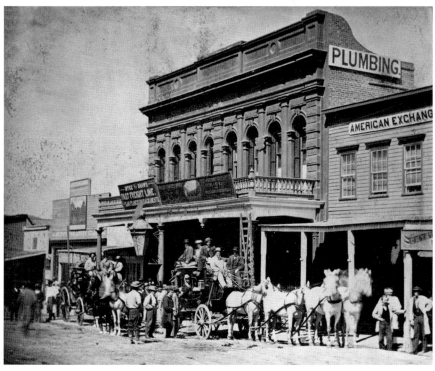

available to riders: a northern route, crossing through Rabe Meadows, and a southern route, which looped south of the lake and eventually connected with the westward trail near modern-day Kirkwood Mountain Resort.

A Prime Location for Early Tourism

Although the Pony Express only came through the meadow for a short while, riders' routes continued to be the primary roads for east–west travel. Given the steady stream of gold and silver flowing from Nevada, the "Bonanza Road" (also called the Lake Tahoe Wagon Road) between Virginia City and Placerville became a well-trafficked route. From Friday's Station, the road passed through Rabe Meadows and south of Spooner Summit before arriving in Carson City. Current-day U.S. Route 50 follows much of this same path. It was one of the most wagon-friendly routes to Tahoe when it opened.

As such, many ranchers came through the area (including the Rabe family). It brought more people to Tahoe, as did the newly opened railroad station in Truckee and various steamships. By taking the rail and then a ship, travelers could arrive in South Lake Tahoe from Sacramento in less than a day. By the early 1910s, the word was out that Tahoe was prime not just for resources but also for tourism and nature-based recreation like hunting, fishing and boating. Combine that with the economic boom in San Francisco, and it's no surprise that wealthy Bay Area families were clamoring for an easier way to reach Tahoe by the 1940s—Highway 40 over Donner Summit was still too slow for most travelers coming for just a few days.

So, in the late 1940s, the Sky Harbor Airport and Casino opened. It was on a small piece of land in Rabe Meadows and offered a much quicker way for travelers from San Francisco to fly directly to South Lake Tahoe's casinos and resorts. There's an informational sign about halfway down the Lam Watah Nature Trail, making it easy to see the same beautiful views guests would have had as they landed on Tahoe's grassy shore.

Unfortunately, the new airport was extremely unsafe, owing to a variety of factors. The makeshift runway was loose dirt and was far too steep for both takeoffs and landings, and strong gusts around the mountains meant that updrafts and downdrafts were common. Deadly accidents weren't uncommon during the airport's five-year run. It closed in 1950 and was eventually replaced by the current South Lake Tahoe airport in 1958. However, the land's proximity to the casinos made it quite valuable, and

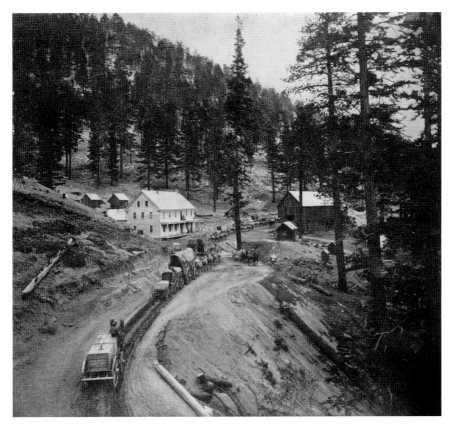

Eastern Sierra passing, probably the "Bonanza Road." 1866. *Library of Congress, LOC LC-USZ62-11012.*

developers made plans to build more casinos in the area. Fortunately, the Nature Conservancy bought the land first.

The Lam Watah Nature Trail has informative signs about Washoe life on the path down to the water, but additional paths wind throughout the entire meadow. Signage about the ancient geological history of Tahoe lines the trails on the northern side of the meadow, making Rabe Meadows an excellent spot for history buffs to spend a morning.

How to Hike It: Lam Watah Nature Trail at Rabe Meadows

Why I Like It: A great spot for a jog, a picture-perfect snowshoe through the woods or a morning stroll with a cup of local coffee

Type of Hike: Loop
Total Mileage: 2 miles +
Elevation Gain: 120 feet (to Nevada Beach)
Difficulty: Easier

Getting There: From South Lake Tahoe, take US-50 E/Lake Tahoe Boulevard for about 3 miles. Turn left on Kahle Drive; parking is immediately on the right. There are restroom facilities but no running water (although the campground at the beach has potable water).

Trailhead Address: 193 Kahle Drive, Stateline, NV 89449

Start: The trail begins near the informational sign, across from the restrooms. The first section of the trail is a great place to see early-season wildflowers since the snow melts fairly quickly here, even in winter.

0.2 mile: Stay left just past the pond.

0.4 mile: Go left (straight) at the split. Go left (more or less straight) again at the next two trail intersections.

0.9 mile: Go left to reach the dog-friendly section of the beach or straight to hit the Nevada Beach facilities.

From the beach, you have several options for how to return to your car. To explore the northern part of the meadow, return to the split just before the beach. Rather than going back on the Lam Watah Trail, make a left and follow the main path as it loops in a clockwise direction back through the meadow. This route goes deeper into the trees, passing by several large boulder fields. Keep an eye out for rounded indentations on the top of the medium-sized boulders. Those are indications that the boulders were used as grindstones for cooking and sharpening tools. The areas where you see grindstones were probably once used as cooking and communal spaces by the Washoe.

On your way out of the valley, look to the northeast (on the other side of US-50 E). You'll have great views of Cave Rock, another easy hike in a location important to the Washoe.

CAVE ROCK

Cave Rock's history is closely tied to the Washoe Tribe, who have valued it as a sacred site for thousands of years. But the history of Cave Rock goes back much farther than that. In fact, it predates humans entirely.

To learn Cave Rock's history, you have to step back in time just a bit farther than 1831, when the first tunnel through the rock opened—back between 2.6 million and 11,700 years ago, in fact, to the Pleistocene era. The period is noteworthy for the mammoths, mastodons and other megafauna that roamed the planet. But it's also when the most recent ice ages occurred, and most of the earth—even some now-tropical zones—was covered in glaciers and permafrost. But for Lake Tahoe, there were other more notable features dominating the landscape: volcanos. The peaks around Tahoe were the southernmost part of the Cascade Volcanic Range. Lassen Peak, now part of Lassen Volcanic National Park, is the current southernmost volcano on the range, having most recently erupted in 1917. But during the Pleistocene era, most of Tahoe was active.

While researchers don't know exactly how many eruptions occurred, they do know that the volcanic lava flow—which may have been via a slow, ongoing eruption or something more dramatic—seeped into the lake significantly enough to change its geography. In 2018, researchers from the California Volcano Observatory studied the rock around the lake and determined that lava flows had raised the lake's level on multiple occasions. When lava flowed into the water, it created dams that moved the water line higher. The damming would have happened at the mouth of the Truckee River, Lake Tahoe's only outlet.

Researchers estimated that the first major damming happened between 2.3 and 2.1 million years ago. Those eruptions caused the lake level to rise, sending it farther inland than it is today. On the north shore, the lake level was likely around the 6,720-foot elevation mark, but near Eagle Rock (on the southwestern shore), evidence of the water line is around 6,480 feet above sea level. (Tahoe's current lake level is around 6,200.) Of course, the lake was level during these high-water periods, but the land around the lake likely shifted in the last several million years, making it seem as though the water line was higher on one side of the lake than the other.

However, a second set of eruptions just under 1 million years ago drove the lake level even higher, covering nearly all of the land in the basin. The lake level from this second damming rose to around 6,850 feet, which would have come close to the top of current-day Brockway Summit between Kings

A man sits atop Cave Rock in 1886. This same point is still accessible today on the Cave Rock trail. *Library of Congress, LOC LC-USZ62-22271.*

Beach and Truckee. You can still see volcanic rock and deposits at areas around Tahoe City's Commons and Skylandia Beaches.

It was during this period that Cave Rock formed. At an elevation of 6,360 feet above sea level, Cave Rock was a volcanic vent (a place from which lava seeps out without necessarily erupting) millions of years ago, possibly contributing to the damming of the lake. This means that Cave Rock was partially or entirely underwater for much of the Pleistocene era, forming the caves that give the rock its name. Cave Rock isn't named for the highway tunnel running through the landmark, but rather for the small caves formed by waves and water that exist high up on the rock's lake-facing side—they're inaccessible today.

Not surprisingly, as Cave Rock dominates the landscape around the area where the Washoe spent their summers, it held special significance. It was a

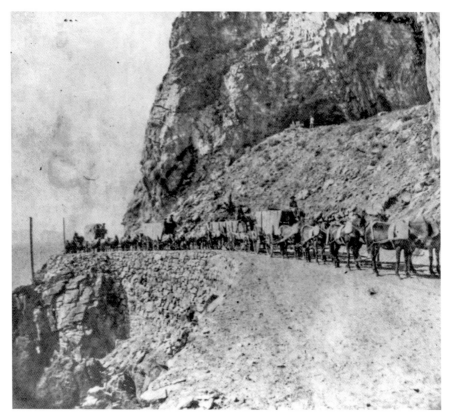

An early wagon road ran around the lake side of Cave Rock prior to building the tunnel. *Library of Congress, LOC Lot 3544-57.*

sacred site and one that the average person couldn't visit—access was limited to spiritual leaders, and women weren't even supposed to look at it (although one wonders how they were supposed to avoid it). When the Washoe were in the valley, they accessed Cave Rock via a small trail that ran behind the rock; the modern-day trail probably follows that route.

Unfortunately, settlers and gold rushers arriving in the Tahoe Basin in the mid-1800s generally paid no respect to the Washoe or their beliefs and traditions. And as it was across the country, when Native Americans tried to use the new American (white) court system to claim ownership and agency, the courts treated them with extreme prejudice, often legislating away their fundamental rights. This was the case with the Washoe, who tried to make legal claims to protect Cave Rock as a sacred site with various lawsuits and court requests. Unsurprisingly, all were denied (as were nearly all claims to protect the Washoe land).

As the rock is directly on the lake, it was an impetus to travel along the east shore. Emigrants and loggers built a wagon route on the lake side of the rock (later used by the Pony Express), but it was dangerous, given the lack of guard rails, frequent avalanches and lack of lighting on the narrow road. By the 1920s, when South Lake Tahoe's tourism industry was booming in earnest, the Nevada Department of Transportation had decided that it to construct a road through the rock. In 1931, it blasted through the rock to create a one-lane road, much to the Washoe's dismay. It was built at the cost of $65,000 and was blasted again in 1957 to allow for traffic in both directions.

In the 1990s, Cave Rock was the center of controversy between the Washoe and tourists when sport rock climbing became popular on the face. Climbers installed permanent metal bolts, marked routes with spray paint and stepped inside the secluded caves. As the Washoe believed that non-spiritual people shouldn't even touch the rock, let alone tar it, it was an offense to alter it to accommodate climbing. In 1997, the Washoe appealed to have climbing banned at Cave Rock, which the U.S. Forest Service approved in 2003. In addition to religious concerns, the Washoe claimed that climbing led to increased trash around the rock, disfiguring the natural site. From 2005 to 2007, a group of outdoor organizations attempted to challenge the ban, but the courts upheld it, and climbing has been banned on Cave Rock since 2008.

Washoe Stories

In Washoe culture, Cave Rock was called *De'ek Wadapush* and was a source of spiritual and sacred knowledge. Touching the rock was a way to absorb that knowledge, which is why only medicine men and healers from the tribes were allowed to approach it. But the rock also plays a large role in several spiritual Washoe stories. One legend says that a mythical bird called an Ang (or Ong) lived in the Caves above *De'ek Wadapush* and would swoop down out of the cave to grab victims from around the lake.

Another says that the rock's underwater caves were home to "water babies," spirits that could be malevolent or helpful but which required a great deal of spiritual energy to understand—another reason why only sacred healers could go near the rock. Other tribes have tales of similar creatures in the water, but for the Washoe, the water babies lived in this

specific location. In some retellings, they could travel through tunnels under the water to reach other lakes and water bodies in Washoe territory. There are kindred tales from the Paiute Tribe, who believed that similar creatures live in Nevada's Pyramid Lake and are responsible for accidents and mysterious disappearances on the lake.

Today, Cave Rock is accessible via a trail behind the rock. The path around the lake was closed in the 1960s and was eventually torn down and replaced with a boat ramp. Most of the caves look west and northwest, so they're best viewed from the water, but the views from the top are still incredible. It's important everywhere in Tahoe to respect the land, but it's more important than ever when hiking here, as it's still considered a sacred area to the Washoe.

How to Hike It: Cave Rock

Why I Like It: Sweeping views of the lake for next to no effort
Type of Hike: Out-and-back
Total Mileage: 0.8 mile
Elevation Gain: 220 feet
Difficulty: Easier (with an optional rock scramble)

Getting There: From South Lake Tahoe, take US-50 E/Lake Tahoe Boulevard toward the west shore for about 9 miles. Turn right onto Cave Rock Drive. The trailhead is a few hundred yards up on the left. No facilities are available. There is a very small parking area at the trailhead, but most cars park on the sides of the road nearby, where a few parking spaces have been marked. Parking does get tight here, but since the trail is quite short, turnover is fairly quick.

Trailhead Address: 669 Cave Rock Drive, Glenbrook, NV 89413

Start: Take the sandy trail from the parking area. The path is well marked and mostly sand and gravel, making it easy to follow.

0.3 mile: The trail branches off to the left, toward the top of the rock. Hikers can either stop here (for a gain of only about 60 feet) or scramble up to the summit of Cave Rock. If you head to the summit, expect a short but steep scramble up medium-sized boulders; smaller dogs and children may have trouble.

From here, you have one of the best views of the lake. From the top, you'll have Monument Peak (home of Heavenly Mountain Resort) to your immediate left; views of Dick's Peak, Maggie's Peak, Mount Tallac and Desolation Wilderness directly across the lake; and the summits of Squaw Valley and the Truckee area across the lake to the right.

Backtrack.

0.8 mile: Back at trailhead.

Trails at D.L. Bliss State Park

D.L. Bliss State Park is one of the most beautiful parks in Tahoe, although it does get extremely busy. Plan to arrive early to get a parking space on weekends. If you get there midmorning or later, you'll probably have to park at the road level and take the mile-long hike down to the shore, which means a mile-long hike back up when you're ready to leave.

Duane Leroy Bliss, the "Father" of Early Tahoe

D.L. Bliss State Park sits in a premium position on Tahoe's west shore, just above Emerald Bay. And the park's longest trail—the Rubicon Trail—crosses in and around Emerald Bay, going past one of the lake's most stunning shorelines: Emerald Bay State Park. But as beautiful as the beaches and campsites are now, they weren't always available to the public: the spectacular views were reserved for lumberman and banker Duane Leroy Bliss. Bliss was truly one of California's first magnates. At the peak of his career, he controlled not just the region's largest logging operation but nearly all the rail transportation in the area, including several rail lines built by his company.

Like many others who succeeded in the gold rush, Bliss was originally from a well-off East Coast family, born in the Berkshires of Massachusetts. He was educated at private schools and traveled to San Francisco in 1850 while still in his late teens. Rather than opting for a college education, he spent time mining and prospecting around California; however, he failed to find much during his years around the mines. In 1860, he moved to Gold Hill (south of current-day Virginia City). He was hired soon after by a Virginia City

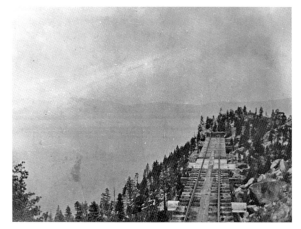

Left: At the peak of logging, dozens of rails covered Tahoe's highest peaks, like this one near Spooner Summit. *Nevada State Railroad Museum.*

Below: The Tahoe Tavern was one of the most luxurious early resorts in Lake Tahoe. *Library of Congress, LOC C-DIG-stereo-1s10308.*

engineer who devised a more efficient mining method that didn't require a handpick, and Bliss began working full time in the nearby quartz mines. This new larger-scale mining strategy—and the realization of just how rich the Comstock Lode was—led to a mining boom. Virginia City's and Gold Hill's populations exploded just a year or so after Bliss's arrival.

In the early 1860s, Bliss cofounded a bank in Virginia City, and although he didn't stay with the company long, it allowed him to meet the most influential businessmen in the region, one of whom hired Bliss to oversee the construction of the Virginia and Truckee (V&T) Railroad. The rail ran between Virginia City and Carson City, carrying gold and silver away from the mines and lumber, supplies and men to Virginia City. Understanding the potential profitability of the operations, Bliss and two other associates formed the Carson and Tahoe Lumber and Fluming Company in 1870. With this, Bliss became a controlling influence in both the rail and logging industries. When his operation became the largest logging operation at the lake, Bliss became exceedingly wealthy.

Bliss stayed in the area and began to diversify his investments around the same time that the mines in the area started to dry up. Knowledgeable about the railroad industry by this time, Bliss applied his business acumen to tourism, again building a vertically integrated industry. He began acquiring land around the lake, opening the Tahoe Tavern (just south of Tahoe City) in 1902 and another resort just a few miles east in Glenbrook in 1906. He also built a private railroad to carry passengers arriving on the transcontinental railroad from Truckee to Tahoe City (the Lake Tahoe Railroad), as well as several steamships to carry passengers around the lake, departing from his resort in Tahoe City.

The luxury resorts added to the Bliss family's wealth, and D.L. Bliss began planning to open a second resort in what is now D.L. Bliss State Park. However, Bliss died in 1907, just after the Glenbrook Inn opened. His remaining family donated much of the park's current acreage to the state in 1929.

The park's Calawee Cove is likely one reason Bliss envisioned a luxurious resort in this location. The horseshoe-shaped beach is accessible only by boat or, now, through the park's steep northernmost trail. Sadly for Bliss, his dream never came to fruition. The park has no overnight lodging (although it does have several campgrounds), and amenities are limited to restrooms and a small park visitor's center.

Bliss is often considered the father of modern-day Lake Tahoe, partially because of his vision for Tahoe as a tourist destination. Because he

D.L. Bliss's Lake Tahoe Railroad followed the same path as the Squaw Valley to Tahoe City bike path does today. 1903. *California History Room, California State Library, Sacramento, California.*

understood the economic value of the area's natural beauty, he set strict standards to ensure against overlogging in the basin. Logged trees had to be at least fifteen inches or wider at the base; smaller trees were spared from the mills.

The Bliss family continued to run the family's tourism operations around the lake, although by the 1960s, they had sold off significant chunks of shoreline. They sold much of the land on the northeastern side of the lake to George Whittell, an eccentric millionaire who bought as much of the east shore as possible to keep trespassers away from his high-end lakefront mansion.

However, tourism and the demand for land in Tahoe is also what forced the Washoe off their land, and Bliss was a driving force behind Tahoe's early tourism. Much of the land Bliss bought was traditional Washoe hunting and living ground, and building roads, resorts and railways took that land from them. That, combined with both unfavorable court rulings and legislation regarding land on the east and south shores, played a major role in the decline of the Washoe People and their traditions. However, more concerted

efforts are today being made to reinstate land rights for the Washoe. The current-day tribe runs Meek's Bay Resort, just a few minutes north of D.L. Bliss State Park.

Tahoe Tavern burned down in 1964 and was never rebuilt, potentially because the draw of Truckee and the 1960 Winter Olympics meant the traveler focus was on skiing, condos and modernity rather than the grandiosity of yesteryear. The remains from the fire were razed and the pier torn out to make room for the Tavern Shores Condos, which sit in the same spot the Tavern did, on Tahoe Tavern Road.

The main trails of historical value in the park are the Rubicon Trail and the Lighthouse Trail, both covered in detail on the following pages. However, the park also offers shorter and easier hikes, including the half-mile Balancing Rock Nature Trail, which leads to a precariously perched 130-ton stone, and various ranger-led family and nature hikes during the tourist season.

Getting There: From Tahoe City, head south on CA-89 S/W Lake Boulevard for 16 miles. Turn left into D.L. Bliss State Park. Parking is ten dollars, and restrooms and basic amenities are available.

Trailhead Address: 9881 CA-89, South Lake Tahoe, CA 96150

THE LIGHTHOUSE TRAIL

You wouldn't think Lake Tahoe would necessarily need a lighthouse—let alone four—but more than one hundred years later, there it is.

In the early 1910s, Lake Tahoe looked a lot different. Rather than having parcels of land divided up into thousands of multimillion-dollar homes, resorts and second-home neighborhoods, the land around the lake was owned by just a handful of people, many of whom owned huge parcels. Cars were brand new to the United States at this point, and it was difficult for the few families who owned them to navigate the rough, unmarked wagon roads around the lake. That made travel by boat the most effective option for moving around the shoreline. Unfortunately, unless there was a full moon, it wasn't easy to make out the points, bays and rocky areas that define Tahoe's shoreline.

So, in about 1910, the Lake Tahoe Protective Association addressed this issue. The organization was formed in 1912 to oppose a proposition from

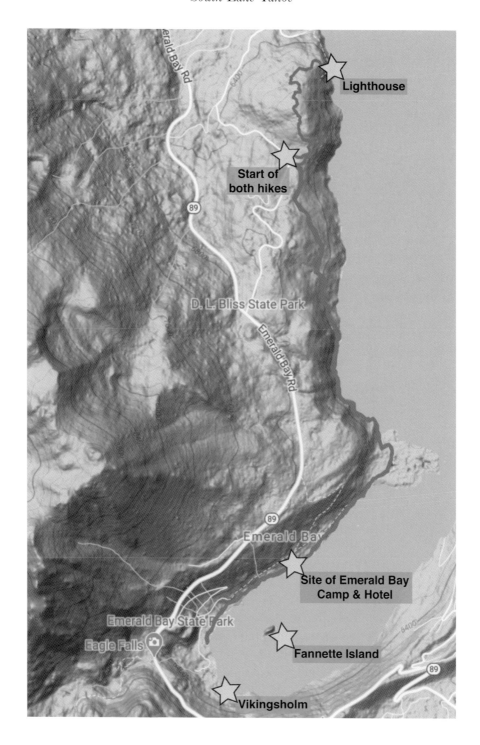

the Truckee River General Electric Company (which became the Sierra Pacific Power Company; now N.V. Energy) and the U.S. Reclamation Service (now the U.S. Bureau of Reclamation, part of the Department of the Interior) to build a dam near the outlet of the Truckee River. They planned to build the dam low enough to drain water from Tahoe even when it was below the low water line, which would have caused the water level in the lake to dip far below its natural levels. In this regard, the LTPA can be considered one of Northern California's earliest conservation organizations. Of course, the electric company eventually did build the dam in Tahoe City, but there are stringent laws and regulations to ensure that the lake stays at a healthy water level.

It was just after this, in 1913, that the LTPA requested that the U.S. Bureau of Lighthouses (1910–38; later merged with the U.S. Coast Guard) build a series of lighthouses around the lake to improve boating safety and mark potentially dangerous section of shoreline. The D.L. Bliss Lighthouse, along with three others, was completed in 1913. Construction costs totaled $900—more than $22,000 by today's inflation rates and quite the sum considering the lighthouse is essentially a three-foot-square wooden shack. Its location on an exposed rock face in what is now D.L. Bliss State Park made it a prime location for a lighthouse but also increased construction costs, as it was difficult to access the site on foot and the rocky shoreline made it dangerous to get too close by boat. On clear nights, the lighthouse's light could be seen from seven miles away, making the site visible from South Lake Tahoe (home of many of Tahoe's earliest tourist camps) and Zephyr Cove, across the lake on the Nevada side. At the time, the SS *Tahoe* made daily trips to shuttle tourists between Tahoe City on the north shore and Emerald Bay on the south shore. The series of lighthouses helped the ship travel safely along the west shore.

The lighthouse was officially decommissioned in 1921, although some reports suggest that its regular use had stopped by 1919. Delivering fuel to the lighthouse was challenging, requiring barrels to be shipped to Emerald Bay, loaded onto a boat to arrive at the beach near the lighthouse and then towed with donkeys on a wagon up the steep face to the lighthouse. Local interest groups determined that a new lighthouse at Sugar Pine Point (now Sugar Pine State Park) would be a feasible project, and the Bureau of Lighthouses soon turned off the light at D.L. Bliss.

As the lighthouse sat abandoned for nearly ninety years, it was subject to both vandalism and the impact of the Sierra Nevada's harsh elements. It had nearly collapsed by the early 2000s, at which point the Tahoe

Heritage Foundation and various parks foundations undertook a restoration effort to rebuild and protect the structure. Restoration efforts are ongoing. While hikers can now get very close to the lighthouse building, entry isn't permitted, and cement supports behind the lighthouse ensure its stability against rockslides and erosion.

The lighthouse was and continues to be the highest-elevation lighthouse in North America. Perhaps fittingly, William Bliss, son of D.L. and Elizabeth Bliss, was a key player in the Lake Tahoe Protective Association and part owner of both the Tahoe City railway and the SS *Tahoe*, which carried guests south. The Bliss family's efforts to protect Lake Tahoe, including their donation of more than seven hundred acres to California State Parks in 1929, ensured that conservation became a priority before the tourism rush of the 1940s and 1950s. Having that conservation plan in place is a key reason why the lake and surrounding peaks are healthy and thriving today, and for that, the LTPA deserves great thanks.

How to Hike It: The Lighthouse Trail

Why I Like It: A beautiful hike to a well-preserved historical site with stunning views
Type of Hike: Loop
Total Mileage: 1.6 miles
Elevation Gain: 380 feet
Difficulty: Easier

There are a few different ways to do this hike. The description here is the quickest method, but you can also do it as part of the northern end of the Rubicon Trail.

Start: Start at the Lighthouse Trail trailhead, off Lester Beach Road. The trail starts flat but quickly begins to gain elevation just past the sign about the history of the lake.

0.9 mile: Intersect with an alternate route to the lighthouse. Take a left and then an immediate right down the stone stairs, which are steep but short. There's not much space around the lighthouse, so you may have to wait at the top on a busy day.

Head back up the steps. Here, you have some options. With the lighthouse behind you, if you go left and then straight (right) at the intersection, you'll hit the Rubicon Trail, returning to your starting point 0.7 mile later, for a total hike elevation gain of 380 feet.

If you go right at the top of the stairs, you can add in the 0.9-mile Lighthouse Trail Loop, which adds 410 feet of elevation gain. If you take that route, make a left when you reconnect with the Rubicon Trail to return to the Lighthouse Trail Trailhead. You can access both Calawee Cove Beach and Lester Beach from the northernmost point of the loop.

The Rubicon Trail to Emerald Bay

A Wealthy Widow Builds a Summer Home

As if the views along the hike weren't good enough, the Rubicon Trail passes by two Tahoe historic sites: Vikingsholm Castle and the former Emerald Bay Camp and Hotel. And on Fannette Island—the only island in Lake Tahoe— you'll also see the remains of the former teahouse owned by Lora Josephine Knight, who directed the construction of Vikingsholm in 1929.

On the northern side of Emerald Bay, about a half mile before Vikingsholm, sit the remains of Emerald Bay Camp and Hotel. Just past the remains is the boundary of one of California's best parks: Emerald Bay State Park. The shining gem of this park—aside from objectively gorgeous Emerald Bay itself, of course—is Vikingsholm Castle, built under the direction of Lora Josephine Knight. The home's moniker couldn't be more fitting, as Vikingsholm (which translates to "Viking Island") looks like an eleventh-century Norwegian palace. Knight, a socialite with a home in Santa Barbara and a horse farm in Wisconsin, bought roughly 240 acres in South Lake Tahoe from the Armstrong family, with whom she ran in the same social circles. Knight had her sights set on building her dream home in Tahoe, paying the exorbitant sum of $250,000 for the land—the equivalent of nearly $4 million in 2020.

However, Knight was not the first person to covet the stunning views and dream of setting up a luxurious homestead. The first recorded owner of the land (likely taken, rather than purchased) was "Stagecoach King" Ben Holladay, in the mid-1860s. Holladay got rich after purchasing the Pony

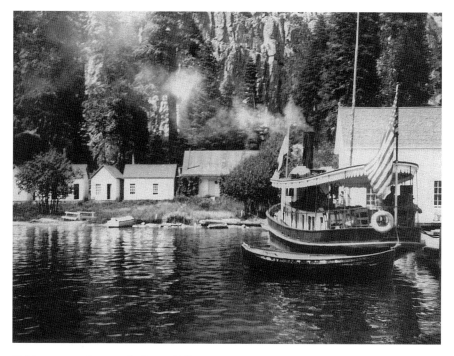

Cabins at an early resort in Emerald Bay.

Express's remaining assets, converting them into a reliable wagon trail (known as the Overland Trail) and then selling those assets to Wells Fargo just before the railroad rendered mail delivery by wagon obsolete.

Holladay became one of America's wealthiest men while his Overland Trail was the primary east–west wagon trail to California, especially as he had the U.S. government contract to carry mail. In the late 1800s, Holladay moved north and sold a portion of the land by Emerald Bay to Dr. Paul Kirby and his wife, Lucy, who opened the Emerald Bay Camp and Hotel in 1884. Kirby then sold a portion of that land to William Henry Armstrong, who used the cabins at the resort as his summer home until 1928, when Knight extended her generous offer. Knight, by then an extremely wealthy widow twice over, spent the following years traveling to study the art and homes in the Scandinavian countries. Eventually, she hired her nephew (and architect) Lennart Palme to design a home inspired by Swedish lakefront fjords on her very own piece of Tahoe lakefront. Although Knight already paid $250,000 for the land, constructing the home cost another $150,000 (around $2.2 million in 2020s dollars). According to Christie's Real Estate Listings for 2018, the average price of a lakefront home on a small lot was

Above: Emerald Bay Camp newspaper ad from the June 11, 1925 edition of the *Oakland Tribune*.

Right: "Stagecoach King" Ben Holladay was one of the wealthiest men in the West after he acquired the assets of the Pony Express. *Beaverton Oregon Historical Photo Gallery.*

$8.2 million, making Emerald Bay quite a steal for Knight, despite the absurdity of the sum in the 1920s.

Vikingsholm was Knight's summer home until she died in 1945, after which it passed through several owners before being sold at a discount to California State Parks. The home is currently open for tours (summer only), and very little has changed since 1929. The Scandinavian influences are apparent, with exterior details like carved wooden lintels, a wood-shingle roof and stone across the façade. Inside, you'll find everything from carved wooden dragons to floor-to-ceiling fireplaces and hand-painted wainscoting and furniture. As for the resorts around the bay, the largest one—Emerald Bay Resort and Camp—continued to operate after the state acquired the land, although it closed soon after it started building the park in 1954. Nearly all of the assets were destroyed, and today, all you can see are a few pieces of the old pier and the foundations of a few of the main buildings (near the current Emerald Bay Boat Camp).

Hermit Isle and the Ghost of Captain Dick

As impressive as it would be on its own, Vikingsholm isn't the only structure Knight commissioned still standing. On Emerald Bay's Fannette Island— the only island in Lake Tahoe—sits the remains of Knight's teahouse, built around the same time as the home. When Knight had guests, she would

have them rowed out to the teahouse to enjoy an afternoon on the island. Now, the teahouse is mostly just a shell—the roof is caved in—and heavy boat traffic prevents visitors from swimming to the island.

Interestingly, Knight wasn't the first person to build on Fannette Island, although the previous building had a very different purpose. The honor of being the first developer of Fannette Island (although indigenous Americans may have used it) goes to Captain Richard "Dick," Barter, hired by Ben Holladay to be the year-round caretaker at Holladay's Emerald Bay summer home. Barter lived on the island, moving in and out of Emerald Bay solely by boat.

As a retired British naval captain, he was accustomed to life on the water. He left the property rarely and only for one reason: to paddle to the nearest saloon, which happened to be roughly sixteen miles north in Tahoe City. The voyage across the lake wasn't easy, especially when winter storms were rolling in, and Barter ended up losing several toes to frostbite after capsizing in 1870. After he recovered, knowing the dangers of his lifestyle, he began a rather macabre project: building a crypt on Fannette Island, complete with a coffin and cross, to use as his final resting place. This gave the island one of its first nicknames: Hermit Isle. Unfortunately, luck wasn't on Barter's side, and he was presumed drowned after a second capsizing just a few years later. Legends of the "ghost of Captain Dick" continued to swirl around Emerald Bay for decades. A July 21, 1957 issue of the *Oaklands Tribune* included a quote from a San Francisco author telling of the ghostly rumors:

> *The antics of this eccentric, salty character had cast their shadow across the natural magnificence of Emerald Bay. A legend still persists than on chilly autumn evenings, when a gray mist lies across the island, the ghost of Captain Richard Barter may vaguely be seen climbing slowly to the top of the rock in the hope that he will be able to pry open his sepulcher and find rest in his granite tomb.*

Where did the Fannette Island name come from? No one knows exactly, but a good guess is that it's a misspelling of the word *coquette*, a nickname given to the island for being beautiful but stony—much like a "coquette" of the mid-1800s. It's also been called Emerald Isle, for obvious reasons.

If you're keen to learn more about the Rubicon Trail, be aware that there are *two* Rubicon trails in the vicinity: this one and a second twenty-two-mile trail running from Georgetown to Tahoma, on Tahoe's west shore. The latter is primarily used for off-road driving, and the two are not related or connected.

How to Hike It: The Rubicon Trail to Emerald Bay

Why I Like It: One of the most beautiful trails in the country with a healthy
 dose of history mixed in
Type of Hike: Out-and-back
Total Mileage: 7.2 miles +
Elevation Gain: 700 feet
Difficulty: More Difficult

Start: Start at the Lighthouse Trail Head. Go right immediately after the
 start. The trail is single-track, mostly dirt, mostly shady and flat.

0.6 mile: Cross a small bridge; there are excellent views begin on the left,
 although the cliffs to the right are equally impressive.

0.8 mile: Reach a good lookout point on a wooden deck.

1 mile: After this point, you'll have a few steep switchbacks and narrow
 sections of trail with steep drop-offs on both sides.

1.5 miles: Small stream/runoff crossing (you can usually step across rocks).

1.8 miles: Reach a really nice cove area. It's accessible only by boat or trail,
 so it's rarely crowded. This is a great place for a snack break (or a swim,
 if it's warm). The trail turns inland immediately after passing the cove.

2 miles: First views of Emerald Bay. There are several ladders/bridges over
 the next half mile leading down to the water on the left.

2.7 miles: Reach the Emerald Bay Boat Camp. Just before the boat camp,
 there are two cement foundations on the right that were part of the early
 Emerald Bay Resort and Camp. Stay left at the various trail splits to hug
 the shore and stay on the Rubicon Trail.

3.6 miles: Reach Emerald Bay Beach. Restrooms are to the right and straight
 ahead is Vikingsholm, as well as a small gift and snack shop (summer only).

From here, you can backtrack for a total distance of 7 miles and a gain of
around 1,000 feet or hike a farther 2 miles to take the Rubicon Trail to Eagle
Point Campground (+800 feet) and turn around there.

Chapter 6
TAHOE'S EARLY TOURISM

Tahoe's main tourist draw has been outdoor recreation for nearly as long as white settlers have been in the area—although, in fairness, the Donner Party tragedy may not have helped bring people to Truckee in the 1840s.

While many of Tahoe's earliest developers got rich from mining and logging, many more dabbled in tourism. The story of D.L. Bliss, builder of the earliest tourist infrastructure along the lake, is well documented, but he wasn't the only one. Fallen Leaf Lake played host to a boys' camp that was so popular it started welcoming the boys' entire families after a few years, and owners of supply stations provided lodging for both business and pleasure. Early resorts like the Bijou Lodge and Al Tahoe Inn shared their beaches with Washoe summering on the shore.

In Truckee, tourists started driving in from the Bay Area before roads were even completed; it was trendy in the early 1910s for motor clubs to attempt the Sierra Crossing on the old wagon roads. Before the advent of cars, most travelers arrived on the train, sometimes staying on the north shore but usually going to lakeside resorts farther south.

Most of the early ski development was on the north shore, spurred by the 1939 opening of Sugar Bowl Ski Resort and given another boost when Squaw Valley hosted the Winter Olympics in 1960. It was the first to be televised on television and brought global attention to the sleepy town. Developers on the Nevada side of the lake quickly cashed in on the downhill skiing craze and built Diamond Peak Ski Resort, the first resort in the West

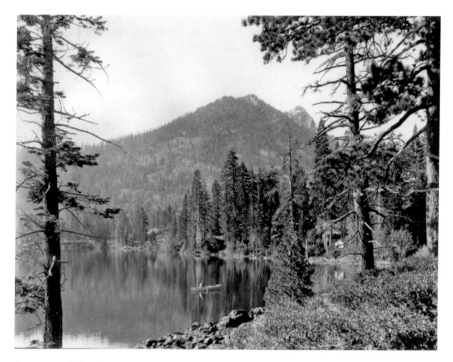

A rower on Fallen Leaf Lake, circa 1910. *California History Room, California State Library, Sacramento, California.*

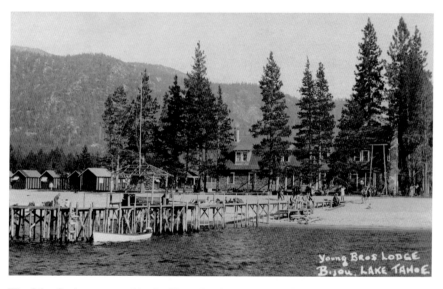

The Bijou Lodge, managed by the Young brothers, was one of Tahoe's first beachfront hotels, circa 1910. *California History Room, California State Library, Sacramento, California.*

to have snowmaking capabilities. Hollywood celebrities flocked to the north shore in the 1950s and 1960s to rub elbows with Frank Sinatra and the Kennedy family.

Luxury resorts drew travelers to the south shore in the early twentieth century, though by the 1950s, more affordable motels and luxury casinos had replaced most of the old-school luxury lodges. Today, the south shore is known for more options of hotels, restaurants and nightlife, while the north shore is known for being a little more remote and outdoorsy. Fortunately for tourists, the road system is a little better than it was in the nineteenth century. Roads wind around the lake, allowing tourists to move between the beaches, ski resorts and towns in a matter of minutes, rather than requiring travel on steamships and passenger rails.

Tourism plays a crucial role in most stories around the lake, but the hikes in this chapter focus on some of the areas that stand out as key influences in shaping Tahoe's current-day recreational boom.

FALLEN LEAF LAKE

Much like Donner Lake, Fallen Leaf Lake is a stunning destination, but because it's in the shadow of Lake Tahoe, it doesn't get the attention it deserves. That's probably a good thing for hikers and snowshoers, as Fallen Leaf Lake is a beautiful spot to enjoy nature with a fraction of Tahoe's crowds.

Much of the land around Fallen Leaf Lake belongs to Stanford University, which uses it to run a summer "camp" for alumni and hold conferences affiliated with the university. Interestingly, Stanford's connection to the lake goes back more than one hundred years—so as popular as it is for Tahoe locals to blame tourists from the San Francisco Bay area for overcrowding Tahoe, it's tourists from the Bay Area who first preserved Fallen Leaf Lake. The university has played a pivotal role in protecting and conserving the land and around the lake since the 1890s.

The first development at Fallen Leaf came in 1892, when Stanford alumnus William Wrightman Price built a boys' summer camp where hiking, fishing and paddle sports were on the docket. The camp grew in popularity, eventually attracting entire families rather than just their children, and Price added cabins and piers. Since the journey to Fallen Leaf Lake from the Bay Area was so long, guests tended to stay for weeks at a time—and parents and adults likely didn't want to sleep in tents all summer.

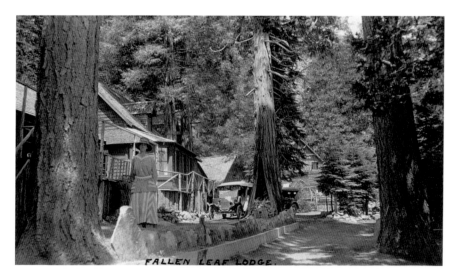

Tourist Grace McCarthy standing in front of a resort lodge at Fallen Leaf Lake. *California State Archives, Office of the Secretary of State, Sacramento, California, McCarthy (William M.) Photograph Collection.*

Travelers to Fallen Leaf Lake were able to make use of the transportation system already built by D.L. Bliss, but it was a long journey. From San Francisco, travelers would drive to Sacramento and then take the transcontinental railroad to Truckee, where they'd transfer to the Lake Tahoe Railroad to take them to Tahoe City. In Tahoe City, they boarded one of three steamships to Emerald Bay and then piled into a wagon that carried them up six hundred feet out of Emerald Bay to the eastern shore of Fallen Leaf Lake. From there, they'd board yet another boat to ferry them across the lake to the camp on the western end. It's no surprise that travelers wanted proper beds.

By the early 1910s, families who returned to the camp year after year had begun to build their own nearby vacation homes, eventually establishing the first neighborhood at Fallen Leaf Lake. The owners again upgraded the camp with a larger lodge building that both increased their tourist numbers and, interestingly, employed *Grapes of Wrath* author John Steinbeck in the 1920s. Stanford University eventually bought the development in 1959. According to university records, lodging was still reasonably affordable in the 1960s—it was just $65 for room and board for an adult for an entire week. You'll now pay well over $3,000 for two people for a week.

But perhaps what's even more impressive than development at the lake is what's under the lake. While rumors abound of mysteries and horrors at

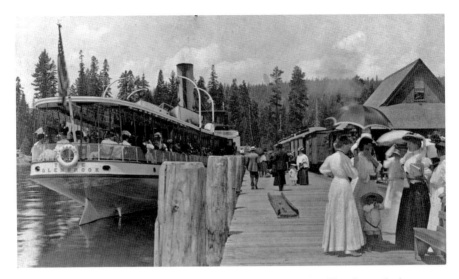

Steamships carried passengers from the train station at the Tahoe City pier to the luxury resorts on the south shore of the lake. *California History Room, California State Library, Sacramento, California.*

Tahoe's depths—like skeletons of railroad workers, sunken treasures or even the "Tahoe Tessie" lake monster—scientists have proof of the fascinating history below Fallen Leaf Lake. While there's no sea monster, there is something else almost as impressive, at least to outdoor enthusiasts: a nearly one-hundred-foot-tall petrified underwater forest.

Tahoe's water levels have risen and fallen over the eons, rising above the current level at times in the lake's ancient past. The same happened with Fallen Leaf Lake, which sits about one hundred feet higher than Lake Tahoe. During the ice ages, both lakes' water levels were much lower than they are today since much of the earth's water was frozen as ice. And since Fallen Leaf Lake is fed mostly by snowmelt, it's possible that the lake could have dried up entirely during periods of low snowfall, and these trees could have taken root during that period. According to findings published by an underwater research team in 2011, the trees grew over a span of 250 years between the years 900 and 1100 CE. They found more than eighty trees standing on the bottom of the four-hundred-foot-deep lake, some of which date to different periods, which could suggest a few periods of drought and freezing.

However, other researchers are exploring a second theory, although most still support the idea that the trees grew during a drought. An alternate proposal suggests that the trees grew on land thousands of years ago and slid into the lake during the same period of high volcanic activity that formed

Lake Tahoe. The underwater trees weren't discovered until 1997, so research into the history is still underway.

Regardless of how the trees made it into the lake, it's quite fascinating to stare at the surface and know they're not too far underneath. As the trees are buoyant, they float upright like a still-growing forest, with heavy rocks and tangled roots holding them on the bottom. Since the water below the surface is so cold, the trees are exceptionally well preserved. While the elevation and temperatures make it hard for scuba divers and researchers to spend much time underwater, new developments in scuba and submersibles may soon reveal more information about this ancient forest—or perhaps find something new altogether.

How to Hike It: Fallen Leaf Lake

Why I Like It: A very easy walk to a dog- and kid-friendly lake
Type of Hike: Out-and-back
Total Mileage: 0.5 mile +
Elevation Gain: 100 feet +
Difficulty: Easier

Getting There: From South Lake Tahoe, take CA-89 N/Emerald Bay Road for 3 miles. Turn left onto Fallen Leaf Lake Road. Follow the road for about 0.8 mile, passing the campground, until you come to a clearing with a trail on both sides. If you miss this particular access point (or if there's no room to park), keep going on the road, as there are several trails leading to the lake over the next mile. There are no facilities at the trailhead, although the campground does have restrooms and running water.

The roads around Fallen Leaf Lake are closed from about December to April, depending on snow. To snowshoe, park at one of the lots off CA-89 N and plan to snowshoe in. Be sure to check current road conditions to see which roads around the lake are open during your visit. The twisting road that separates Lake Tahoe from Fallen Leaf Lake is also subject to frequent winter closures due to its steep grade, avalanche risks and minimal guard rails.

Trailhead Address: Fallen Leaf Road, South Lake Tahoe, CA 96150

Start: Take the path from the parking area headed toward the lake, crossing a few dirt paths soon after the start.

0.2 mile: Reach a clearing; go straight and continue up the steep trail through the rocks. It gains roughly 50 feet of elevation. You'll see the lake from the top.

You can continue along this ridgeline to circle the lake in either direction (the current Stanford Camp is at the far end of the lake) or walk down to the water. This is approximately where the first boys' camp was at the lake before Price relocated it to the western end. Not much remains of the old camp, although hikers with a keen eye may be able to spot old metal apparatus lying in the shallows here and there. There's usually enough shoreline for a pleasant walk around the lake in either direction.

You can return to the parking area via the same route or take any of the unofficial trails away from the lake and make a loop back to the parking area via Fallen Leaf Road—although walking along the lake is generally far more pleasant. Dogs are welcome at the lake, and you'll often see a few pups splashing in the shallows on summer mornings.

TALLAC HISTORIC SITE

The Tallac Historic Site is one of the most interesting walks in Tahoe for history buffs. The route through the woods passes by two historic sites (the Pope estate and the Baldwin estate) and goes past the remains of Tahoe's first glamorous hotels: the Tallac Hotel. You can even add on the Valhalla estate for a fourth site.

Fertile Soil for Indigenous Americans

The history of the Tallac Historic Site begins well before any settlers had heard of California—or even arrived at Plymouth Rock, for that matter. The Tallac Site, on the shore of the lake and next to Taylor Creek, was an ideal spot for Native Americans to spend the summer. The Washoe likely used this site for centuries, and while records are scant, historians have found evidence

of plant cultivation here at Da-ow-ago, or "the edge of the lake." Now, the U.S. Forest Service and the Tahoe Heritage Foundation manage the site in a private-public partnership, but there's a Washoe plant garden on-site with traditional native plants with names in both English and Washoe.

There's also a reconstructed Washoe winter home guests can enter. The house is a *galis-dungal* ("winter home"), and it looks much like the traditional hide tepees associated with Native Americans of the Great Plains. However, the *galis-dungal* is made with thick, durable bark and supported with lodgepole pines, making it much more permanent than a tepee covered with hides or plant growth. *Galis-dungals* would eventually sink into the earth and build up enough mud and dirt to secure them to the ground, creating a winter home that lasted through years of heavy winters. The Washoe, of course, didn't spend winters at elevations this high. The park service asked the Washoe Tribe to re-create a *galis-dungal* to share it with visitors to the Tallac Site.

The Washoe used homes like these until the mid-1800s. The nearby Bijou Lodge shared a beach with summering Washoe for many years, during the overlap of tourism and Washoe habitation on the south shore. There's also a section of the Baldwin Museum dedicated to Washoe life in the region.

"Lucky" Baldwin's Casino Draws Crowds

This site's modern-day story begins with E.J. "Lucky" Baldwin, an East Coast transplant to California who migrated west during the gold rush. He brought property in San Francisco soon after arriving and managed to strike it rich in real estate during the city's boom. Like many wealthy San Franciscans, the Baldwin family spent summers at Lake Tahoe. Baldwin eventually bought land near a small hotel known as the Tallac Point House, a small tourist lodge owned by Ephraim "Yank" Clements—the same Yank who established the Yank's Station Pony Express station in Meyers. Clements and his wife had dabbled in hostelry while running the lodging and restaurant at Yank's Station, and they opened the Tallac Point House in 1870 when new routes directed traffic away Meyers. The Tallac Point House and Baldwin's new Tallac Resort operated next door to each other until Baldwin bought Clements's property in 1880 and incorporated it into the Tallac Resort.

Baldwin began expanding the property and added additional offerings in the 1890s, shaping the resort into a luxurious getaway for San Francisco residents who could afford the long (and expensive) trip. And the Tallac Resort was well worth the trip. The lakefront lodge included boathouses, a

From left to right: E.J. "Lucky" Baldwin, Dextra Baldwin (daughter of Anita M. Baldwin), Baldwin M. Baldwin (son of Anita M. Baldwin) and Anita M. Baldwin. *Arcadia Public Library, Arcadia, California.*

common area with a large outdoor fountain, the lake's first casino, several piers and a roomy beachfront at nearby Tallac Beach.

Rates were pricey by standards of the 1900s. Guests would pay anywhere from twenty-one to thirty dollars per week, plus extra for a private bath. By contrast, two dollars per day would have gotten you a room in the heart of San Francisco. Of course, the rate at the Tallac Resort included plenty of activities, and guests could fill their days from a robust schedule ranging from horseback riding to hiking to lake cruises and fishing trips. And evenings would be filled with gambling, musical performances, multi-course dinners and no shortage of cocktails.

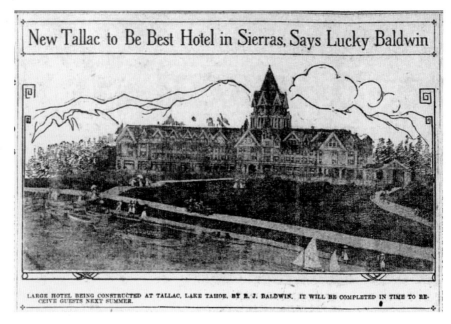

New Tallac to Be Best Hotel in Sierras, Says Lucky Baldwin

LARGE HOTEL BEING CONSTRUCTED AT TALLAC, LAKE TAHOE, BY E. J. BALDWIN. IT WILL BE COMPLETED IN TIME TO RE-
CEIVE GUESTS NEXT SUMMER.

Advertisement from the September 15, 1907 *San Francisco Call.*

However, gambling was illegal in California, although that didn't dissuade Baldwin. At three stories and nearly two hundred feet long, the Tallac Casino was massive, but Baldwin had a simple solution for hiding the operation during infrequent police visits: close up shop. Since the only police officer in the region was based more than three hours to the west, it was easy for the casino to get a warning when he was on his way. They'd simply hide the evidence of gambling, replace it with above-board activities and wait for the sheriff to be duped by the inspection. Whether the sheriff really didn't see anything illegal or whether Baldwin greased his palm to get him to look the other way is anyone's guess. Newspaper articles show that Baldwin's tricks were well known to the public, but there's no record of him ever receiving any fines.

Baldwin didn't have to worry about pulling off his eyebrow-raising strategy for too long, as he died in 1909. A fire destroyed many of the hotel buildings in 1914, and Baldwin's daughter, Anita, eventually closed the resort in 1920 when she saw how much sewage and waste was leaking into the lake. She had the resort demolished later that same year, and now all that remains is the cement footprint of the casino, along with a suggestion of where the fountain may have been. Signs in the area point out where various buildings stood on the property.

The land became the property of Anita's daughter, Dextra, who built a vacation home nearby, finished in 1924. The property included a five-thousand-square-foot main house—the current-day Baldwin House Museum—and two cottages salvaged from her grandfather's resort, where Dextra and Anita stayed during construction. When Dextra died in the late 1960s, her estate sold the property to the forest service.

To the east of the Baldwin estate is the Pope estate, the oldest and most sprawling of the historic homes. San Francisco banker George Tallant built the estate in 1894 but sold it in 1899 to Lloyd Tevis, president of Wells Fargo. Unfortunately, Tevis died before he could ever stay at the property, and it was his son, William Tevis, who expanded the homestead to include additional buildings. He also cultivated the botanical garden-like grounds, which includes the only Giant Sequoia trees in Lake Tahoe. Tevis sold the property to George Pope, who gave the home its tongue-in-cheek nickname: "The Vatican Lodge."

The property included the main house at more than four thousand square feet, plus three roomy lodges for guests, additional buildings for staff and caretakers and even a barn and equestrian facilities. The main home and all three guest houses are maintained by the park service and available to view during tours. Guests can still wander around the large property when the homes are closed.

The final of the three estates at the Tallac site is Valhalla, also known as the Heller estate. Although nearby Vikingsholm gets most of the attention, this home is also Scandinavian-inspired and, in fact, predates Vikingsholm by seven years. (It was finished in 1922.) The estate passed through a few families before the forest service purchased it in 1971 for $550,000. The home is now open to the public, and the Valhalla Grand Hall is available for artistic performances and private events.

How to Hike It: Tallac Historic Site

Why I Like It: A great year-round walk through Tahoe's early tourism history
Type of Hike: Loop
Total Mileage: 1.8 miles +
Elevation Gain: Flat
Difficulty: Easier

Getting There: From South Lake Tahoe, take CA-89 N/Emerald Bay Road for 3 miles. Turn right on Heritage Way. You can also park at the Taylor

Creek Visitor's Center if Tallac's lot is full. Parking is five dollars, and restrooms and running water are available.

Trailhead Address: 1 Heritage Way, South Lake Tahoe, CA 96150

There's no right or wrong way to visit the Tallac Historic Site. The homes and beaches are connected by well-maintained trails and footpaths. There's a walking tour of the Tallac Resort site, marked by numbered signs, and the other properties also have informational plaques and markers. Tallac Beach is on the westernmost side of the property, followed by the Tallac Resort Site, Baldwin estate, Pope estate and Heller estate (Valhalla) on the easternmost side. It's possible to walk around all of the sites in just under 2 miles, although it's best to plan to wander.

SNOWFLAKE LODGE AT DIAMOND PEAK SKI RESORT

Diamond Peak has some of the best, if not the best, views of any ski resort in Tahoe (although Homewood Resort on the west shore could make a strong case). Perched on the hillside about as close as possible to the lake, Diamond Peak is owned by the Town of Incline Village. The town's been attracting tourists since the 1930s, perhaps because of those amazing views.

Incline Village—named for the steep railroad that once carried logs up the hillside to the east—is on the Nevada side of the lake, making it a popular destination for Californians seeking a Vegas-type experience with a Tahoe twist. Only a few miles away from Incline Village is the Cal-Neva Resort, the resort split between states once owned by Frank Sinatra. The resort attracted the who's who of Hollywood for decades, from fellow Rat Pack members Dean Martin and Joey Bishop to Judy Garland and Marilyn Monroe—the latter spent her last weekend alive at the resort's eponymous Monroe cabin. Rumors of mob bosses traveling in the secret tunnels under the resort abounded in the 1950s and 1960s. And just a few miles down the street, in a thicket of pines near the beach, was King's Castle, the medieval-themed hotel known for over-the-top décor and luxurious Broadway-style shows. It's now the elegant Hyatt Regency Lake Tahoe Resort, Spa and Casino.

But it wasn't just the lure of gambling and high-end accommodations that drew people to Incline Village. It was, and still is, the great outdoor

oup | manships of the Central committee for the Garden
Branch Young adult Com- Center.

:lub
was
iza-
cin-
an

Dorothy Kilgallen

Did Marilyn Try Suicide At Lodge?

am,
af-
fea-
vith
iges

THE LOS ANGELES au-

ram

Above: Newspaper clip from the August 26, 1962 edition of the *Cincinnati Enquirer.*

Right: Luggi Foegger, director of the Ski Incline Ski School. *Diamond Peak Resort.*

access that drew wealthy Californians to the alpine playground. But while South Lake Tahoe was quickly developing with hotels and restaurants, it wasn't until the 1960 Olympics that the north shore of Tahoe caught the public's attention. And since the northeastern shore of the lake was mostly untouched since the logging operations closed, it was prime real estate for developers looking to take advantage of the mountain sports boom. Most of the land had been purchased by George Whittell of Thunderbird Lodge, who preferred to leave as much wilderness as possible between his home and other neighbors—perhaps because he kept both an elephant and lion as pets.

Enter Art Wood, a resort developer who purchased most of the land now part of Incline Village from Whittell in 1960. Wood envisioned a planned community centered on a ski resort. He contracted with Austrian-born ski expert Luggi Foeger, who famously developed Yosemite National Park's Badger Pass Ski Area (now called Ski Yosemite). Wood originally chose a higher-elevation peak for his resort, but Foegger, recognizing that the burgeoning community needed beginner terrain, instead suggested the current-day location, thanks to its fantastic lake views and mix of gentle and steep slopes.

A few months and $2 million later, Ski Incline opened. In addition to four lifts, it featured something no other nearby resort had: snowmaking equipment. Making snow with machines was revolutionary at the time, although it didn't take long before other nearby resorts followed suit. Another

expansion in the 1980s added more lifts and challenging terrain, as well as a new name for the resort: Diamond Peak, so named for the resort's newly accessible black diamond (expert) terrain.

Today, the resort is a year-round draw thanks to the Snowflake Lodge, a mid-mountain restaurant that was one of the most glamorous places to have a glass of wine in the 1960s. Although it's been updated and modernized, Snowflake Lodge is still open, offering views of Squaw Valley to the northeast and the east shore beaches and Thunderbird Lodge to the south. The lodge is accessible in the winter by skiing, snowboarding, snowshoeing or cross-country skiing, and in the summer and fall, it's a short out-and-back hike from the Diamond Peak Base Lodge. The lodge is only open in the winter, so bring your own food and drink if you plan on a spring or summer picnic at the top.

How to Hike It: Snowflake Lodge at Diamond Peak Ski Resort

Why I Like It: A quick hike to possibly the most picturesque picnic spot in Tahoe
Type of Hike: Out-and-back
Total Mileage: 2.6 miles
Elevation Gain: 650 feet
Difficulty: More Difficult

Getting There: Head north on Country Club Drive from Tahoe Boulevard in Incline Village. Make a right onto Ski Way. Diamond Peak Ski Resort is 1.2 miles ahead on the right.

Trailhead Address: 1210 Ski Way, Incline Village, NV 89451

Start: The trail begins on the fire road next to the base lodge. Walk under the Lodgepole Quad ski lift.

0.4 mile: Stay on the road as it turns right. It gains elevation fairly gradually, with a few very short steeper sections. Stay on the road the entire way.

1.3 miles: Reach Snowflake Lodge. Backtrack.

2.6 miles: Back at base lodge.

If you're snowshoeing or visiting in the winter, you'll need a free uphill travel pass, available in advance at DiamondPeak.com. The Snowflake Lodge restrooms are only open while the lifts are operating.

Sugar Bowl Resort to Squaw Valley/Alpine Meadows

Perhaps Truckee's most famous hike, the route from Sugar Bowl Ski Resort to Squaw Valley Ski Resort[*] is one of the longest day hikes in the area, with impressive views of the highest points in the northern Sierra Nevada. It's only accessible in late summer, and even then, you'll likely be hiking through the occasional snow patch. The vast majority of the hike is at high elevations, with about half of the hike's 14.5 miles at elevations above eight thousand feet. This side of Truckee gets far more snow than anywhere else in town, which is perhaps why ski industry CEOs have had it on their radar for more than one hundred years.

Sugar Bowl Ski Resort: Pioneers of Tahoe Skiing

Sugar Bowl Ski Resort is one of Tahoe's first ski resorts, open since 1939. It was also the first resort in California to install a chairlift and the first to install a gondola (in 1953; it's actually still in use). But development in the area goes back much farther than 1939. As with most modern-day development in Truckee, Sugar Bowl's history intertwined with the development of driving routes over Donner Pass.

Although the railroad brought tourists to the Lake Tahoe area in the late 1800s, it wasn't until the Lincoln Highway's completion in 1913 that people of average means in Sacramento and San Francisco could visit the lake. Before that, travel was expensive and drawn out, limited to the upper echelon of society, who could afford the time and cost. Much of the land across the summit owned by the Southern Pacific Railroad, which began selling acreage around the tracks in the 1920s. Perhaps because it was considered "undevelopable," the railroad sold the land covering Sugar Bowl Ski Resort for less than fifteen dollars.

[*] In the summer of 2020, Squaw Valley announced plans to change its name, noting the racial and misogynistic history of the word *squaw*. As of writing, the new name has not been announced.

Prior to the early 1910s, skiing was a form of transportation, not a sport. A man seen on skis near the top of Donner Pass, circa 1870. *California History Room, California State Library, Sacramento, California.*

Prior to the 1890s, skiing was basic, like today's backcountry skiing. Skiers had to traverse up the peaks on foot before skiing down—no infrastructure of any kind was in place. Fortunately, ski enthusiasts didn't have to look far for inspiration when it was time to develop the area. Just down the street in Truckee, skiers built the nation's first mechanized ski lift (a rope tow) as part of the Truckee Winter Carnival in the late 1910s. Parts of that tow still remain at what was the Hilltop Winter Sports Area (now Cottonwood Restaurant).

The lift served skiers during ski races and demonstrations, as well as tobogganers and sledders during Truckee's Winter Carnival, which ran annually from 1895 until around 1916. By that point, winter sports had

become a standard weekend activity everywhere throughout town (although ski jumps and ice palaces still popped up here and there). Seeing how popular the Hilltop rope tow was, skiers built a few similar ones on Sugar Bowl Resort's base (near Lake Mary).

In 1937, the property on Donner Summit once again hit the market, this time for a cool $6,740—after all, tourism was booming, as was the sport of downhill skiing. Understanding the potential value of the land, professional Austrian skier Hans Schroll attempted to buy the land in partnership with Austrian ski instructor Bill Klein, who had been teaching ski lessons in Truckee for the last decade. Unfortunately for Schroll, he was unable to come up with the money and ended up taking on several local partners to buy the resort, eventually forming the Sugar Bowl Corporation. The name "Sugar Bowl" came from the near-perfect snow quality and the natural bowl shape of the summits.

In the late 1930s, Schroll and his partners built the small village at the base of Sugar Bowl, as well the Sugar Bowl Lodge, which still looks today much like it did in 1939. And in December 1940, the resort installed the first chairlift in California directly in front of the lodge. Skiing was a steal at the time compared to today's rates, which can be more than $150 for a one-day lift ticket. Sugar Bowl charged $0.25 for a round-trip ride or $2.00 if you wanted to ski down. These offerings drew tourists from San Francisco, as did the ski races the resort hosted, won mostly by Austrian skiers Schroll and Klein invited. The resort also attracted Hollywood celebrities, taking advantage of the ever-improving roads in the area. One person who took a particular interest in the resort was Walt Disney, who set several early cartoons in the winter wonderland. Disney also provided capital to assist in the resort's early development, which is why many areas of the resort are named in his honor, including "Mt. Disney" and the "Disney Express" lift, as well as runs with names like "Disney Traverse" and "Donald Duck."

Tourism took a dip during World War II when the railroad stopped carrying passengers east but had rebounded again by 1950. More lifts were installed, including the first West Coast gondola. Although the gondola has received several mechanical upgrades and improvements since then, guests can still arrive at the resort village on the gondola, which runs from the Sugar Bowl Village to the Gondola Parking Lot on Highway 40. The ride takes about seven minutes, as it did back in the 1950s, but powder skiers should note that overly long or wide skis may not fit in the vintage four-person cars. Prior to the constriction of the gondola, it took about thirty minutes to reach the resort via a tractor tow.

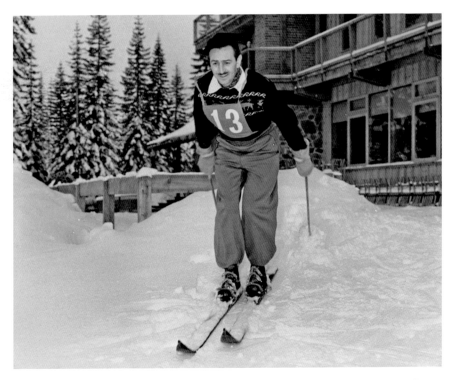

Walt Disney in front of the Sugar Bowl Resort Lodge, late 1930s. *San Francisco History Center, San Francisco Public Library.*

The year 1960 saw the return of Walt Disney to northern Lake Tahoe when he directed the celebrations for the 1960 Winter Olympic Games, held at nearby Squaw Ski Resort (the ending point of this hike). When Highway 80 opened in the 1960s, Sugar Bowl saw another tourist boom and further expanded, adding additional lifts and housing. Ski movie pioneer Warren Miller filmed several movies at Sugar Bowl in the 1970s, further cementing its reputation as a winter ski mecca.

In 1994, Sugar Bowl Resort opened another peak on the resort's far left side—Judah Peak, which the Sugar Bowl to Squaw hike traverses. In fact, you can now ski down from near the top of Roller Pass, one of the crossings used by settlers in the 1860s. In the second mile of the hike, you'll traverse under the Peak's Mount Judah Express Lift and cross at the top of the Jerome Hill Express Lift. (The latter will be to your right around the 1.5-mile mark. You may have to bushwhack for a short period to reach it if the bushes are overgrown, but it's easy to spot.)

The resort hasn't lost its authentic roots and remains one of the few privately owned ski resorts in the country. The Sugar Bowl to Squaw hike traverses along the resort's eastern ridgeline before heading through the saddle at Roller Pass and continuing south along the ridgeline toward Tahoe's west shore. You'll have excellent views of Sugar Bow's terrain for the first few miles and views of Lake Mary, site of the first makeshift rope tows at the resort, just a few minutes past the trailhead.

The hike begins at the Sugar Bowl Ski Academy, which may look unassuming but has quite the reputation for success. Bill Klein and his brother, Fred, taught here well before Sugar Bowl Resort opened, essentially developing modern ski coaching in the United States. Graduates of the ski academy have competed on the U.S. cross-country and downhill ski teams, as well as the World Junior Freeride Tour.

Squaw Valley and the First Televised Olympic Games

Sugar Bowl may have been home to the region's earliest skiing, but it's thanks to Squaw Valley that Lake Tahoe is world-famous for skiing. More specifically, it's mostly due to Squaw's hosting of the 1960 Winter Olympics that modern-day tourism boomed on the north shore.

Squaw Valley's modern story of development begins in 1931, when local skier Wayne Poulsen—who had already made a name for himself in Tahoe's earliest ski competitions—bought the land around current-day Squaw Valley from the Southern Pacific Railroad. He teamed up with local lawyer and ski enthusiast Alex Cushing (who lends his name to the resort's annual "Cushing Crossing" pond skimming event) to secure capital and government permissions to build a resort in the valley.

The resort opened to the public in 1949 with just one lift chair: Squaw One. Holding two passengers per chair (quite unusual at the time), the lift held the record for being the longest chair lift in the country, stretching for more than 8,200 feet and rising more than 2,000 feet to the summit.

In 1950, the first year Squaw's on-mountain hotel was open, local ads advertised rooms ranging from one dollar to six dollars per night, although many guests stayed at the Tahoe Tavern in nearby Tahoe City, owned and run by Tahoe's famous Bliss family. (It closed just a few years later in the mid-1950s.) There's still a Squaw One lift at the resort today, although it's received multiple safety and mechanical upgrades and changes. Perhaps

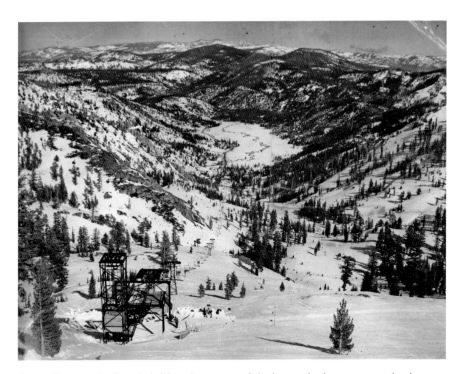

Squaw One was the first chair lift at the resort and the longest in the country at the time. *Squaw Valley/Alpine Meadows.*

Advertisement for Squaw from the May 24, 1920 issue of the *Sacramento Bee.*

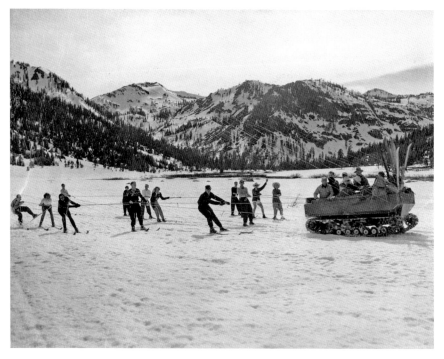

Before winning the Olympics bid, Squaw had just one lift, and a sled would pull skiers up to the top of easier slops. *Squaw Valley/Alpine Meadows.*

due to the impressive lift, Squaw Valley won the bid in 1955 to host the 1960 Winter Olympics—the first games shown on television.

At the time, the resort had just one lift, two rope tows and a small hotel, so much had to be done to accommodate the games. According to a November 4, 1949 article in the Northern California *Chico-Enterprise Record*, the bill to develop the site to be Olympic-ready reached more than $20 million, paid primarily by state park funds, congressional appropriation, donations and revenue expected during the two-week games.

Cushing and the Squaw Valley team spent the years leading up to the games improving infrastructure, adding the following:

- Blyth Arena, a covered ice hockey and ice skating arena. It was demolished after the games to make more parking and sat near the current location of the SnoVentures (kids) terrain area.
- Three separate buildings for administration, speeches and awards and media. The media building needed to be larger than

ever before, as it was the first televised Olympics. In addition to using bulky camera equipment, media teams needed space to sort through film and manually edit shots on film.

- A lodging complex to house the athletes. This building still stands today as the Olympic House. In 1960, 665 athletes competed across twenty-seven disciplines, and many of them stayed on-site in the valley or nearby in Truckee and Tahoe City. Today, the small conference center would be nowhere near large enough to house athletes; Pyeongchang's Winter 2018 Games attracted 2,914 athletes in thirty-five different sports.
- An expanded village with restaurants, a post office, space for spectators, a sewage treatment plant, outdoor ice-skating rinks and additional spectator lodging.
- Six new lifts, including the KT-22 lift. It was named in honor of Sandy Poulsen, Wayne Poulsen's wife. According to Wayne, Sandy was a bit too timid to ski straight down the face, so she instead made kick turns (directional changes while stopped) from top to bottom. It took her twenty-two kick turns to make it down, hence the name. (There are multiple routes down now.)

Were it not for the Winter Olympics, Squaw Valley's development would have likely moved much slower. But thanks to the six additional lifts added for the games, it had become one of the country's largest resorts by the mid-1960s. It also helped put Tahoe on the map as a tourist destination for travelers from the Midwest and East Coast. In addition to being the first Olympic Games viewers could watch from afar, it was the first to televise the opening and closing ceremonies, thus starting the modern-day pageantry associated with the games. To really "wow" viewers at home, Alex Cushing turned to California's most well-known master of imagination and celebration: Walt Disney, already a fan of the area thanks to his investments in Sugar Bowl.

Pageantry was no small undertaking, especially as the term was fairly wide-reaching: Disney's team was responsible for the opening and closing ceremonies, decorations and presentation, nightly events, backdrops and staging for famous performers and even tasks like lines and crowd management, a topic with which Disney obviously had experience. Many of the structures and attractions designed by Disney are still at the resort today, including the huge "display of nations" structure that honored the countries participating in the games. It's been relocated to the intersection

of Highway 89 and Squaw Valley Road, where two Olympic torches also burn year-round.

While the idea was to ensure that every aspect of the games inspired awe in spectators, Disney also had other motives for agreeing to take on the role: he planned to build a Disney-themed ski resort in California. In 1965, he purchased a considerable tract of land and announced plans to build the Mineral Valley Ski Resort abutting Sequoia National Forest. The project was expected to cost $35 million, and estimates suggested that it could attract more than 1 million visits per year. Renderings showed plans for a twenty-two-lift resort, complete with a massive hotel, restaurants, shopping and ice-skating rinks. Eventually, the project was scuttled thanks to continued legal delays by the Sierra Club and expanded environmental regulations. Now, the tract of land is just an empty valley in the national park.

Disney died before the plan moved too far along, but it's clear he loved the California mountains. In fact, some people say the boulders around the Big Thunder Mountain Railroad roller coaster in Disney World were inspired by the massive boulders around Sugar Bowl and Squaw Valley. Whether that's true or not, there are certainly plenty of similarities. To decide for yourself, take the "Five Lakes" trail from Alpine Meadows (not detailed in this book), whose boulders certainly look suspiciously like the Florida theme park ride.

Tourism development in Tahoe boomed after the Olympics, and Squaw Valley continued to grow. The mountain expanded farther north, adding lifts to the top of Granite Chief Peak. This is where the Sugar Bowl–Squaw hike first crosses the resort boundary, entering from the north before climbing toward Granite Chief Peak. The trail follows the Granite Chief hiking trail back down into the Squaw Valley Resort Village, which is not the same route as the Granite Chief chairlift. However, if you have energy left at the end of the hike, you can continue hiking to Granite Chief and the Shirley Lake area of Squaw Valley rather than turning left to return to the village (around the 11-mile mark). As of writing, guests who take that route can opt to take the gondola from High Camp to the Squaw Valley Village at no charge, eliminating the final 3.5 downhill miles.

How to Hike It: Sugar Bowl Resort to Squaw Valley/Alpine Meadows

Why I Like It: A bucket-list hike linking two famous West Coast ski resorts
Type of Hike: Point-to-point

Total Mileage: 14.5 miles
Elevation Gain: 2,500 feet (down 3,500 feet)
Difficulty: Most Difficult

Getting There: Parking is off Old Highway 40 (Donner Pass Road) in Truckee. From Truckee, head west on Donner Pass Road, continuing past the lake. Drive about 3 miles past the lake. Parking is on the left at Summit Haus, immediately after the road closure gate. There's no fee for park. In the summer, there's a small snack bar at the parking area and a portable restroom at the trailhead.

You'll need to leave a car in the Squaw Valley parking lot: 1960 Squaw Valley Road, Olympic Valley, CA 96146

Trailhead Address: 96161 Old Donner Summit Road, Truckee, CA 96161

Start: Begin at the Old Sugar Bowl Academy Parking lot, following the same route as the Judah Summit hike. The route is exactly the same for the first 2 miles. Count on a semi-steep and rocky uphill hike for the first mile.

1.1 miles: Go right, following signs to Judah Summit and the Pacific Crest Trail. At this point, you're traversing across some of Sugar Bowl Resort's ski runs off Judah Summit.

1.5 miles: Look to the right and you'll see the top of Sugar Bowl's Jerome Hill Lift. You can scramble across the small wooded area to get there if you're willing to bushwhack, although there's sometimes a narrow foot-stomped path leading over.

2 miles: The trail splits again. Head right, following signs toward Roller Pass. This is where the trail diverges from the Judah Summit trail. Instead of backtracking to the split, continue to the right.

For the next few miles, the trail meanders along the ridgelines, switching between different types of terrain quickly. Expect exposed rock faces, shaded wooded sections and single-track through brush. Regardless of the terrain, the trail is mostly a dirt path and not very rocky (by Tahoe standards).

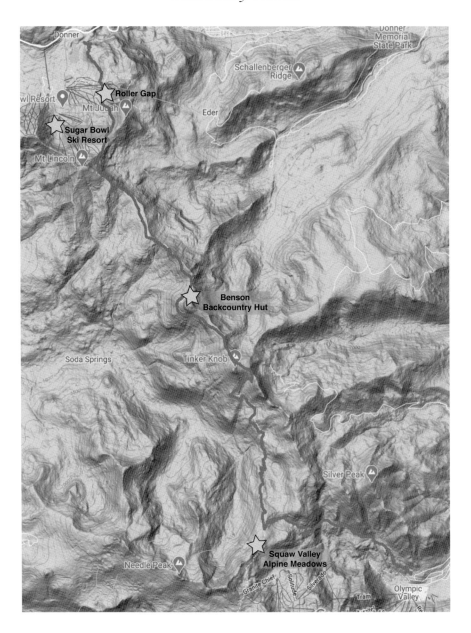

2.6 miles: You're approaching the top of the ridgeline now and should have excellent views for much of the hike from here forward. The climb is steady but manageable, with the steepest climb around mile 4.5.

5.4 miles: The trail forks; go right. To the left is the Benson Hut, a popular hut for backcountry skiers in the winter. For the next mile or so you'll cross a few talus piles (rockslides), so there's no defined path. Walk directly across them, stepping carefully since some of the rocks can be loose. Anderson Peak is to your left just after the Benson Hut, and Tinker's Knob is the summit directly ahead.

6.5 miles: Pass by a few trees with clearings underneath, probably used by hikers on the PCT. These are some of the few shady areas along the middle section of the trail and ideal for a stretch or snack break.

7.2 miles: Reach the turnoff for Tinker's Knob. The peak is named for James Tinker, proprietor of a waystation near current-day Soda Springs, who apparently had a prominent nose. Go left, unless you want to add on the hike to Tinker's Knob. It's a very short scramble with an additional 140 feet of elevation gain. This is also the highest point of the hike at 8,750 above sea level. Go right at the trail sign just past the Tinker's Knob turnoff. The next few miles are almost entirely downhill.

9.4 miles: What goes down must come up. The trail begins a steady climb back up to the ridgeline, switchbacking several times in the process.

9.8 miles: Keep left at the trail intersection (right leads to Painted Rock).

11 miles: Intersection with the Granite Chief Trail. Turn left to the Squaw Valley Village or go straight (right) to continue to Granite Chief. Hiking from here to the top of the tram at High Camp adds 3 miles and about 800 feet of climbing. This intersection is easy to miss.

12.2 miles: Around this point, you'll start to cross huge slabs of granite. It can be hard to find your route, but in general, stay to the left, walking parallel to the large granite rock walls. Hikers often create small rock stacks (cairns) marking the direction of the trail. These few miles are somewhat steep, so you can often see the trail downhill. The trail is usually marked with orange blazes (paint marks), although they can be a bit faded sometimes.

13.8 miles: The trail branches off in several points to the right. All trails lead to the village, so take whichever one you want. If you stay to the left the

entire time, you'll end up on Sandy Way, about a five-minute walk from the Squaw Parking lot. They all end very near one another, so it's not worth backtracking if you make a wrong turn.

14.5 miles: Reach the parking lot for Squaw Valley Resort.

Chapter 7

BEYOND TAHOE

L ake Tahoe's towns have been the meeting point for commerce and socialization for centuries, but that doesn't mean the mountains and valleys north of the lake sat empty. Readers willing to make a drive outside the basin will find plenty of locations with stories to tell. A day trip away from the lake can bring you to trails you'll have almost entirely to yourself, even when the towns around Tahoe are packed with tourists.

Because so many settlers and emigrants came through the Sierras from the early 1800s onward, it's no surprise that they eventually fanned out, exploring the valleys and peaks around the region. The earliest routes for U.S. transcontinental mail service skirted just south of the lake, carried by a Norwegian skier who took shelter in rock caves when the snow was too deep to traverse. North of the lake, lonely miners named the Sierra Buttes' highest peak for their favorite 1800s showgirl, and later, the country's earliest cartographers mapped the sprawling mountain range from that same summit. Even farther north is a historic fire lookout, built to address the fears of wildfires that had destroyed entire towns in Montana and Idaho. And to the west is Mormon Station in Genoa, site of the first permanent settlement in Nevada (and home of the state's oldest saloon). Sure, Lake Tahoe is impressive, but the more remote regions around the lake are also well worth a day trip.

Residents of Butte, Montana, watch a fire destroy their town in 1905. *Library of Congress, LC-USZ62-118153.*

SNOWSHOE THOMPSON TRAIL

Lake Tahoe has no shortage of quirky characters—including Thunderbird Lodge's George Whittell and notorious outlaw of the Sierra "Tarantula" Bill, who committed Truckee's very first (recorded) murder—but "Snowshoe" Thompson is in a league all his own. Born in Norway in 1827, John Albert Thompson became the very first postal carrier through Tahoe, delivering mail year-round beginning in 1856.

Thompson moved to the United States at age ten, and by the 1850s, he was living in Placerville, west of South Lake Tahoe. In 1856, he began

Snowshoe Thompson sits on his porch with his dog. *California Faces: Selections from the Bancroft Library Portrait Collection, Bancroft Library, University of California–Berkeley.*

delivering mail between Placerville and Genoa, in Nevada. The route he used would later become the basis of this section of the Pony Express and now mirrors much of U.S. Route 50.

Of course, there were no roads or trails in the mid-1800s along Thompson's route. The passing was treacherous with wagons—the Donner Party met their fate in the still-wild Sierra less than a decade earlier—and nearly impassable in the winter. Pack mules were unable to traverse through the deep snow, and rerouting to avoid the Sierra peaks added months to the mail's already-slow journey. Despite this, Thompson answered a newspaper ad posted in 1855 seeking a new mail carrier for the route. Because of his familiarity with snowy conditions (and possibly a lack of other applicants), he got the job, despite being a sharecropper for most of his adult life.

Knowing that traditional transportation methods would be useless in deep snow, Thompson delivered mail on something from his childhood: skis. Today, we'd consider them cross-country skis, but in the 1850s, they were referred to as "snow-shoes" in camps and mining towns through the West. Snowshoes similar to today's versions were used in the mountains, but mostly by Native Americans, and Thompson was one of the first in the West to use skis. The trip from Placerville to Nevada City (around 110 miles) took Thompson two or three days, depending on the conditions. Before he enlisted in the mail service, the quickest trip was about two weeks on foot.

Thompson carried everything from mail to newspapers, clothing, books and early ore found in the mines around Virginia City. In addition to being the region's first successful postman, he also served as one of the pioneers of skiing in California. His skis were anywhere between seven and ten feet long, and with turned-up tips on either end, Thompson was one of the first to show that travel across snow was possible. A witness's account in a March 1869 edition of the *San Francisco Examiner* reported that Thompson attended

a snowshoe race (probably more like a downhill ski race) and stunned onlookers with his cambered skis. (The same article stated that Thompson declined to participate or bet on the races.) Norwegians had been using similar skis for decades, but they were new to the Sierra (as many things were during the mid-1800s).

Despite his reputation, Thompson was probably not the very first to introduce skis to California. But he was likely one of the first to use them for anything other than moving around mining camps. However, it didn't take long before he was outpaced by local racers who swapped backcountry terrain for well-groomed slopes and began using a waxy substance to enhance their speed on icy conditions.

Thompson's legacy doesn't stop with skiing and the mail, however. Perhaps part of the reason he's so well known is that he also acted as Tahoe's first ad hoc search-and-rescue team. Although Thompson himself traveled and worked alone, he often assisted in lifesaving operations, many of which were retold in local police dispatches in local papers. He's credited with saving several lives over his twenty-year mail delivery career and claims to have never gotten lost in the mountains. Despite making crossings at more than ten thousand feet above sea level during the trek, Thompson carried but a few items for his personal use, including his signature flat-brimmed hat, which he sports in most area monuments.

Unfortunately for Thompson, the government never actually paid him for his services, and his only compensation came through the occasional direct payment from mail recipients. Thompson made a trip to Washington, D.C., in 1872 to demand his back pay from Congress, but he ran out of money after a few weeks and never got his chance to speak before the assembly.

Thompson also had a brief stint in politics before he died of pneumonia in 1876. He was also elected to several local and statewide positions and played a role in the Battle of Pyramid Lake, in which he joined a group of armed and poorly organized settlers in attacking a Paiute group. The group claimed that it was in retribution for an attack on settlers around Nevada's Pyramid Lake. However, there's no real proof as to who started that altercation. Some sources say that settlers abducted several Paiute women and that the "attack" by the Paiute men was simply an attempt to rescue them. Regardless, at the Battle of Pyramid Lake in 1860, most of the settlers were killed or injured, and Thompson was one of the few who escaped, by spending the night hiding in the woods. This led to a series of ongoing altercations between settlers and Native Americans. The Paiute eventually moved out of the area, despite having the upper hand during most of the

fights. Fort Churchill, east of Carson City, was later built as a lookout station to avoid future conflicts between settlers and Native Americans.

The Snowshoe Thompson trail covers an area Thompson likely crossed hundreds of times as it's one of the lowest-elevation passes on his route. It's also likely a spot frequented by both settlers and Native Americans, creating plenty of opportunities for Thompson to trade while delivering mail. It's a short trail, but it goes past one of Tahoe's quirkiest sites: the cave where Thompson is said to have slept when heavy snow and stormy weather forced him to delay his trip.

There's also an engraved rock bearing the inscription "Rogers, Aug. 28th, '49" near the cave. Based on how much the carving is faded, it's likely 1849 (rather than 1949), but who "Rogers" was is anyone's guess. The year 1849 was the peak of California's gold rush, and since the nearby pass was a popular route for settlers coming to seek their fortunes, it's possible that "Rogers" was a pioneer hoping to commemorate his travel before striking it rich. Rock engravings, along with rust marks on rocks and wheel indentations, are indications that wagons frequently traveled through an area, and researchers have found all three of those at this site. So while we can suspect that Rogers was a gold rusher—maybe even one of the few who did get rich—there's no record available to confirm that.

How to Hike It: Snowshoe Thompson Trail

Why I Like It: A steep but very short hike to one of Tahoe's quirkiest historical sites

Type of Hike: Out-and-back

Total Mileage: 1.2 miles

Elevation Gain: 400 feet

Difficulty: Easier

Getting There: The trailhead is not well marked and difficult to find on maps. From South Lake Tahoe, take US-50 W for approximately 5 miles and then go left at the traffic circle, making a left on to CA 89 S. Follow the road for 11 miles and then make a left at the dead end onto CA-88 E/CA-89 S. You'll soon pass Sorenson's Resort on the right; the trailhead parking is 1.1 miles ahead on the left.

Trailhead Address: Alpine State Highway, Markleeville, CA 96120

Start: Take the trail on the left side of the parking lot, just past the historical sign. After less than 0.1 mile, you'll hit a small water flow (more of a runoff) to your left. Cross the trail here, to the left. (It looks like you should go straight, but that goes through dense trees. Immediately after crossing, you'll see a small yellow sign on a tree marking the California Trail.)

0.2 mile: Reach the Snowshoe Thompson cave. The trail keeps going straight to pass a few emigrant rust marks on rocks, but it's mostly downhill, so you'll have to hike back up to the cave.

On your way back, stand with the Snowshoe Thompson cave sign to your back and look straight, across the trail. About fifty yards down, you'll see a 6-foot-tall rock with a flat face, almost like a large tombstone. That's the "Rogers" engraving. Try not to touch the stone, as it's wearing away quickly.

From there, backtrack to the parking lot. You can end your hike there or jump on the Horsethief Canyon Trail on the other side of the parking area. It's a 7-mile round trip hike that gains about 2,000 feet of elevation as it climbs up to Cary Peak and past some beautiful lookout points. The moniker comes from the warning issued to travelers through this area in the 1800s, when horse thieves would steal horses from travelers and sell them to arriving travelers in Carson Valley.

MOUNT LOLA

The fact that Mount Lola is named after Lola Montez proves that the "stripper with a heart of gold" trope isn't reserved just for Broadway musicals and detective TV shows. Lola Montez—who also has several lakes and a half dozen roads and lanes named in her honor—was one of Truckee's most-loved visitors in the 1800s, and this magnificent peak is an homage to her beauty.

The "Queen of Bohemia" Comes to California

Lola Montez (née Eliza Rosanna Gilbert) arrived in San Francisco in 1853, but her reputation long preceded her. Born in Ireland in 1821, she lived in

both India and Scotland in her youth until marrying an English army officer twice her age when she was only sixteen. However, she soon became bored with her life as a young housewife, and rather than stay with her husband in India, she returned to Europe, technically married but living alone. By her late teens, she had already become friendly with other men, and her husband, Lieutenant Thomas James, filed for divorce on the grounds of adultery (the only legal reason for divorce in 1830s England). Montez would have had to appear in court and plead her case—a shameful task on its own back then, especially given that being a divorced woman meant she would never be accepted in English society. As such, she decided instead to start life over, moving to Spain and changing her name to Lola Montez in the mid-1840s.

Rather than using her given name and leaning on her Irish heritage, she adopted the persona of a Spanish showgirl, performing captivating Spanish dances throughout the country. She became well known in and around Madrid, and her world grew as she traveled throughout Europe to perform.

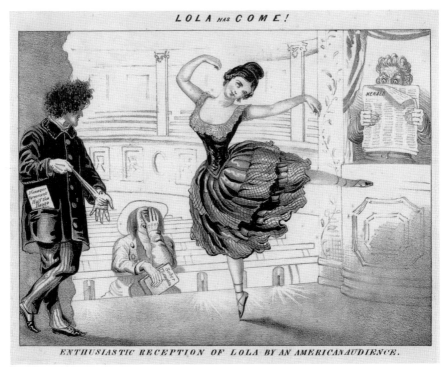

The arrival of Lola Montez in San Francisco was big news to American audiences. *Library of Congress, LOC LC-DIG-pga-11159.*

She ultimately was noticed by King Ludwig of Bavaria, who kept her as his mistress and gave her the titles Baroness Rosenthal and Countess of Lansfeld. However, just two years later, Montez left Germany (and King Ludwig) to escape the German protests that would eventually push Ludwig off the throne.

By her arrival in San Francisco, she was already a household name. Newspapers described her beauty in poetic ode; an 1852 edition of the *Perry County Democrat* from Pennsylvania described her as

> *a perfect Venus; about the middle height, but at that period slender and extremely graceful. Her cheeks were slightly tinged, her silken eye lash sentinels to a clear and piercing blue eye, her lips ever wreathed with a smile, and a fine and delicately molded chin.*

The same paper continued to wax poetic about Montez's impending arrival in California:

> [W]*e have no doubt she will attract great attention in this country, notwithstanding her chequered life. There is much in it to wonder at, to admire, and to regret.*

That newspaper's prophecies proved correct, and it didn't take long for her to start booking performance halls in San Francisco; newspapers reported that top seats in premier venues were going for sixty-five dollars or more to see her dance. It also didn't take long for San Francisco's men to notice her, most of whom cared little about her "sullied" reputation in London. She married San Francisco journalist Patrick Hull just two months after her arrival, although it's possible they met on the ocean voyage to San Francisco.

Unfortunately for Hull, the marriage was short-lived and dissolved less than a year later, when Montez began touring the growing gold rush mining camps in the Sierra—somewhat like a modern-day USO tour. Her exact tour schedule isn't known, but she traveled through camps in Tahoe and the northern Sierra Nevada in 1853 and 1854. What is known is that she crossed Donner Pass in the summer of 1854, traveling with miners and investors to the various camps. Her performances so wooed miners near Truckee that they named Mount Lola—and the lakes around Mount Lola—in her honor. At 9,147 feet tall, it's the highest point in the Sierra Buttes.

While Montez was well known in cities, she was likely one of the first women to visit many of these mining camps (certainly the first

Bust of Lola Montez, circa 1847. *Jerome Robbins Dance Division, New York Public Library.*

celebrity). Word of her stylish shows—European burlesque meets early vaudeville cabaret—was hot gossip as miners traveled between camps. It's also possible that her reputation among the miners was tarnished or embellished, either by more buttoned-up women and elites who looked down on her carefree, rule-breaking attitude or perhaps by the miners themselves, anxious to spread rumors about this "new kind of woman" free of society's Victorian attitudes. While Montez's acts were steeped in sexuality and likely considered erotic, lewd or even obscene by societal standards, she wasn't a prostitute, and a peek at a topless Montez was the most men's ticket costs would get them.

After touring the region during the early years of the gold rush, Montez bought a home in nearby Grass Valley (west of Truckee), although she didn't stay there long. She traveled extensively to perform, touring in both Australia and New York. She eventually began to spend her time primarily on the East Coast, where she dabbled in everything from fashion and etiquette to sexuality and parapsychology. For as full as her life was, it's hard to believe that it was so short—she died in New York City of pneumonia at age forty.

After her death, her life continued to be romanticized, beginning with the news of her passing in which papers called her the "Queen of Bohemia" and "no doubt a good and noble-hearted woman."

Today, Montez's former home in Grass Valley is a historical site, although the actual home has been rebuilt; the one standing is a replica. Many details of her life that don't revolve around her performances or ties to notable men were never recorded, but there are stories of her helping other women develop careers in show business, donating to and volunteering in orphans and widows homes and luring wealthy investors to keep the mines—and the men who worked them—afloat. The historical plaque at her home describes her as "bringing culture and refinement to this rude mining camp, a mistress of intrigue and a feminist before her time."

America's Early Cartographers Camp Out on Mount Lola

Although Mount Lola didn't see much traffic in the mid-1800s—and there's no reason to believe Montez ever crossed her eponymous mountain herself—it would eventually prove to be one of the most important of the Sierra Buttes summits.

By the late 1870s, the gold rush was in full swing, and California had been part of the union for more than a decade. As explorers like John Frémont, Kit Carson and Lewis and Clark were busy creating maps of the best routes and rivers for westward travel, more scientifically minded types were eager to make their own maps of California. The maps made by geologists and geographers were intended to be more objective, measuring distances and landmarks as they were rather than making assessments around ease of travel and the safest passages (although they would certainly help in that purpose).

One such scientist with interest in the mountains was George Davidson of the Office of Coast Survey (which would eventually become part of the National Oceanic and Atmospheric Administration). The office knew that having accurate maps of the rugged terrain west of the Mississippi River would be advantageous in developing the western half of the expanding country. So Davidson was chosen to accurately map the northern Sierra Nevada peaks—a most important region of California, considering the amount of gold being pulled from the nearby mines each year. Davidson was already familiar with the area, having spent the early 1870s studying planetary movement patterns from a research tower near Donner Peak.

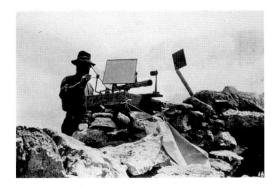

Heliotropes reflected the sun brightly back at faraway peaks, allow researchers to more accurately measure distances in the mountains. *National Oceanic and Atmospheric Administration, B.A. Colonna Album.*

To get an accurate picture of the Northern California peaks, Davidson leaned on the lessons he'd learned on Donner Summit—namely, that nighttime observations worked best and that the higher the vantage point, the better. He selected several mountains from which to measure distances. Among them were Mount Lola, Mount Lassen (now a national park) and Mount Shasta to the north. Davidson planned to establish research stations on those summits to house the long-distance measuring devices he'd use: a heliotrope and a theodolite, both of which were the primary tools for surveying until the introduction of GPS technology in the 1980s.

At each station, Davidson's team would establish a research station on a level surface. They'd place a heliotrope—a mirror-like device for reflecting the sun—on each point. Those heliotropes would reflect the sun brightly enough to be visible from the other summits, allowing researchers to use a theodolite to measure the angles between their location, other research stations and surrounding peaks. Once the researchers knew the angles between points (and a few other measurements, such as elevation), they could measure the distance between points using basic trigonometric principles.

Traditionally, measurements like this would be made at night, as a distant large lantern or industrial light was easier to see at night. But because there was no way to get a light to the top of many of the area's remote peaks, some measurements required daytime work. According to the NOAA publication "Nine Days on the Summit of Mt. Shasta in Northern California," from a researcher on Davidson's team, they were able to measure longer distances with more accuracy than researchers in Europe, measuring distances of nearly two hundred miles with record-breaking accuracy.

Of course, researchers would have to make hundreds of measurements while studying the terrain, and the work moved slowly. Since there were no roads or trails to most of these summits, researchers stayed on site during the process. And though the studies on Mount Lola took place roughly 150

years ago, the research buildings still stand, as does a lone stone chimney likely used to keep the researchers warm during cold Tahoe nights. The two stone structures remaining on Mount Lola are roughly ten feet across, with walls three or four feet high. In the center of each is a flat, short column on which the researchers likely placed the sun-reflecting heliotropes, as they had to be at a precise height. There are no signs or information at these structures, so it's easy to think that they're simply huts built by modern-day backcountry skiers. But they're actually the remains of some of the country's earliest research and surveying of the West, making them a fascinating piece of still-standing history. You can walk into the structures today, and although not much remains, there are geocaching boxes in each one with notebooks to sign your name.

When you reach the top, be sure to take a moment and imagine the difficulty of summiting the peak with pack animals loaded with bricks and supplies, wearing nineteenth-century clothing and footwear and trying to protect the fragile surveying equipment. It was an adventurous undertaking but helped solidify the country's reputation around the turn of the century as a global leader in science and research.

How to Hike It: Mount Lola

Why I Like It: A challenging and little-known hike to the highest peak in Nevada County and highest peak in the Sierra Buttes

Type of Hike: Out-and-back

Total Mileage: 10.4 miles

Elevation Gain: 2,600 feet

Difficulty: Most Difficult

Getting There: From Truckee, take CA-89 N for 14 miles. Make a left on Bear Valley Road/Cottonwood Road and then an immediate left again onto Jackson Meadows Road. After 1.5 miles, make two lefts to loop onto Henness Pass Road. At the next intersection, turn right to stay on Henness Pass Road. The trailhead is 3.4 miles ahead.

Most of the drive past the turn off CS-89 N is on rough, unmaintained dirt roads. Most cars should be able to make it, but take your time and move slowly. You eventually arrive at a parking area marked "Mount Lola Trailhead." There's parking for at least two dozen cars.

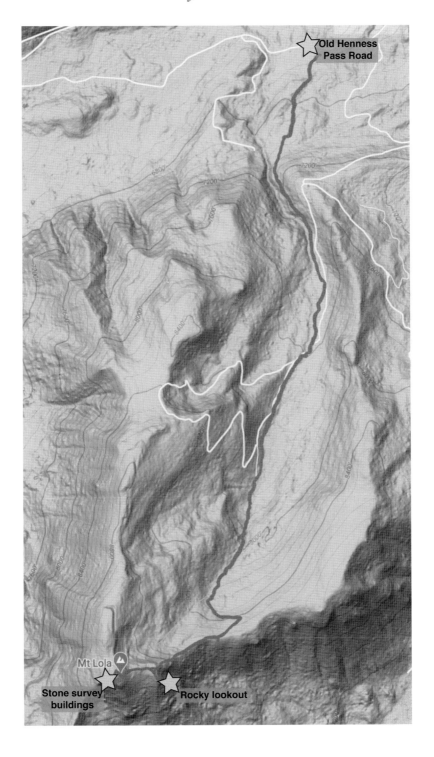

Trailhead Address: Mount Lola Trailhead, Henness Pass Road, California

Start: Follow the single-track dirt trail through the woods. It has a gradual climb for the first mile or so, gaining about 500 feet. The second mile runs parallel to Cold Stream, and there are a few places to scramble down if you have a water filter.

2.1 miles: You'll come to a dirt fire road. Don't cross it; the trail continues to the right just before the road. (It can be a little overgrown in the spring.) Just a few minutes after this, you'll cross the road again (if you look up, you'll see a wooden "trail" sign on a tree pointing to the right). Go right and follow the road for fifty yards or so before passing between two boulders to continue on the trail.

Immediately after this is the biggest stream crossing of the hike. It's no problem in the late summer and fall, especially thanks to the makeshift log bridges built by early-season hikers, but you may have to do some rock hopping in the spring and early summer when the water is a bit higher. Once you cross the stream, the trail continues to the left.

2.5 miles: Reach the Coldstream Valley on your left. This is a fantastic area for wildflowers in the spring and summer. The valley itself can get marshy, but the trail sits a few feet above the valley. So while you may encounter a bit of mud here and there, it's never impassable. Just watch your step through the drainage ditches. The next mile is fairly flat.

3.5 miles: The climbing starts here and doesn't stop until you reach the summit. Expect to gain about 1,200 feet in the last mile. While it's the hardest part of the hike, it's well spread out, and once you start climbing out of the woods and get to the more exposed areas, there are plenty of places to take a break while you enjoy the views.

5.2 miles: Reach the summit. From here, you'll have views to the south of Castle Peak (the square-shaped summit at roughly the same elevation) and White Rock Lake to the west. In the opposite direction of White Rock Lake is the eastern end of Independence Lake. The rest of the Sierra Buttes are to the north.

On the way down, there's a large rock outcropping with fantastic views (Mount Lola Knob). There's a small, loose path to reach it, and depending on how loose the rocks are, you may have to scramble a bit. It's about a 5-minute pit stop to climb up it and well worth the extra effort, but if you have a fear of heights, you'll probably want to skip it.

Backtrack.

10.4 miles: Back at trailhead.

SIERRA BUTTES FIRE LOOKOUT TOWER

The Sierra Buttes may not get as much love as the rest of the Sierra Nevada chain, but these mountains just north of Truckee are stunning and offer some of the best views in Northern California. That goes double for the Sierra Buttes Fire Lookout Trail, which runs high above a series of crystal-blue lakes. And the crown jewel of the hike is the impressive fire tower with views for (literally) a hundred miles or more, built in 1915. Perched on a jagged rock outcropping, it's a fantastic reward for a challenging hike.

States didn't come up with the idea to build lookout towers to spot forest fires until the early 1910s, in response to one of the worst fires in U.S. history at the time: the Big Blowup Fire, also known as the Great Fire or Great Fire of 1910. It was the first large-scale, multistate fire managed by the then-young U.S. Forest Service, and it taxed its resources and expertise. It started in Montana's national forests in August 1910 and took ten days and four thousand men to fight as it spread into Idaho and Washington.

Unfortunately, strong winds brought the fire roaring back to life in late August, and it spread quickly, creating more than 1,700 separate fires that destroyed 3 million acres of land across the northwestern United States. Eighty-seven people died, and hundreds of towns were evacuated and partially destroyed. Although firefighters quickly subdued the flames (in part due to rain and snow), it was a wakeup call for the country that it needed a better wildfire strategy.

So, in 1915, the forest service created a more robust strategy, including strong prevention and response measures. That necessitated having a better system in place for spotting fires before they grew out of control, and throughout the 1910s, the country built hundreds of these fire towers on

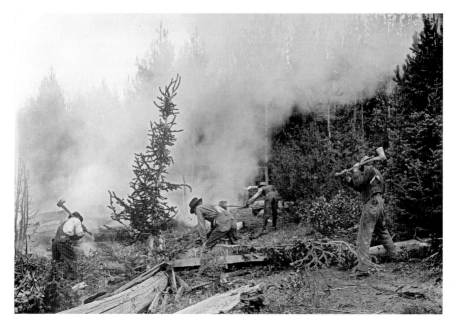

Early firefighting methods were slow and labor-intensive. Circa 1920. *Library of Congress, LC-DIG-npcc-29463.*

high points in the West. In Tahoe National Forest, three towers were built in 1915 at a total cost of $2,500: one on Sardine Point (closer to Truckee), one on Fall Creek mountain (west of Tahoe) and this one, in the Sierra Buttes. Many more fire towers were eventually built in the area, including a still-standing fire tower on Martis Peak between Truckee and King's Beach, as well as dozens more by the Civilian Conservation Corps.

The strategy for using the towers was straightforward. Constructed on the area's tallest peaks, they had sweeping views of the surrounding mountains; on a clear day, you can see Mount Lassen (nearly one hundred miles away) from the Sierra Buttes tower. A watch person would sit in the tower and watch for smoke or signs of fire. If they saw it, they'd use a compass-like device installed in the center of the building to calculate the approximate location and then call or radio the forest service to let them know where it was. This was the only method at the time for finding fires in remote areas before they spread to towns and homes. Fire-spotters would either stay in the tower for a few days during their shifts or ride on horseback each morning to the site.

Interestingly, the first private organization to build fire towers was the Central Pacific Railroad, which built much smaller versions out of necessity.

THREE NEW LOOKOUTS FOR TAHOE FOREST

NEVADA CITY (Nevada Co.), April 2.—Forest Supervisor Bigelow has announced that three new lookout stations will be established in the Tahoe National Forest during the coming Summer.

The lookouts will be stationed on the Sierra Buttes, two miles and a half from Sierra City, at an elevation of 8,615 feet; on Fall Creek Mountain, nine miles southeast of Graniteville, at an elevation of 7,552 feet, and on Sardine Point, on the summit of the Sierras, at an elevation of 8,250 feet.

The estimated cost of establishing the three new lookouts is $2,500.

Left: Clip from the April 2, 1915 *Sacramento Bee*.

Below: A woman looks for smoke from a fire lookout tower. *Fritz-Metcalf Photograph Collection, SD254.C3.E93 c.2, Bioscience & Natural Resources Library, University of California–Berkeley.*

It had several wooden structures around Donner Summit from which employees would watch for railroad fire around the wooden snowsheds, which were highly prone to fires caused by passing trains.

By the 1920s, California had more than six hundred fire lookout towers, which doubled as aircraft watch towers during World War II. But by the 1960s, airplanes, satellites and other modern technology were proving to be easier and more effective methods for spotting fires, so most fire stations today (including this one) are no longer used for official duties. The existing staircase to the tower was added in 1964 and is quite secure, although it

A fire tower on Mount Hough, built around the same time. *Fritz-Metcalf Photograph Collection, SD254.C3.E93 c.2, Bioscience & Natural Resources Library, University of California–Berkeley.*

may look fragile (it's bolted directly into the rock). There are nearly two hundred steep stairs to the top, with a railing and mid-stair platform. It's fine to ascend it as slowly as you'd like, although it's best to let others move up or down first if you're uncomfortable letting go of the handrail.

How to Hike It: Sierra Buttes Fire Lookout Trail

Why I Like It: A steep hike to a historic structure with stunning Northern California views

Type of Hike: Out-and-back

Total Mileage: 4.8 miles

Elevation Gain: 1,540 feet

Difficulty: Most Difficult

Getting There: From Truckee, take CA-89 N to Sierraville. Turn left at the light when the street dead ends. Stay on this road (CA-49 N) for 17.5 miles and then turn right onto Gold Lake Highway. After 1.3 miles, turn

left onto Packer Lake Road. Stay on Packer Lake Road for 4.5 miles and then make a left on Gold Valley Road. The parking area is 0.4 mile ahead on the left.

You actually can drive all the way to the fire lookout, but it's a very steep, rocky road, and you'll need four-wheel drive and high clearance. It's only recommended for people with experience in off-road driving.

Trailhead Address: Sierra Buttes Fire Lookout, Pacific Crest Trail, Sierra City, CA 96125

Start: Walk past the green gate along a wide path. The hike is steep right out of the gate, gaining 300 feet of elevation in the first 0.5 mile.

0.5 mile: Go right at the split. You'll cross a ridgeline often filled with late-season wildflowers.

0.8 mile: Intersect the Pacific Crest Trail; go straight.

1.1 miles: Stay left at the split. (If you don't see a split, don't worry—the trail very clearly goes in the correct direction, and the off-shoot is sometimes overgrown anyway.)

1.4 miles: Around this point, you'll start getting excellent views of the Sardine Lakes on your left. Stay on the main trail for the next section, which has a few steep switchbacks as it meanders through the woods.

1.9 miles: Hit the Sierra Buttes Trail road. Go left here, walking up the road (make a mental note of this intersection, as it's easy to miss on the way back down). The next 0.5 mile on this road is steep as you wind up to the tower. This is where the amazing views of the Buttes start, and it's easy to see why they put the fire lookout here.

2.3 miles: Reach the base of the tower. Feel free to climb up the stairs and enter the tower. The steps and the rail are very secure and bolted to the rock. Your fellow hikers won't mind if you need to climb it slowly, but don't crowd the fire tower; you may need to wait your turn on very busy days.

Backtrack. On your way back, be sure not to miss the right turn back onto the trail through the woods. If you continue on a fire road and pass a green gate, you've gone too far. If you do prefer to walk back down the fire road, take a right at the PCT intersection and then a left when you return to the Sierra Buttes Trail. From there, it's less than a mile back to the parking area.

4.8 miles: Back at parking.

Hope Valley to Scott's Lake

Hope Valley is one of the least busy places near Lake Tahoe—or maybe it just feels that way, since the valley is so large. Either way, it's an excellent spot for a day outdoors, especially in autumn.

Hope Valley, just to the southeast of South Lake Tahoe, was undoubtedly used by Native Americans for centuries before white settlers' arrival. It's in the heart of Nevada's Washoe territory.

But it didn't become Hope Valley until the late 1840s, when it was a stop for the Mormon Battalion heading home from the Mexican-American War (the battalion also established Mormon Station). Hope Valley, which sits just a few miles to the east of Carson Pass, was the first spot to restock and set up a comfortable camp once the battalion came down from the summit. The valley had running water, food and much warmer temperatures than the Sierra summits, which gave the settlers "hope" that they'd make it home, hence the name. It doesn't hurt that they arrived in the valley at the end of July, when the valley was probably warm and filled with wildlife.

By the 1850s, it was still fairly undeveloped, although there was a small lodge and livestock barn in the vicinity for people traveling west on the Carson Route. Pickett's Junction—the current-day intersection of Carson Pass Highway and Luther Pass Road—was likely the site of the Hope Valley Pony Express Station, although it went by several different names before Edward M. Pickett purchased the land and opened his station in 1881.

There are signs about both the Emigrant Trail and the Pony Express in Hope Valley. The informational sign about the Carson Emigrant Route is placed directly in front of the old wagon route; you can even see the dirt imprints from wagon wheels. Wagons likely took several routes through the valley, and the best vantage point to look for those routes is from across the

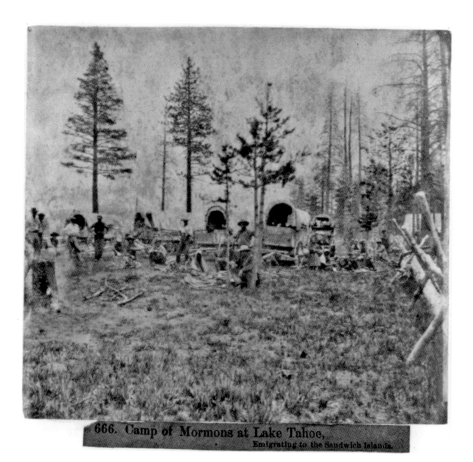

666. Camp of Mormons at Lake Tahoe, Emigrating to the Sandwich Islands.

Mormons traveling home from California were the first emigrants to use the Carson Trail, likely widening the path for wagon travel as they went. *Library of Congress, LC-USZ62-20362.*

valley, once it starts climbing up the other side. If you see what looks like a wide path without much foliage or plant growth, you're probably looking at an old wagon trail.

Estimates suggest that nearly three thousand settlers entered California via the Carson Route in the late 1840s, and likely all of them stopped in Hope Valley. However, in 1852, an alternate route opened: the Johnson Toll Road, also known as the Johnson Cutoff. The shortcut was first shown to John Calhoun Johnson by a Native American scout named Fall Leaf, although in true Manifest Destiny style, it was named for Johnson, not Fall Leaf. The new route eliminated the steep and challenging Carson Pass section of the trail (at more than 8,600 feet). Instead, it crossed closer to Luther Pass, cutting off

2,000 feet of elevation and fifty miles in the process. The highest point on this route was Echo Pass, near Echo Lake, closer to 7,500 feet in elevation. It was the only route west that could attempt to operate year-round and set the path for eventual U.S. Route 50. It was also the route used by the Pony Express.

Interestingly, the first road to South Lake Tahoe also diverted from here, leading to the lake's first resort, built likely as a camp in the 1860s or 1870s. That resort was built by a developer who thought that the transcontinental railroad would come through the south side of the lake, and when it didn't, he sold it to Al Sprague, who opened the Al Tahoe Inn around 1905. Although the resort no longer exists, you can still see where it once was, as the entire neighborhood around the area is still called Al Tahoe.

To take Johnson's Cutoff, travelers would follow the Carson Route to Hope Valley, turning northwest (along current-day Luther Pass Road) instead of southwest. That made Hope Valley one of the last low-elevation places to take a break, which kept it in business for many years.

By 1900, companies had developed better roads around Tahoe, and much of the valley had been sold to sheepherders and farmers. One of those farmers was Martin Sorensen, who bought 170 acres in 1916 and began renting out campsites to passing travelers. He soon added modest cabins, and by the 1930s, cabins were available for tourists at about seventy-five cents per night. Sorensen's Hotel is still open today, although Wylder Hotel Group currently owns it. It has a large outdoor patio space that makes an excellent stop for a meal or glass of wine after a day in Hope Valley.

The trail outlined here enters Hope Valley near an old emigrant road before crossing the valley and climbing up the other side toward Luther Pass, mirroring the route taken by settlers on Johnson's Cutoff. The trail eventually ends at Scott's Lake, just under Waterhouse Peak. While crossing the valley, you'll go past the remains of old ranches and farmsteads in the area. It also passes by amazing views of Pickett Peak, named for Edward M. Pickett.

How to Hike It: Hope Valley to Scott's Lake

Why I Like It: A mix of road and single-track routes for bikers and hikers leading to a remote alpine lake

Type of Hike: Out-and-back

Total Mileage: 8.2 miles

Elevation Gain: 1,150 feet

Difficulty: More Difficult

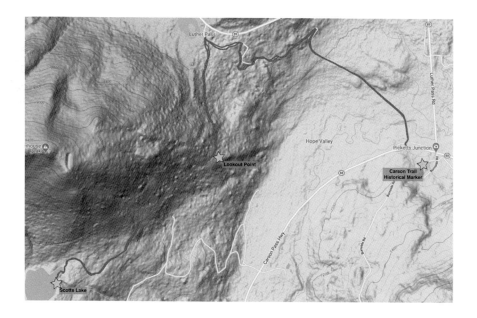

Getting There: From South Lake Tahoe, take US-50 W/Emerald Bay Road for 5 miles. Go left onto CA-89 S at the traffic circle. Follow it for 11 miles and then make a right at the dead end onto CA-89 S. Parking is immediately ahead on the right. The trailhead has basic restrooms but no running water.

Trailhead Address: Hope Valley Wildlife Area Parking Lot, Alpine State Hwy, Markleeville, CA 96120

Start: Take the paved path, which soon widens into a semi-paved road (Old Luther Pass Road). Follow the road directly across the valley. There's a Carson Route historical sign just past the start and the remains of several old sheepherding pens less than ten minutes into the hike.

0.9 mile: Reach the other side of the valley. From here, the trail curves up and into the woods. You can walk up the old road or take the small trails through the woods. They eventually lead to the same spot.

2 miles: Take the single-track trail to the left, marked with a wooden sign reading "Trail."

2.6 miles: Reach a clearing with an excellent lookout point on the left, with triangle-shaped Pickett Peak in the distance.

Stay on the trail, which goes through a tighter, rockier section. It's fine on foot, but mountain bikers should pay attention, as some sections are fairly technical.

3.7 miles: Reach Scott's Lake Road and turn right, up the fire road.

4.1 miles: Turn left when you see Scott's Lake on the left.

Retrace your steps to head back to the parking area (don't forget to turn left back onto the single-track trail as you leave the lake rather than taking the road back down).

8.2 miles: Back at parking.

RESOURCES

Land Managers

D.L. Bliss State Park. parks.ca.gov/?page_id=505.
Donner Memorial State Park. parks.ca.gov/?page_id=503.
Eldorado National Forest. fs.usda.gov/Eldorado.
Lake Tahoe Basin Management Unit. fs.usda.gov/ltbmu.
Malakoff Diggins State Historic Park. www.parks.ca.gov/?page_id=494.
Spooner Lake—Lake Tahoe Nevada State Park. parks.nv.gov/parks/lake-tahoe-nevada-state-park-1.
Sugar Pine Point State Park. parks.ca.gov/?page_id=510.
Tahoe National Forest. fs.usda.gov/tahoe.

Hiking Education

Center for Outdoor Ethics. LNT.org.
Lake Tahoe Visitor's Authority. TahoeSouth.com.
National Park Service. nps.gov/subjects/trails/index.htm.
North Lake Tahoe Chamber of Commerce. GoTahoeNorth.com.

History Resources

California National Historic Trail. nps.gov/cali/index.htm.
California Trail Interpretive Center. CaliforniaTrailCenter.org.

Donner Summit Historical Society. DonnerSummitHistoricalSociety.org.
Jim Beckwourth Historical Society. Beckwourth.org.
Lake Tahoe Historical Society. LakeTahoeMuseum.org.
Nevada Historical Society. NVHistoricalSociety.org.
North Lake Tahoe Historical Society. NorthTahoeMuseums.org.
Tahoe Heritage Society. TahoeHeritage.org.
Truckee-Donner Historical Society. TruckeeHistory.org.
Up and Over Carson Pass. CarsonPass.com.

Resorts

Diamond Peak Ski Resort. diamondpeak.com.
Squaw Valley/Alpine Meadows. SquawAlpine.com.
Sugar Bowl Ski Resort. Sugarbowl.com.

Trail Maintenance and Building

Friends of Incline Trails. inclinetrails.org.
Pacific Crest Trail Association. PCTA.org.
Sierra Buttes Trail Stewardship. sierratrails.org.
Tahoe Area Mountain Biking Association. TAMBA.org.
Truckee Donner Land Trust. TDlandtrust.org.
Truckee Rim Trail Association. truckeetrails.org.

TRAILS BY GEOGRAPHIC LOCATION

INCLINE VILLAGE

NORTH OF TRUCKEE

SOUTH LAKE TAHOE

BIBLIOGRAPHY

Chapter 1

Brown, Julie. "Despite Twice as Many Visitors as Yosemite, Here's Why Lake Tahoe Isn't a National Park." *SF Gate* (blog), October 30, 2020. https://www.sfgate.com.

Lankford, Scott. *Tahoe Beneath the Surface: The Hidden Stories of America's Largest Mountain Lake*. Berkeley, CA: Heyday, 1990.

Leave No Trace—Center for Outdoor Ethics. "The Seven Principles—Leave No Trace Center for Outdoor Ethics." September 29, 2020. https://lnt.org.

Makley, Michael J. *A Short History of Lake Tahoe*. Reno: University of Nevada Press, 2011.

National Park Service, U.S. Department of the Interior "Staying Safe Around Bears." April 13, 2018. https://www.nps.gov.

Richardson, Will. "Tahoe's Felines a Rare Sight." *Tahoe Quarterly*, 2014.

Tahoe Regional Planning Agency. "Tahoe's History." December 2, 2020. https://www.trpa.org.

Chapter 2

Augherton, Tom. "James Beckwourth." *True West Magazine* (2015).

Baltimore Sun. "Pay of the Washington Commissioners." March 2, 1861.

Bonner, Thomas D., and James P. Beckwourth. *The Life and Adventures of*

Bibliography

James P. Beckwourth: Mountaineer, Scout, and Pioneer and Chief of the Crow Nation of Indians. New York: Harper and Brothers Publishers, 1856.

Breen, Patrick. "Patrick Breen Diary." Online Archive of California. https://oac.cdlib.org.

California-Nevada Chapter of the Oregon California Trails Association. "Carson River Route." October 29, 2020. http://canvocta.org.

Colorado Virtual Library. "James Pierson Beckwourth: African American Mountain Man, Fur Trader, Explorer." Colorado State Library, June 18, 2018. https://www.coloradovirtuallibrary.org.

Debczak, Michellle. "How Lewis Keseberg Was Branded the Killer Cannibal of the Donner Party." Mental Floss, September 19, 2018. https://www.mentalfloss.com.

The Diggins. "The Lost Cabin Mine: Kirkwood, California." November 2, 2020. https://thediggings.com.

Donner Summit Historical Society. "Roller Pass." November 2, 2020. http://www.donnersummithistoricalsociety.org.

Emigrant Trail Museum. Historical displays. Truckee, California.

Encyclopaedia Britannica. "Donner Party." March 25, 2020. https://www.britannica.com.

Ferris, Charlie. "Outside with Charlie: Mine, Miners." *Mountain Democrat*, September 14, 2016.

Frémont, John Charles, and Anne Farrar Hyde. *Frémont's First Impressions: The Original Report of His Exploring Expeditions of 1842–1844*. Lincoln, NE: Bison Books, 2012.

Goodyear, Dana. "What Happened at Alder Creek." *The New Yorker*, April 24, 2006.

Harris, E.W. "The Early Emigrant Pass between Mt. Judah and Mt. Lincoln." *Nevada Historical Society Quarterly* 22, no. 1 (1979): 33–41.

Hartford Daily Courant. "Very Late from Oregon and California." August 16, 1847.

History. "Mountain Man James Beckwourth Is Born." A&E Television Networks, November 16, 2009. https://www.history.com.

Jim Beckwourth. "James Pierson Beckwourth: 1798–1866." December 10, 2020. https://www.beckwourth.org.

Los Angeles Times. "Queue-Cutting at Pendleton; 'Lost Cabin' Mine." October 24, 1904.

Mormon-Carson Pass Emigrant Trail. "Mormon-Carson Pass Emigrant Trail Historical Marker." The Historical Marker Database, July 26, 2018. https://www.hmdb.org.

Murphy, Virginia Reed. "Across the Plains in the Donner Party: A Personal Narrative of the Overland Trip to California." *Century Magazine* 42 (1891).

National Park Service, U.S. Department of the Interior. "California National Historic Trail—American Latino Heritage: A Discover Our Shared Heritage Travel Itinerary." February 15, 2021. https://www.nps.gov.

———. "Traveling the Emigrant Trails." Scotts Bluff National Monument, Nebraska. https://www.nps.gov/scbl/planyourvisit/upload/Traveling-the-Emigrant-Trails.pdf.

Nunis, Doyce B. *The Bidwell-Bartleson Party: 1841 California Emigrant Adventure: The Documents and Memoirs of the Overland Pioneers.* [Santa Cruz, CA?]: Western Tangier Press, 1991.

Old Highway 40/Donner Pass Road historical displays, Truckee, California.

Owens, Kenneth N. "The Mormon-Carson Emigrant Trail in Western History." *Montana: The Magazine of Western History* 42, no. 1 (1992): 14–27. http://www.jstor.org/stable/4519446.

Sierra College—California Trail System. "Stories/Galleries." November 15, 2021. https://www.sierracollege.edu.

Snowy Range Reflections: Journal of Sierra Nevada History & Biography 1, no. 1. "Lewis Keseberg of the Donner Party" (2008). https://www.sierracollege.edu/ejournals/jsnhb/v1n1/LKeseberg.html.

Chapter 3

Boca Townsite. Informational displays, Truckee, California.

Bureau International des Expositions. "No Small Beer: Brewing Success at Expo 1889 Paris." May 13, 2020. https://www.bie-paris.org.

DePuy, Dave. "California's First Lager: Boca Beer." *Sierra Sun*, June 13, 2019.

Donner Summit Historical Society. "Martis Indians: Ancient Tribe of the Sierra Nevada." December 7, 2020. http://www.donnersummithistoricalsociety.org.

———. "Snowsheds of Donner Summit." November 9, 2020. http://www.donnersummithistoricalsociety.org.

Federal Highway Administration, with Richard Weingroff. "Highway History: The Lincoln Highway" October 6, 2020. https://www.fhwa.dot.gov.

Foster, D.G., J. Betts and L.C. Sandelin. *The Association of Style 7 Rock Art and the Martis Complex in the Northern Sierra Nevada of California.* Sacramento: California Department of Forestry and Fire Protection, 1998.

Gilliss, John R. "Tunnels of the Union Pacific Railroad." *Van Nostrand's Eclectic Engineering Magazine* 2 (January 5, 1870).

History. "Automobile History." A&E Television Networks, April 26, 2010. https://www.history.com.

———. "Transcontinental Railroad." A&E Television Networks, April 20, 2010. https://www.history.com.

Howard, Thomas Frederick. *Sierra Crossing: First Roads to California.* Berkeley: University of California Press, 1998.

Kyburz Flat. Informational displays, Truckee, California.

Lai, H. Mark, and Philip P. Choy. *A History of the Chinese in California: A Syllabus.* San Francisco, CA: Chinese Historical Society of America, 1984.

Lin, James. "History." Lincoln Highway Association. December 22, 2020. https://www.lincolnhighwayassoc.org.

McCarthy, Joe. "The Lincoln Highway." *American Heritage* 25, no. 4 (June 1974).

McCormick, David. "Nevada's Basque History." *Nevada Magazine* (2020).

Morgan, Wade. "Basque-Ing in Northern Nevada Heritage." Travel Nevada, November 30, 2020. https://travelnevada.com.

Public Broadcasting Service. "Chinese Immigrants and the Gold Rush." November 10, 2020. https://www.pbs.org.

———. "The West—The Land of Gold and Hope." New Perspectives on the West, 2001. https://www.pbs.org.

Sacramento Bee. "The Anti-Chinese Crusade." 1886.

———. "'One Cent a Word' Ads." July 17, 1890.

San Francisco Examiner. "Cri-Pins in Council." May 4, 1871.

Santa Cruz Surf. "Fierce Fire at Boca." April 14, 1904.

Shostak, Elizabeth. "Basque Americans." Countries and Their Cultures, October 10, 2020. https://www.everyculture.com.

Sierra Nevada Geotourism. "Henness Pass Road (No. 421 California Historical Landmark)." Sierra County Historical Society, November 16, 2020. https://sierranevadageotourism.org.

Sierra Sun. "History: The Shootout at Hurd's Saloon." February 12, 2021.

Town of Truckee. "Historical Overview." Truckee, California. https://www.townoftruckee.com.

Truckee Chamber of Commerce. "History + Walking Map—Truckee." Truckee, California, November 6, 2020. https://www.truckee.com.

Truckee Donner Railroad Society. "History of Truckee Railroads." November 14, 2020. https://www.truckeedonnerrailroadsociety.com.

Truckee Ranger District Tahoe National Forest. "Boca Townsite Trail." https://www.fs.usda.gov/Internet/FSE_DOCUMENTS/stelprdb5353792.pdf.

U.S. Census Office. *Table 1: Population of the United States (By States and Territories)* § (1870). https://www2.census.gov/library/publications/decennial/1870/population/1870a-04.pdf.

Wilcox, Molly. "The Truckee Method: How an Anti-Chinese Boycott Came to Be." *Moonshine, Inc.* (blog), April 23, 2019. https://www.moonshineink.com.

Yung, Judy, Gordon H. Chang, and H. Mark Lai. "Chinese American Voices: From the Gold Rush to the Present." In *Chinese American Voices: from the Gold Rush to the Present (Story from Hau-Hon Wong)*. Berkeley: University of California Press, 2012.

Chapter 4

Backpacker Magazine 8. "Incline Flume Trail: A Gem of History" (October 3, 2017).

California State Parks. Malakoff Diggins State Historic Park brochure, n.d.

California State Parks Living History Programs. Malakoff Diggins State Historic Park Environmental Living Program, n.d. https://sierragoldparksfoundation.org/wp-content/uploads/2020/02/ELP-Manual9_28_17.pdf.

Department of the Interior, with Hugh A. Shamberger. "The Story of the Water Supply for the Comstock § (1972)." https://pubs.usgs.gov/pp/0779/report.pdf.

Herr, Alexandria. "Mercury in Our Waters: The 10,000-Year Legacy of California's Gold Rush." KCET, January 23, 2021. https://www.kcet.org.

Historical Marker Database. "Hobart Mills Historical Marker." February 13, 2019. https://www.hmdb.org.

Howle, J.F., C.N. Alpers, A.J. Ward, S. Bond and J.A. Curtis. "Quantifying Erosion Rates by Using Terrestrial Laser Scanning at Malakoff Diggins State Historic Park, Nevada County, California, 2014–17." U.S. Geological Survey Open-File Report, 2019. https://doi.org/10.3133/ofr20191124.

Malakoff Diggins State Historic Park. Informational displays, Nevada County, California.

Marysville Evening Democrat. "For Paper and Pulp." June 9, 1899.

Nevada Legislature, Legislative Committee for the Review and Oversight of the Tahoe Regional Planning Agency and the Marlette Lake Water System. "Historic Marlette Water System," 2017. https://www.leg.state.nv.us.

Orlando, James. "Hydraulic Mine Pits of California." U.S. Geological Survey Data Release, 2016. http://dx.doi.org/10.5066/F7J38QMD.

Pierce, Morris A. "Documentary History of American Water-Works." Virginia City, Nevada Waterworks, 2017. http://www.waterworkshistory.us.

Richards, Gordon. "Incline Village, circa 1800: Land of Lumber and Fertile Soil." *Sierra Sun*, June 4, 2007.

Sacramento Bee. "Hobart Mills Shrine Will Honor Memory of Founder." September 3, 1938.

San Francisco Call. "Calvin's Death Causes Inquiry." September 19, 1903.

Tahja, Katy. "Building Really Steep Railroads." Kelley House Museum, June 21, 2020. https://www.kelleyhousemuseum.org.

U.S. Bureau of Labor Statistics. "CPI Inflation Calculator." November 4, 2020. https://www.bls.gov.

U.S. Forest Service/Department of Agriculture. "History of Tahoe National Forest: 1840–1940." http://npshistory.com.

Chapter 5

Brown, Julie. "A Fortune, a Widow and a Castle in Lake Tahoe's Emerald Bay." *SF Gate* (blog), January 9, 2021. https://www.sfgate.com.

Christie's International Real Estate. https://www.christiesrealestate.com.

Clarke, David. "The Haunting Legend of the Water Babies from Pyramid Lake." *Standard News*, August 3, 2016. https://standardnews.com.

Dance for All People—Naraya Cultural Preservation Council. "NCPC: Cave Rock." July 7, 2017. https://danceforallpeople.com.

D.L. Bliss State Park. Informational displays, South Lake Tahoe, California.

Harpster, Jack, and Ronald M. James. *Lumber Baron of the Comstock Lode: The Life and Times of Duane L. Bliss*. Staunton, VA: American History Press, 2015.

Kennedy, Michael. "Up in the Air: Cave Rock's Future Hangs in the Balance of Past and Present." *Los Angeles Times*, September 9, 2003.

Kortemeier, Winifred, Andrew Calvert, James G. Moore and Richard Schweickert. "Pleistocene Volcanism and Shifting Shorelines at Lake Tahoe, California." *Geosphere* 14, no. 2 (2018): 812–34. https://doi.org/10.1130/GES01551.1.

Modesto Bee and News-Herald. "Emerald Bay Camp to Attract Many." July 11, 1923.

Nevers, Jo Ann. *Wa She Shu: A Washo Tribal History*. Reno: Inter-Tribal Council of Nevada, 1988.

New Sweden Cultural Heritage Society. "A Scandinavian Castle in California?— Really?" https://www.newsweden.org/lib/doc/culture/Vikingsholm.pdf.

Oregon History Project. "Ben Holladay." March 17, 2018. https://www.oregonhistoryproject.org.

Parker, David B. "Sacred Place vs. Recreational Space: Outdoors Buffs Sometimes Miss the Meaning of American Indian Sites." *Reno Gazette-Journal*, March 19, 2003.

Rabe Meadows. Informational displays, South Lake Tahoe, California.

Sierra State Parks Foundation. "History & Natural History—D.L. Bliss State Park." https://sierrastateparks.org.

Special Collections, University Libraries, University of Nevada. Bliss family records.

U.S. Forest Service. "Bonanza Road System." Humboldt-Toiyabe National Forest—History & Culture. https://www.fs.usda.gov.

Washoe Tribe of California and Nevada. "Washoe History: A Brief Summary." https://washoetribe.us.

Chapter 6

Bosworth, Brendon. "An Underwater Forest Reveals the Story of a Historic Megadrought." *High Country News*, December 25, 2012.

California Department of Parks and Recreation. "Olympics at Squaw Valley, 1960." http://www.150.parks.ca.gov.

Chico Enterprise-Record. "Tab for Sponsoring Squaw Valley Olympics Expected to Climb to Whopping $20 Million." November 4, 1959.

Cottonwood Restaurant. "Surrounded by History." June 26, 1970. https://www.cottonwoodrestaurant.com.

Diamond Peak Ski Resort. "Diamond Peak History." https://www.diamondpeak.com.

International Olympic Committee (IOC). "Squaw Valley 1960: How It All Began." https://www.olympic.org.

Kleppe, J.A., D.S. Brothers, G.M. Kent, F. Biondi, S. Jensen and N.W. Driscoll. "Duration and Severity of Medieval Drought in the Lake Tahoe Basin." *Quaternary Science Reviews* 30, nos. 23–24 (2011): 3,269–79.

McLaughlin, Mark. "Taking a 'Peak' Back at the History of Incline Village's Ski Resort." *North Lake Tahoe Bonanza*, March 27, 2015.

North Lake Tahoe Chamber of Commerce. "History and Facts: Tahoe History." May 21, 2020. https://www.gotahoenorth.com.

Sacramento Bee. "Will Establish Gambling Casino Opposite Tallac on Lake Tahoe." September 14, 1905.

Schilling, Cam. "A Brief History of Tahoe and Its People." *Tahoe South* (blog). Lake Tahoe Visitors Authority. https://tahoesouth.com.

Snowbrains (blog). "The History of Sugar Bowl Ski Resort | 75-Years of Powder." January 30, 2019. https://snowbrains.com.

Squaw Valley Alpine Meadows. "About Us." https://www.squawalpine.com.

Stanford Sierra. "Our History." April 6, 2020. https://stanfordsierra.com.

Sugar Bowl Ski Resort. "Sugar Bowl's History: The First Chair Lift and Gondola in California." https://www.sugarbowl.com.

Tallac Historic Site. Historical displays, South Lake Tahoe, California.

U.S. Ski & Snowboard Hall of Fame. "Luggi Foeger." October 12, 2018. https://skihall.com.

Van Etten, Carol. Tahoe Country. "Tallac—Yesteryear and Today." http://tahoecountry.com.

Vournas, Dino. "A Look at Lake Tahoe's Ski History, as Sugar Bowl Turns 80." *Mercury News*, November 6, 2019. https://www.mercurynews.com.

Yesterday's America. "The 1960 Winter Olympics: Sports in the Modern Era." April 13, 2020. https://yesterdaysamerica.com.

Chapter 7

Beede, Jill. "Snowshoe Thompson: 'Viking of the Sierra.'" Snowshoe Thompson—Friends of Snowshoe Thompson. https://snowshoethompson.org.

Berkeley Gazette. "Famous Spider Dance Is Driving Men Wild." June 19, 1853.

California-Nevada Chapter of the Oregon California Trails Association. "Johnson's Cutoff." http://canvocta.org.

Campbell, W.W. "The Astronomical Activities of Professor George Davidson." *Publications of the Astronomical Society of the Pacific* 26, no. 152 (1914): 29–37.

Cincinnati Daily Press. "Decease of the Queen of Bohemia—Sketch of the Life of Lola Montez." January 24, 1861.

Colonna, Benjamin Azariah. *Nine Days on the Summit of Mt. Shasta in Northern California.* New Market, VA: E.O. Henkel, 1923.

Daily Appeal. "Loss by Fire at Genoa Will Exceed Thirty Thousand Dollars." June 29, 1910.

Dustman, Karen. *Hope Valley History*. N.p.: Clairitage Press, October 19, 2007. https://www.clairitage.com.

Encyclopaedia Britannica. "Lola Montez." February 13, 2021. https://www.britannica.com.

Forest History Society. "The 1910 Fires." October 9, 2020. https://foresthistory.org.

Genoa Bar and Saloon. http://www.genoabarandsaloon.com.

History. "Frontiersman Jedediah Smith Is Born." A&E Television Networks, November 16, 2009. https://www.history.com.

McLaughlin, Mark. "Sierra Sex Siren: At Donner Pass Sits Lola Montez Lake, Named for One of History's Most Provocative Women." *Sierra Sun*, October 1, 2015.

Moag, Jeff. "Snowshoe Thompson Had to Be the Most Badass Backcountry Skiing Mailman Ever." Adventure Journal, December 26, 2019. https://shop.adventure-journal.com.

National Oceanic and Atmospheric Administration. "An Angular Point of View: A Photo Collection Illustrating the History of Theodolites at the National Geodetic Survey." NOAA 200th: Collections: Theodolites, April 18, 2006. https://celebrating200years.noaa.gov.

Perry County Democrat. "Brief History of Lola Montez." February 5, 1892.

Snowbrains (blog). "The Most Legendary Skier in California History?: 'Snowshoe Thompson.'" March 6, 2020. https://snowbrains.com.

Struss, Emily. "Nine Questions About Lookout Towers." National Forest Foundation, August 25, 2014. https://www.nationalforests.org.

U.S. Forest Service. "Fire Lookouts: Eldorado National Forest." https://www.fs.usda.gov/Internet/FSE_DOCUMENTS/fseprd636763.pdf.

INDEX

Whittell, George 108, 123, 137, 159, 176
Wood, Art 159
World War II 163

Z

Zephyr Cove 119, 140

ABOUT THE AUTHOR

Suzie Dundas is a Lake Tahoe–based freelance writer and editor. She grew up on the East Coast and worked in politics and on political campaigns before moving out west to be in the mountains. She's written for *Outside Magazine, Lonely Planet, Forbes, Frommer's Guides* and more. When she's not working, she's usually mountain biking, hiking or looking for ghost towns to explore. She has a MA in media and communication and loves trivia, history and being outdoors, so writing this book was a natural fit. You can find more of her work or download digital files of these trails at suziedundas.com.

Visit us at
www.historypress.com